Synthesis Lectures on Engineers, Technology, & Society

Volume 28

Series Editor

Caroline Baillie, School of Environmental Systems Engineering, The University of Western Australia, Crawley, WA, Australia

The mission of this Lecture series is to foster an understanding for engineers and scientists on the inclusive nature of their profession. The creation and proliferation of technologies needs to be inclusive as it has effects on all of humankind, regardless of national boundaries, socio-economic status, gender, race and ethnicity, or creed. The Lectures will combine expertise in sociology, political economics, philosophy of science, history, engineering, engineering education, participatory research, development studies, sustainability, psychotherapy, policy studies, and epistemology. The Lectures will be relevant to all engineers practicing in all parts of the world.

Sander Münster · Fabrizio Ivan Apollonio ·
Ina Bluemel · Federico Fallavollita ·
Riccardo Foschi · Marc Grellert ·
Marinos Ioannides · Peter Heinrich Jahn ·
Richard Kurdiovsky · Piotr Kuroczyński ·
Jan-Eric Lutteroth · Heike Messemer ·
Georg Schelbert

Handbook of Digital 3D Reconstruction of Historical Architecture

Springer

Authors
See next page

ISSN 1933-3633 ISSN 1933-3641 (electronic)
Synthesis Lectures on Engineers, Technology, & Society
ISBN 978-3-031-43362-7 ISBN 978-3-031-43363-4 (eBook)
https://doi.org/10.1007/978-3-031-43363-4

This Springer imprint is published by the registered company Springer Nature Switzerland AG
The registered company address is: Gewerbestrasse 11, 6330 Cham, Switzerland

Paper in this product is recyclable.

Sander Münster
Friedrich-Schiller-Universität Jena
Jena, Germany

Ina Bluemel
Hochschule Hannover
Hannover, Germany

Riccardo Foschi
Università di Bologna
Bologna, Italy

Marinos Ioannides
Cyprus University of Technology
Limassol, Cyprus

Richard Kurdiovsky
Austrian Academy of Sciences
Vienna, Austria

Jan-Eric Lutteroth
University of Applied Sciences Mainz
Mainz, Germany

Georg Schelbert
Zentralinstitut für Kunstgeschichte
Munich, Germany

Fabrizio Ivan Apollonio
Università di Bologna
Bologna, Italy

Federico Fallavollita
Università di Bologna
Cesena, Italy

Marc Grellert
Technische Universität Darmstadt
Darmstadt, Germany

Peter Heinrich Jahn
Technische Universität Dresden
Dresden, Germany

Piotr Kuroczyński
Hochschule Mainz – University of Applied
Sciences
Mainz, Germany

Heike Messemer
TUD Dresden University of Technology
Dresden, Germany

Editors' Foreword

In research on architectural history, digital 3D reconstructions have been used for more than 30 years as knowledge carriers, research tools, and means of representation. The number of digital reconstructions created has increased continuously in recent years, yet they exhibit highly varying technical, graphical, and content-related qualities. This raises the question of criteria and approaches to evaluate and validate the use of models, tools, and results. In view of this, the use of digital reconstruction methods in architectural history research has always been subject to ambivalence. Impressive applications and potential areas for research are contrasted by a whole series of extremely justified scientific and methodological reservations.

Between 2018 and 2022, thanks to funding from the German Research Foundation (DFG), 14 network members from Germany, Italy, and Austria have been working on the Digital 3D Reconstructions as Tools for Research in Architectural History network on the question of how 3D reconstructions can methodically and validly advance our knowledge of historical architecture and what conditions are conducive to this.

This handbook is intended to make these results available to students, experts, and other interested parties who wish to study the digital 3D reconstruction of historical architecture in more detail. It should serve as a guide for students to get a thematic overview and practical insight. The book provides answers to two core questions: What is a digital 3D reconstruction? How are they created and what are they used for? Practical instructions, condensed knowledge, explanations of technical terms and example projects, literature, and further references provide information of varying density and enable an individual introduction to the topic.

Although all chapters of the handbook have been extensively reviewed and amended by all authors, there have been main responsibilities in writing content: The introduction was written by Heike Messemer and Sander Münster. The basics and definitions chapter was written by Richard Kurdiovsky, Peter Heinrich Jahn, and Sander Münster. The chapter about scholarly methods was chaired by Georg Schelbert and Heike Messemer. The main author of the scholarly community chapter was Jan-Eric Lutteroth. The chapters on workflows, legislation, and infrastructures were chaired by Sander Münster. The chapters on Modelling and Visualization have been written by Federico Fallavollita, Riccardo Foschi,

and Fabrizio Apollonio. The documentation chapter was written by Marc Grellert and Piotr Kuroczyński.

Due to its focus, some topics are not included in the handbook. Teaching 3D technologies for humanities and heritage purposes is a highly important topic and there is much discourse and research about how to do it: see a recent overview [1] and resources [2]. Innovation systems enable academic research to be transferred into business models and ventures. Innovation for 3D and cultural heritage is targeted by numerous funding activities and ecosystems as well as research activities [3]. Policies on 3D and cultural heritage receive only a mention here. Policies are principles of action to be "adopted or proposed by an organization or individual" [4] and can define national or international priorities for research, preservation, and education, codes of conduct for digital cultural heritage or educational frameworks. They are, therefore, very influential in 3D modelling for heritage.

Another exclusion by intention concerns ongoing activities. As this is a handbook, most projects and developments that are not finalized have been excluded. A 2019 overview of research activities can be found in the publication *Der Modelle Tugend 2.0* by the working group on digital 3D construction for digital humanities in the German-speaking countries (DHd) [5].

References

1. Münster S et al (2021) Teaching digital heritage and digital humanities – a current state and prospects. Int Arch Photogramm Remote Sensing Spatial Inf Sci XLVI-M-1–2021:471–478
2. Münster S et al (2021) Virtuelle Akademie zur digitalen 3D-Rekonstruktion. Paper presented at the DHd 2021
3. Ulutas Aydogan S et al A Framework to Support Digital Humanities and Cultural Heritage Studies Research. In, Cham, 2021. Research and Education in Urban History in the Age of Digital Libraries. Springer International Publishing, pp 237–267
4. Oxford (2022) Oxford's English dictionary: Policies
5. Kuroczyński P et al (eds) (2019) Der Modelle Tugend 2.0: Digitale 3D-Rekonstruktion als virtueller Raum der architekturhistorischen Forschung. Heidelberg University Press, Heidelberg

Acknowledgements

There are several people we would like to thank: Florian Niebling, Erik Champion, Richard Beacham, Stephan Hoppe, Frithjof Schwarz, Irene Cazzaro, Christoph Klose, and Constanze Roth for their inputs to the meetings. Language proofreading has been done by Kate Sotejeff-Wilson. We thank Liv Eichner, Antonio Esposito, and Dora Luise Münster for their feedback on the manuscript. Parts of the chapter about Documentation arose from the DFG project IDOVIR with contributions by Jonas Bruschke, Marc Grellert, Wolfgang Stille, and Markus Wacker.

Contents

Abbreviations

2D	Two-dimensional
3D	Three-dimensional
3D CBV	3D Computer-Based Visualization
4D	Four-dimensional (as three spatial dimensions plus time)
AI	Artificial Intelligence
AR	Augmented Reality
BIM	Building Information Modeling
CAD	Computer Aided Design
CGI	Computer Generated Images
CMC	Computer Mediated Communication
CV	Computer Vision
GIS	Geo Information System
ICT	Information and Communication Technologies
LoD	Level of Detail
ML	Machine Learning
MR	Mixed Reality
NURBS	Non-Uniform Rational B-Spline
VR	Virtual Reality
XR	Extended Reality

Introduction

1

Abstract

This chapter provides a brief overview of the history of digital 3D reconstruction. It shows in which contexts the first research projects were undertaken and how the resulting 3D models were presented to the public. It sheds light on the institutionalization of 3D reconstruction in research at universities, presentations at conferences, and specialization of architectural companies.

Guiding questions
- When were digital 3D reconstructions first created?
- What was the purpose of the earliest digital 3D reconstructions?
- Where was one of the earliest research contexts for digital 3D reconstructions?
- How did 3D reconstructions gain importance over time?

Basic terms
- History
- Presentation media
- Professionalization

© The Author(s) 2024
S. Münster et al., *Handbook of Digital 3D Reconstruction of Historical Architecture*,
Synthesis Lectures on Engineers, Technology, & Society 28,
https://doi.org/10.1007/978-3-031-43363-4_1

1.1 A Brief History of 3D Reconstruction

3D modeling involves established methods that were used in history studies long before the advent of computer-aided visualization techniques [1]. As early as the Renaissance, scholars studied the appearance of the architecture of the past, analyzing it by means of images, and using it in their creative processes as a model for constructing their own contemporary buildings [2]. As architectural history became established as an academic discipline, reconstruction gained new importance, especially with regard to architecture that had been lost; studies were made of the appearance of the Late Antique Basilica of St. Peter in Rome, which had been demolished in 1514 [3–5], the early construction phases of the Cathedral of Santiago de Compostela [6, 7] or, as a prominent present-day example, the former Berlin Royal Palace [8, 9]. Such traditional reconstructions are prompted by questions as to their original appearance, often posed as issues in buildings archaeology, which cannot be verified through in-situ observation. They may serve—as in the case of the Berlin Royal Palace—as the basis for an actual architectural reconstruction. The advent of visualization techniques for 3D modeling was initiated primarily by 3D reconstruction in the early 1980s [10, 11], while 3D modeling via the digitization of heritage objects became mainstream in the early 2000s [12].

Digital 3D reconstructions of historical architecture are increasingly present in media contexts such as museums, documentaries, computer games, Internet platforms, and many more. The first digital 3D reconstructions of historical architecture, based on scientific principles and in the form of textured volume models, date back to the early 1980s [10, pp. 65–89]. In Great Britain, several projects were created in archaeology during this period [13, pp. 45–46]: For example, the ancient structures of the Roman temple precinct at Bath were digitally reconstructed in 1983/84 and the legionary bathhouses at Caerleon in 1985 [14]. Both projects were created by John Woodwark, who was teaching mechanical engineering at Bath University at the time, using the software DORA (Divided Object-Space Ray-Casting Algorithm). He used plans, elevations, and dimensions of individual buildings. Between 1984 and 1986, archaeologists Birthe Kjølbe-Biddle and Martin Biddle worked with the IBM UK Scientific Centre to create digital 3D reconstructions of the 7th-century Old Minster Cathedral in Winchester [15, pp. 152–154, 16]. This was based on their extensive research and excavations of the church complex, which no longer exists. The goal of all these projects was to give the public a glimpse of architecture that no longer exists today. This was done by producing images of the 3D model for a television report (Bath), a video in the information center of the historic site (Caerleon), postcards with images of the 3D models (Bath and Caerleon), and a film with exterior and interior views of the 3D reconstructed building for presentation in an exhibition of the British Museum (Old Minster in Winchester). Here, the 3D models acted as presentation media.

From about 1986 3D reconstructions began to serve as a research tool. For example, from 1986 to 1987, the mural "The School of Athens" by Raphael in the Vatican (1509–1511) was digitally reconstructed to investigate the representation of perspective [17, pp. xiii, 18]. The interdisciplinary project was carried out at the Technische Hochschule Darmstadt (today: Technische Universität Darmstadt) in computer science, mathematics, and architecture under the advice of the art historian Oskar Bätschmann.

All this work in the 1980s was made possible primarily not only by the enormous development in computer technology since the 1960s, but also by developments in video art, architecture, and film [10, pp. 53–61]. In the 1990s, numerous centers were founded at universities specializing in the 3D reconstruction of historical architecture such as CAD in der Architektur, TU Darmstadt; Visualization Team, University of Warwick; Cultural Virtual Reality Laboratory, University of California, Los Angeles [10, pp. 165–169]. Conferences to serve the exchange of experts in the field were held for the first time and some continue today [10, pp. 297–298]. These include the conference series on Computer Applications in Archaeology (today: Computer Applications & Quantitative Methods in Archaeology, also held outside Great Britain since 1992), Electronic Information, the Visual Arts and Beyond since 1994, and International Society on Virtual Systems and Multimedia since 1995. This professionalization of 3D reconstruction continued around 2000 with specialized companies such as Archimedix founded by Philipp Möckl, Marc Möller (†), and Reinhard Munzel, Architectura Virtualis founded by Marc Grellert and Manfred Koob (†)[1] or Faber Courtial,[2] founded by Jörg and Maria Courtial.[3]

At the same time, departments of different universities specialized in digital 3D reconstructions and are still working in this field today. These include the Universität Cottbus—Senftenberg, Lehrstuhl Architektur und Visualisierung, directed by Dominik Lengyel; Technische Universität Darmstadt, FG Digitales Gestalten—Forschungsbereich Digitale Rekonstruktionen, directed by Marc Grellert; the Mainz University of Applied Sciences, Applied Computer Science and Visualization in Architecture, directed by Piotr Kuroczyński; Friedrich-Schiller-Universität Jena, Digital Humanities (Images/Objects), directed by Sander Münster; Hochschule für Technik und Wirtschaft Dresden, Computergraphik—DREMATRIX, directed by Markus Wacker; Università di Bologna, Dipartimento di Architettura, Fabrizio I. Apollonio. To this day, universities and conferences are not only essential places for the creation of digital 3D reconstructions of historical architecture, but also for discussion, interdisciplinary collaboration, and knowledge transfer [11, p. 42].

[1] http://www.architectura-virtualis.de, accessed on 1.2.2023.

[2] https://www.archimedix.com, accessed on 1.2.2023.

[3] https://faber-courtial.de/, accessed on 1.2.2023.

1.2 Examples of 3D Reconstruction Projects

Playing Angkor
3D models and a game engine used by Tom Chandler in his Ph.D. thesis to research and teach the daily life and practices in historic Angkor Wat [19].[4]

Modellathon 2020/2021

Student competition in the German-speaking countries to digitally 3D reconstruct the historic business premises of Carl Zeiss AG in Jena, Germany, dating from the late 19th to early 20th centuries, which only partially exist today [20].[5]

3D Reconstruction of Synagogues (1994 to 2030) destroyed by the Nazis and reconstructed under the direction of Marc Grellert is an example of a content-driven ongoing project that develops the whole range of interfaces and media used from

[4] www.virtualangkor.com, accessed on 1.2.2023.
[5] Image credits: Christine Käfer and Lilia Gaivan.

renderings and films to virtual and augmented reality to rapid prototyping. The content of remembrance of the Shoah, showing the lost Jewish culture and challenging antisemitism, is still relevant [21].

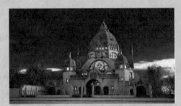

Digital reconstruction of Piazza delle Erbe in Verona, 14th century: 3D reconstruction of the medieval market of Piazza delle Erbe in Verona. The project was curated by the University of Bologna and IULM University of Milan. It culminated in a docufilm presented at Expo 2015 titled "Piazze, palazzi del potere e mercati del cibo nell'Italia di Dante." [22].[6]

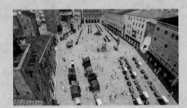

Jena4D: This research group develops and tests workflows for the automated reconstruction of cityscapes via building geometries reconstructed in the client browser from historical cadaster plans. Those roofed building shapes are mapped with

[6] http://www.centrofasoli.unibo.it/centro_italiano/Expo2015_01.html, accessed on 1.2.2023.

automatically located and oriented photographs. This 4D model is world-scale and enriched by links to texts and information, e.g., Wikipedia articles, and accessible as a 4D website via smartphone browsers [23].[7]

Three Points of View for the Drawing Adoration of the Magi by Leonardo da Vinci: In this project, Apollonio et al. 3D reconstructed the architectural models drawn by Leonardo da Vinci in his famous "The Adoration of the Magi" (and preparatory drawings). This reconstruction helped to visualize and prove that the artist did not follow the canonical perspective construction of the time, so the resultant 3D reconstructed models look deformed [24].

Digital reconstruction of the exposition at the Spirito Santo Church in Bologna: In this project, a multi-disciplinary team, directed by the Pinacoteca Nazionale and

[7] https://4dcity.org, accessed on 1.2.2023.

the University of Bologna, realized the 3D reconstruction of the exposition wanted by Canova and held in the church of the Spirito Santo in Bologna in 1817.[8]

Hypothetical Reconstruction of the Roman Theatre of Urbs Salvia: The modern city of Urbisaglia, Roman Urbs Salvia, features many traces of its ancient origins. One of the most noteworthy is the theatre, dated around 23 BCE. The article presents a new, hypothetical virtual reconstruction of the structure, based on recent research on the geometric framework used by Roman architects. The article aims to demonstrate a methodology for a monument characterized by the poor state of preservation [25].

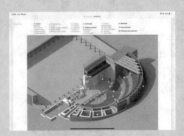

Generative Models for Relief Perspective Architectures: The potential of generative representation is applied to the study of relief perspective architectures realized in Italy between the 16th and 17th centuries. In architecture, relief perspective is a 3D structure able to create the illusion of great depth in small spaces. The method used in the case study of the Avila Chapel in Santa Maria in Trastevere in Rome (Antonio Gherardi 1678) is based on the use of a relief perspective camera, which

[8] https://da.unibo.it/it/eventi/il-da-E-antonio-canova-E-bologna-una-mostra-sulle-origini-della-pin acoteca, accessed on 1.2.2023.

can create both a linear perspective and a relief perspective. The authors experimented mechanically and automatically with perspective transformations from the affine space to the illusory space and vice versa to see the case study in a different light [26].

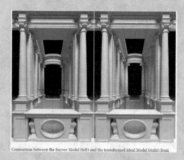

Comparison between the Survey Model (left) and the transformed Ideal Model (right) from

Back to the Future—Visualizing the Planning and Building of the Dresden Zwinger: This court-like building is the most famous Baroque one in the city with a diverse history and of architectural importance. It started in 1709 as an orangery laid out at the rear of the Residential Castle and was extended due to the need for representation facilities until the first half of the 19th century. An extensive project grew out of this: 14 construction and planning phases of the Dresden Zwinger were reconstructed or simulated in detail [27].[9]

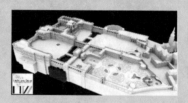

[9] Image credits: Staatliche Burgen, Schlösser und Gärten Sachsen gGmbH and Hochschule für Technik und Wirtschaft (HTW), Dresden.

Summary

This chapter provides a brief overview of the history of digital 3D reconstruction. It shows in which contexts the first research projects were undertaken and how the resulting 3D models were presented to the public. It sheds light on the institutionalization of 3D reconstruction in research at universities, presentations at conferences, and specialization of architectural companies.

Projects

- 1984–1986: 3D reconstruction of the **Old Minster** (erected seventh century, demolished twelfth century) in Winchester, in two videos presented in television programs, created under the direction of the software developer Andy Walter and four students in close cooperation with the archaeologists Birthe Kjølbe-Biddle and Martin Biddle [15, 16].
- 1986 to 1987: 3D reconstruction of the mural "**The School of Athens**" by Raphael in the Vatican (1509–1511) to investigate perspective representation, at the Technische Hochschule Darmstadt (today: Technische Universität Darmstadt) in computer science, mathematics, and architecture under the advice of the art historian Oskar Bätschmann [17, 18].
- 1989: 3D reconstruction of the Romanesque church **Cluny III in Burgundy**, France, by the architectural company asb baudat in Bensheim, Germany, under the direction of the architect Manfred Koob, presented as part of a TV documentary [28].

Key literature

- Messemer, H. (2020). Digitale 3D-Modelle historischer Architektur. Entwicklung, Potentiale und Analyse eines neuen Bildmediums aus kunsthistorischer Perspektive. Heidelberg, arthistoricum.net [10].
- Messemer, H. (2016). The Beginnings of Digital Visualization of Historical Architecture in the Academic Field. In: Virtual Palaces, Part II. Lost Palaces and their Afterlife. Virtual Reconstruction between Science and the Media, Hoppe, S., Breitling, S. (Eds.); pp. 21–54 [11].
- Grellert, M. (2007). Immaterielle Zeugnisse—Synagogen in Deutschland. Potentiale digitaler Technologien für das Erinnern zerstörter Architektur. Bielefeld [21].
- Kuroczyński, P.; Pfarr-Harfst, M.; Münster, S., (Eds.) Der Modelle Tugend 2.0: Digitale 3D-Rekonstruktion als virtueller Raum der architekturhistorischen Forschung. Heidelberg University Press: Heidelberg, 2019 [29].
- Münster, S. (2022) Digital 3D Technologies for Humanities Research and Education: An Overview. Applied Sciences, 12:2426 [30].

- Münster, S. (2011). Entstehungs- und Verwendungskontexte von 3D-CAD-Modellen in den Geschichtswissenschaften. In: Virtual Enterprises, Communities & Social Networks, Meissner, K., Engelien, M. (Eds.); Dresden, TUDpress; pp. 99–108 [31].

References

1. Chadarevian Sd et al (2004) Models - the third dimension of science
2. Carpo M (2001) Architecture in the age of printing. orality, writing, typography, and printed images in the history of architectural theory
3. Krautheimer R (1937–1977) Corpus basilicarum christianarum Romae, 5 vols
4. Arbeiter A (1988) Alt-St.-Peter in Geschichte und Wissenschaft: Abfolge der Bauten, Rekonstruktion, Architekturprogramm
5. Andaloro M (ed) (2006) La pittura medievale a Roma. Corpus, Bd. 1: L' orizzonte tardoantico e le nuove immagini. Milano
6. Horst R (2012) Die Sakraltopographie der romanischen Jakobus-Kathedrale. Studien zur Kunstgeschichte des Mittelalters und der Frühen Neuzeit
7. Conant KJ (1926) The early architectural history of the Cathedral of Santiago de Compostela
8. Rettig M (2011) Rekonstruktion am Beispiel Berliner Schloss aus kunsthistorischer Sicht
9. Hinterkeuser G (2003) Das Berliner Schloss. Der Umbau durch Andreas Schlüter
10. Messemer H (2020) Digitale 3D-Modelle historischer Architektur. Entwicklung, Potentiale und Analyse eines neuen Bildmediums aus kunsthistorischer Perspektive. Computing in Art and Architecture. arthistoricum.net, Heidelberg
11. Messemer H (2016) The beginnings of digital visualization of historical architecture in the academic field. In: Hoppe S et al. (eds) Virtual palaces, part II. Lost palaces and their afterlife. Virtual reconstruction between science and the media, pp 21–54
12. De Luca L (2011) Methods, formalisms and tools for the semantic-based surveying and representation of architectural heritage. Appl Geomat 6(2):115–139
13. Reilly P (1996) Access to insights: stimulating archaeological visualisation in the 1990s. In: Márton E (ed) The future of our past '93–'95. International conference of informatics. Budapest, pp 38–51
14. Woodwark J (1991) Reconstructing history with computer graphics. IEEE Comput Graphics Appl 11:18–20
15. Reilly P (1992) Three-dimensional modelling and primary archaeological data. In: Reilly P et al (eds) Archaeology and the information age. A global perspective. Routledge, London, pp 147–173
16. Reilly P et al (2016) Rediscovering and modernising the digital old minster of Winchester. Digit Appl Archaeol Cult Herit 3:33–41
17. Mazzola G et al. (eds) (1987) Rasterbild — Bildraster. Anwendung der Graphischen Datenverarbeitung zur geometrischen Analyse eines Meisterwerks der Renaissance: Raffaels »Schule von Athen«. Ausstellung auf der Mathildenhöhe. Springer, Berlin/Heidelberg/New York
18. Krömker D et al (1987) Rekonstruktion und Modellierung. In: Mazzola G et al (eds) Rasterbild — Bildraster. Anwendung der Graphischen Datenverarbeitung zur geometrischen Analyse eines Meisterwerks der Renaissance: Raffaels »Schule von Athen«. Ausstellung auf der Mathildenhöhe. Springer, Berlin/Heidelberg/New York, pp 35–64

19. Chandler T (2013) Playing Angkor: exploring the archaeological themes of the Khmer empire through game engine technologies. In: 41st computer applications and quantitative methods in archaeology conference 2013 Perth
20. Smolarski R et al (2023) Modellathon—Eine digitale Lehr- und Lernmethode. Zur 3D-Rekonstruktion der historischen Fabrikanlage von Carl Zeiss Jena. In: Britsche F et al (eds) Visual History and Geschichtsdidaktik. (Interdisziplinäre) Impulse und Anregungen für Praxis und Wissenschaft. Wochenschau Verlag, Frankfurt/M., pp 224–237
21. Grellert M (2007) Immaterielle Zeugnisse – Synagogen in Deutschland: Potentiale digitaler Technologien für das Erinnern zerstörter Architektur. TU Darmstadt, Darmstadt
22. Apollonio FI et al (2016) Digital reconstruction of Piazza delle Erbe in Verona at XIVth century
23. Münster S et al (2021) Toward an automated pipeline for a browser-based, city-scale mobile 4D VR application based on historical images. In: Research and education in urban history in the age of digital libraries. Springer International Publishing, Cham, pp 106–128
24. Apollonio FI et al (2021) Three points of view for the drawing adoration of the magi by Leonardo da Vinci. Heritage 4(3):2183–2204
25. Bassoli I et al (2022) Hypothesis of reconstruction of the Roman theater of Urbs Salvia. SCIRES-IT- SCIentific RESearch and Information Technology 12(1):151–164
26. Baglioni L et al (2021) Generative models for relief perspective architectures. Nexus Netw J 23(4):879–898
27. Jahn PH, Wacker M, Welich D (2016) Virtual palaces, part II: lost palaces and their after-life – virtual reconstruction between science and media (Hoppe S, Breitling S (eds)), vol 3. PALATIUM e-Publications, Palatium, München, pp 267–301. http://www.courtresidences.eu/uploads/publications/virtual-palaces-II.pdf] , Accessed 1.2.2023
28. Koob M (1993) Die dreidimensionale Rekonstruktion und Simulation von Cluny III. In: Horst C et al (eds) Cluny. Architektur als Vision. Heidelberg
29. Kuroczyński P et al (eds) (2019) Der Modelle Tugend 2.0: Digitale 3D-Rekonstruktion als virtueller Raum der architekturhistorischen Forschung. Heidelberg University Press, Heidelberg
30. Münster S (2022) Digital 3D technologies for humanities research and education: an overview. Appl Sci 12(5):2426
31. Münster S (2011) Entstehungs- und Verwendungskontexte von 3D-CAD-Modellen in den Geschichtswissenschaften. In: Meissner K et al (eds) Virtual enterprises, communities & social networks. TUDpress, Dresden, pp 99–108

Basics and Definitions

<div style="text-align:right">**2**</div>

Abstract

This chapter introduces key concepts of 3D modeling in the humanities. A 3D model can represent a great variety of objects. The objects of 3D modeling of historical architecture are lost or extant buildings, their modifications, and designs that were never executed. These buildings are as much part of the cultural heritage as their plans. The chapter begins with a survey of source-based historical knowledge as the basis of analysis, historic interpretation, and reconstruction of any historical situation. It then addresses modeling in general as a scientific practice, its use in architecture, and the advantages of its digitization.

Guiding questions

- What are the basic definitions and concepts related to 3D modeling?
- Why and how does it with historic architecture and cultural heritage?
- What are sources, and what is their purpose?
- How is reconstruction done?
- Why model, and how can one do this in a scientific way?
- What is a model? (in general, and in architecture)
- What are the conditions for digital 3D modeling?

© The Author(s) 2024

S. Münster et al., *Handbook of Digital 3D Reconstruction of Historical Architecture*,
Synthesis Lectures on Engineers, Technology, & Society 28,
https://doi.org/10.1007/978-3-031-43363-4_2

Basic terms
- Historic architecture
- Cultural heritage
- Sources
- Reconstruction
- Modeling and models
- 3D reconstruction versus 3D modeling
- Simulation

2.1 Architectural History

Architectural history explores buildings, constructions, and structures, deals with urban planning, and analyses architectural theory, discourse, and media such as architectural drawings and models. It also explores the people, groups, and networks that were behind all this. Architectural history thus regards architecture as a cultural phenomenon.

As a scientific discipline, architectural history has close ties to art history, archeology, and architectural education. It is thus interdisciplinary and can include social sciences, economics, or technical sciences. This great diversity of disciplines yields a very wide range of possible research questions. As a historical discipline, architectural history deals with the past, including the recent past, and explores things such as appearance and form, placement, functions of built environments, and the influences of people such as patrons or users, on developments in the history of style, of immanent meanings or changes in meaning. In other words, it tries to reconstruct the historical context. In this way, an object is located temporally, spatially, socially, and discursively.

It is important to note that buildings have rarely come down to us as they originally looked, but that they are subject to permanent changes. These changes can be formally visible (e.g., early modern parts added to a medieval building), and purely functional (e.g., an 18th-century monastery building redeveloped for university purposes). For a well-founded historical analysis, the original state must therefore be examined. And if this has not been preserved, it must be reconstructed—whether ideally as pure thought, in descriptive texts, or materially in an architectural drawing or model, either as an analog or a digital reconstruction. This last option is much more immediately vivid—and is the topic of this handbook.

Architecture is a built social order and a reflection of humanity's thoughts and actions. Buildings with religious, political, profane, or other uses embody an important part of the cultural heritage of human societies. Due to its (mostly) physical nature, architecture belongs to a tangible cultural heritage. Even architectural projects that remained on paper belong to the cultural heritage, but in this case to the intangible one. Other examples

of intangible cultural heritage are music, dance, customs, or workflows, while natural heritage comprises for example mountains or caves. Representational buildings, whether religious like temples and churches or secular like princely palaces or parliaments, often demonstrate the cultural achievements to which their creators dedicate the most effort and material resources. It is not uncommon for these buildings to be erected on symbolic sites, whether they acquire this special meaning before or after they have been built.

Further reading: Architecture as part of cultural heritage

Architecture is part of our cultural heritage. In general, **cultural heritage** can be understood as traces and expressions from the past, which are used in and influence contemporary society [2]. Cultural heritage can be regarded as property that a person cannot inherit; instead, it must be acquired, e.g., by a society that perceives it as valuable [3]. While cultural heritage traditionally focuses on tangible objects, a broader understanding adds intangible heritage (e.g., dances, customs, workflows) and natural heritage (Fig. 2.1). Architecture, understood as the human-built environment, is the manifestation of social practices and therefore relates to both, tangible and intangible cultural heritage. It serves different purposes and users, takes on different shapes and sizes, and depends on different conditions, but always serves human demands. As diverse as architecture is, so are the possibilities for dealing with it in the sciences and in the humanities. There are some great examples of 3D modeling of intangible cultural heritage, regarding customs and daily life [4, 5] in past cultures [6], but the focus here is on tangible heritage.

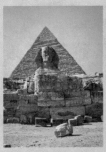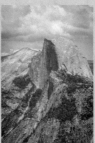

Cultural Heritage – Intangible Natural Cultural Digital Cultural Her-
e.g., monuments Cultural Her- Heritage – e.g., itage – e.g., computer
 itage – e.g., mountains games
 rites

Fig. 2.1 Types of cultural heritage [1] (Images: Münster (left-middle), right: https://www.eur opeana.eu/de/item/916118/S_TEK_object_TEKS0057154, accessed on 1.2.2023)

Another important concept is the **digital (cultural) heritage,** of which digital 3D models form part. It comprises technologies to preserve, research, and communicate

cultural heritage [7] and it includes materials like texts and images, created digitally or digitized, as well as digital resources of human knowledge or expression (e.g., cultural, educational, or scientific) [8]. This latter facet comprises various digital technologies to study cultural heritage [9]. Around those topics, various scholarly communities have formed during the past few decades such as digital humanities, digital archeology, or digital history studies [10].

In human history, the decay or deliberate destruction of such symbolic architecture is just as constant as the attempts to commemorate it, to preserve its lost meaning or to charge the sites with a new one. Although physical reconstruction is the most consistent and effective form of remembrance here, it remains the exception not least because of the high construction costs. Other forms predominate, such as remembrance in rites, oral traditions, texts, and pictures.

Forms of remembrance that focus on the visual presentation of the destroyed object, primarily drawings and haptic models, can be considered close to the methods of architecture. For a long time, they were the only way for the public to remember buildings that no longer existed or of which only a few remains survived. Information and communication technology has revolutionized the representation and communication of architecture. Graphic data processing has achieved a vividness in the representation of destroyed buildings, especially in interiors, that has rarely been achieved by other media until now. The digital 3D models of historical architecture which resulted from this process are the subject of this book.

Further reading: Research on 3D reconstruction in general Theoretical foundations and epistemological recommendations of 3D modeling of cultural heritage have been studied for a long time, e.g., within various EU projects [11, 12]; on a national level in Germany by the task group for 3D reconstruction of the DHd association [13], the Digital Art History workgroup [14], and the DFG Network for 3D reconstruction of architectural history [15], and by numerous recent publications [16–18].

2.2 Reconstruction

Reconstruction is the process of re-creating something that no longer exists or is unknown, for example, a lost work of music, literature, or art, a destroyed building, or a sequence of events (Fig. 2.2). The term reconstruction describes both the process and its outcome.

The concept of reconstruction can be traced back to the Renaissance and from its very beginning, it was closely connected with archeology. Shortly before his death, the famous Italian painter and architect Raffaello Santi (1483–1520) developed a memorandum for

3D Reconstruction of a non-extant (destroyed) church 3D Reconstruction of a never realized (planned) garden. 3D Digitization of a pottery arte-fact.

Fig. 2.2 3D modeling versus state of existence (Images: Münster)

an archeological survey of the ancient ruins of Rome. The aim was not to document the buildings in their ruined state, because as such they seemed to be insufficient like "bones without flesh," but to present them in their concluded original appearance, this by using ortho-projected plans [19].

Like Santi's one, a reconstruction always needs to be based on sources, which we need to analyze and interpret. Otherwise, it would be no more than imagination or subjective fantasy. Yet, the interpretative part of the process leads to an inevitable characteristic of a reconstruction: it is hypothetical. Things that have passed are gone and irretrievable. We must always be aware of this: when we reconstruct, we create anew.

Motives to reconstruct can be manifold, and it is important to be aware that they may be ideologically underpinned. Destruction, be they unaccountable as in natural disasters, wanton and deliberate as in wars, accidental or caused by negligence as in fires, is often the occasion to physically rebuild a building or parts of it, following the lost forms as faithfully as the current state of mind allows, desires, or even forbids.

Reconstruction is closely linked to the idea of the original—and Western culture holds the physical original in particularly high esteem. We often value the reconstruction much less and tend to criticize it more easily. Therefore, we must carefully and consciously distinguish whether a reconstruction was carried out from the ground up, including the time interval between the reconstruction and the destruction, or whether only parts of a building were reconstructed—this is where the concept of restoration begins to blur. And we must consider the significance of buildings for cultural identity, as well as the ideologies and mentalities that led to a reconstruction.

Reconstruction is not limited to the 1:1 translation of physical remains into a virtual model. What has been lost can be reconstructed in writing descriptive texts, visually as drawings, or haptically in scaled-down models. These forms have long been used by architectural history researchers. With the expansion of new media in recent decades, digital, virtual reconstructions create new technical capabilities to expand, modify, and add.

Digital media reconstruction of historical architecture is part of the digital humanities. According to the Principles of Seville, virtual reconstruction is a digital process that is fundamentally analogous to physical reconstruction. "A virtual model is used to visually reconstruct a building or object built by humans at a certain time in the past, starting from the available physical evidence of these buildings or objects, scientifically justified comparative conclusions and, in general, all the studies carried out by archaeologists and other experts related to archaeological and historical science" [20, p. 2]. Of course, this does not apply to archaeology and antiquities alone, but to all historical disciplines. Medieval archaeology is therefore just as affected as the restoration and conservation of historical monuments, buildings, and objects.

Virtual or digital reconstruction not only strives to restore an artifact to how it looked at the time of its creation but can also reconstruct successive phases of use of an object and thus the sequence of building states. Reconstructing lost or altered architecture virtually using digital models brings an enormous advantage for visualization: a digital model is easier to change than a physical (i.e., material-based) model. The visualization is no longer static but can be dynamically adapted to different angles and converted into different formats. Digital 3D reconstructions of historical architecture support the understanding and research of lost or disappeared building conditions, sources, and historical objects. During a digital reconstruction, the provenance, consistency, and correspondence of sources are checked and discrepancies—for example between ground plans and elevations or vedutas—are revealed (→ Scholarly Method).

2.3 Sources

Sources are the very basis for any study in architectural history and consequently for every reconstruction. This section explains the different categories and types of sources and the methods for their use. It gives insights into collaboration between disciplines involved in reconstruction processes (the humanities and technical sciences) which all use the same sources, with different methods and aims.

All historical research is based on sources [21]. Sources are a specific class of cultural heritage items that provide information about past events, phenomena, or objects. In most cases they are tangible (e.g., administration files from archives, historic letters, architectural drawings, plans, or old photographs, inscriptions and other traces on the object itself), but they can be intangible (e.g., oral history provided by former users or inhabitants of a building).

Sources are always biased, by the creators' intention or limited view. Understanding by means of sources is therefore never a neutral act, but requires critical reflection [22], as formalized by source criticism, which analyzes and interprets historical sources e.g., in their contemporary historical context.

Further reading: Sources for 3D reconstructions

Architectural drawings: if available, ortho-projected plans and drawings are the most important source for geometrical reconstructions of non-extant architecture and allow unbiased access to geometrical properties.

Cadaster and maps: ground plots and cadastral information provide directly measurable information, although mostly of lower detail.

Historical photographs and vedutas enable a natural impression of an architectural object and contain information about materials. In contrast to plans, geometrical information is distorted by perspective.

Material evidence (e.g., archaeological remains, similar buildings): if available, physical remains contain comprehensive information about geometries, materiality, and behavior of an object. In many cases they enable (semi-)automated 3D digitization.

Geographical information (e.g., elevation models) are usually very stable, less change-dependent, can provide information, e.g., about outer dimensions of building or an arrangement of floors.

Textual descriptions are in some cases the only sources available or can provide unique information e.g., about spatial arrangements or materials.

Fig. 2.3 Sources for 3D reconstructions (Images: P. H. Jahn, ThULB, Münster)

Sources are classified by the type of textual, image, or audiovisual media, or object sources such as physical remains of buildings [23, 24]. For 3D reconstructions the most relevant and often-used sources are visual (architectural drawings, views, photographs, etc.), textual (historic descriptions, files from building administrations, etc.), and physical (the still existing object or preserved parts of it) (Fig. 2.3).

Technical data from the natural sciences and engineering are also sources. Laser scans and surveys record the actual state of a building. They can serve as sources for the humanities (e.g., to review historical plan sources). The scientific advantage of a digital 3D model of historical architecture is interdisciplinary collaboration [25]. A digital 3D model is often created within a cooperation of several fields (3D modeling, architectural history, monument preservation, surveying technology, etc.) (→ Scholarly Community).

Another main distinction is between primary and secondary sources. Primary sources date from the period being studied or were created by participants to describe the object being studied. They reflect the individual view of the author [22]; examples are drafts, building surveys, or texts such as personal diaries. A secondary source describes, interprets, or analyses a historical object, event, or phenomenon (e.g., a historic text which describes an even older [primary] source that no longer exists). Scientific texts about an architectural object are secondary literature. Occasionally, tertiary sources are mentioned: these are published in collections of material based on secondary (or primary) sources, e.g., compilations or (digital) repositories of sources [26, 27]. Tertiary sources thus include all the contemporary analogies and logics which are often used to bridge gaps of primary sources. In architecture, this includes typologies, building styles, and construction logics.

A distinction should be drawn between (a) **3D digitization**—also called retro-digitization—where an extant cultural heritage object is a source, and (b) **digital 3D reconstruction**—also called source-based reconstruction, where the modeled object can only be envisioned through other sources describing it (e.g., planning documents describing a never-realized, destroyed, or altered object) [28, 29] (→ 3D Modelling).

Sources serve to critically review the model (or its process of creation), and to falsify the content of a source (i.e., as an additional means for source criticism). An example would be a digital 3D reconstruction based on laser scanning, a technique that provides a very precise image of an object that still exists or based on exact recent building measurements. If this model is then compared with historical plans, their accuracy can be checked: whether they were measured as precisely as today's building surveys or only copied from older plans without checking the spatial dimensions, etc.[1] The conclusions we can draw from comparing a constructed 3D model and historical plans can complement, confirm, or refute each other. In the course of a digital reconstruction, not only the provenance but also the consistency of the sources is checked. For example, discrepancies between floor plans and elevations or vedutas can be uncovered. The most fundamental prerequisite for a critical review is the disclosure of the sources and scientific reasoning underlying the model and documenting the creation process of the 3D reconstruction.

[1] This also works the other way around: reconstructed buildings (e.g., after partial destruction) are measured and compared to historical sources.

Further reading: Linking models and sources as a research prospect Source data should be embedded into 3D models to develop new research questions and to generate new insights. Since the source basis for creating models (architectural drawings, photographs, texts, etc.) is now increasingly available in digital formats, they could be directly incorporated into or linked to the models [30, 31]. The digital 3D model thus acquires a platform character and can provide:

- A working space in which the function, affiliation, or interpretation of individual elements (picture, plan, written document) can be tested.
- Access to further media formats (image and text sources), which allow the model to be assessed.
- Presentation of an overall result (or interpretation of only a section, by hiding certain areas).

2.4 Models and Modeling

Why do modeling? And why digitally and in 3D? The aim of this section is to understand the basic way of thinking when modeling is practiced. The term derives from physical models and develops from downscaled ones used since at least the late Middle Ages in the arts and in architecture to visualize a draft physically, haptically, and spatially.

Modeling as a principle dates back to Antiquity, for example, downscaled models of farms as symbolic burial objects in the Old Egyptian funeral cult which refer symbolically to the alimentation of the defunct [32, pp. 7–8, figs. 1.8–1.12, 33, pp. 49–51, Fig. 2.2]—and the world of toys with which mankind is traditionally amusing and teaching its children is well known to everybody. But in its wider sense modeling is a special procedure or approach to generate and/or communicate knowledge using simplified representations of reality. Simplifying to gain knowledge seems paradoxical, because how should knowledge increase by such a reducing process like simplification? Vice versa, simplification separates the important aspects from the unimportant ones. In other words: models focus on the task of research or learning by reducing complexity (Fig. 2.4). Only certain properties of the task are modeled as these are bearers of meaning and thus considered. That is why modeling, in general, means creating "the (simplified) replica of an original system" (or an object) which must be "sufficiently similar to the original system with respect to the purpose of its realization" (author translation of [34], p. 18).

An established explanatory scheme of models in three fundamental aspects is provided by the so-called general model theory as codified by Stachowiak [35]. Also, according to this theory, a model represents a simplified or reduced version of an original, but added is the fundamental aspect of the subjective and pragmatic purpose of each modeling [35, pp. 131–133]:

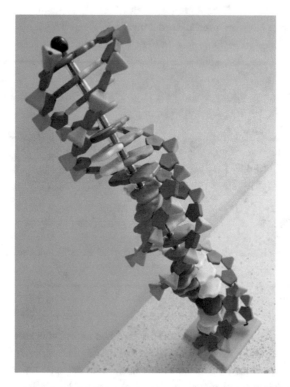

Fig. 2.4 Scientific modeling with the didactic aim: A piece of a DNA model created by the Garvan Institute of Medical Research (Image: Theodore Barons, 2014)

- **Representation**: Models represent originals, whether from imagination (ideas, concepts), expressions, symbols, or physical objects. A model is generally understood to mean the reproduction of an original, and it always refers to an original.
- **Reduction**: Models usually do not include all features of the original but only those considered relevant by the creator.
- **Pragmatism**: Models function as a surrogate of the original within a certain time span, for a certain purpose (transactions), and a certain group of recipients.

Of these three aspects, **representation** might be the clearest: models have always to be more or less similar to the related original like a picture to the depicted (nothing to say that the latter can also be thought of as a model relation).

Reduction (or simplification) is subdivided into different procedures (and always related to pragmatism). Generally usual are for physical models reducing in size by downscaling and transforming into other materials. Downscaling makes the model easier to handle (better moveable, to provide overviews, etc.; on the other hand: for a pragmatic upscaling of very small or even microcosmic objects cfr. Fig. 2.4). Transformation into

twofold model relation

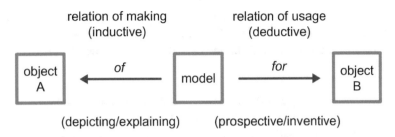

Fig. 2.5 The epistemic twofold model relation, adopted from Bernd Mahr [36] (Image: P. H. Jahn)

other materials is often determined by economic reasons, because during model-based preparatory phases the effort of expensive respectively valuable materials shall be avoided. Didactic models are often much cheaper in their materiality than the represented originals. And if original materials are not stable in their conditions (i.e., bodies of living creatures) they have to be substituted by stable ones in the model. These are only a few examples of a wide range of possibilities for material transformation, but with these the principle might be clear. The result of both, downscaling and material transformation, is the reduction of complexity. As an extreme case of material transformation—one could speak here of a dematerializing *hyper*-transformation—can be regarded as the transformation from the physical into the digital as used in computer-based 3D modeling.

Pragmatism is important: models are always created or produced for a research, teaching, or design task. Therefore, a model can be produced for solving a task (model *for* something) or to represent an object respectively a system (model *of* something) (Fig. 2.5). The time span (as the core aspect of the pragmatic feature) is limited to the duration of the work with the model, its modeling included, or the validity of knowledge stored in the model and expressed by it. Put simply, in time, a model becomes outdated and obsolete e.g. if the original changes or—in case of research—new insights have been gained. Recipients can vary from small teams of scientists or designers (in arts, design, architecture, technics, etc.) and their clients to broader audiences in didactic settings.

For a better understanding of what a model can be, here are some examples:

- A descriptive replica, or reduced model (e.g., of a castle, a car, or a human heart), which is, therefore, a physical and stable object.
- An explanatory model to reproduce part of a phenomenon, even simulate the effects of a physical one (e.g., lighting), or communicate a value or knowledge.
- A predictive model, e.g., to simulate the behavior of (natural or artificial) light to evaluate a lighting system for use in an environment.

- A prototype of an object intended for industrial mass production, which may be a registered model, whose counterfeiting is prohibited by law.
- A dynamic model, e.g., in medicine of the role of the diaphragm in the entry of air into the lungs, in the engineering of floating air over a car or an aircraft design, or in architecture the simulation of façade components like panels for protection against solar radiation.

As we have seen, modeling can also be non-physical, abstract, and therefore only a system of thoughts, or, as often in natural sciences like climate research, a system of calculation. In any case, it is to be mentioned that each modeling must always be thought carefully about what to examine or convey to a target group or audience. Then the model has to be designed according to complexity, level of detail, accuracy, proximity, or distance from reality, and so on. To be aware of these basics is the best way to create good and evident models that will fulfill their purpose.

Further reading: Conditions of scientific models In science and research, models are a helpful and practicable medium of generating knowledge about problems and their solutions or to illustrate results. The latter communicative function is also used in educational situations or museums. To be scientific, a model itself or its producers have to provide evidence about the sources and hypothesis on which it is based, because the arguments need to be traced and verified (inside the model by sources and/or annotations, outside it by commentaries). To guarantee traceability, all primary (analog or digital) data beyond the model should be secured and stored for future research. The model may not be published alone, but with the data and knowledge generated during the preparatory research, and the epistemic results of the modeling process (→ Scholarly Method).

Due to its pragmatic feature, the model should never be the sole medium of research activity. For example, in architectural research, the model of a building may either play an important role in solving a research question about spatial and material properties or in investigating research questions about social, historical, or political contexts. In the former case, formal details may be more important. In the latter case, too, the model could also be significant, but its formal details would be of less interest.

3D modeling as a reconstruction tool of historic architecture, is a method and practice of the humanities. In this research field, a model is generally created "post factum"—after the original [37, p. 335]. In contrast to modeled drafts which are made "ante factum", because they prepare the object to be fabricated, these post-factum-models are created subsequently to illustrate the original including the developed reconstruction of it.

2.5 The Architectural Model

Architecture has been visualized in planning and construction practice using downscaled 3D models for hundreds of years. Architectures are usually dealing with complex spatial structures that are difficult to survey on the outside and difficult to see through on the inside. The first written statements on architectural models come from architects of the Renaissance.

The Florentine Leon Battista Alberti (1404–1472), a universal erudite humanist, who practiced and theorized on architecture, stated about architectural models: "Having constructed these models, it will be possible to examine clearly and consider thoroughly the relationship between the site and the surrounding district, the shape of the area, the number and order of the parts of a building, the appearance of the walls, the strength of the covering, and in short the design and construction of all the elements […]. It will also allow one to increase or decrease the size of those elements freely, to exchange them, and to make new proposals and alterations until everything fits together well and meets with approval" [38, pp. 120–126, 32, pp. 26–30, 33, pp. 121–123].[2]

Alberti refers here to several pragmatic advantages of the 3D and thus spatial architectural model compared to 2D and thus plane, non-spatial drafts. The model, which is conceived as a scaled-down version of the reference original, is intended to make the building to be designed spatially visible, comprehensible, and transparent, thus anticipating ideas of the effect the building may have when constructed. A fine example from Alberti's time is the model of the Strozzi Palace, built in Florence and still existing today (Fig. 2.6). The scaled-down version is made of wood, can be disassembled into individual stories, and has some interchangeable modules with variants for the façade design. In addition to the reduction in size, for further simplifications building materials are transformed from stone and plaster into wood and details such as door and window frames in the interiors of rooms are omitted.[3]

With his desire for problem-free modification at any time, Alberti formulated a pragmatism that can almost be called visionary in principle, and which digital 3D modeling is only now able to fulfill in practice. In physical modeling, which had been practiced for centuries, modification of the model always involved a degree of manual work—be aware

[2] L. B. Alberti, […] de Re aedificatoria opus elegantissimum, et quam maxime utile, Florence 1485, 2nd book (without pagination); cited after the current English edition: On the art of building in ten books. Transl. by Joseph Rykwert et al, MIT Press, Cambridge, Mass. 1987 [5th edn 1994], p. 34.— For further aspects of Alberti's theory on architectural modelling [39, pp. 78–81].

[3] Recently displayed on the original site in the Museino di Palazzo Strozzi, on loan from the Museo Nazionale del Bargello, Florence [38], pp. 101–107, 222–224 (cat. no. 79), figs. 37–56; [40], pp. 75–86, esp. pp. 77–78, figs. 2.2–2.3, plate III; [41], pp. 19–73, esp. pp. 32/35, figs. on pp. 72/73p; the catalogue articles nos. 143–145, pp. 519–520 (n. b.: by Amanda Lillie, who is unusually supposing that the preserved alternative stripes for the façades should be fragments of lost two further models of the whole building).

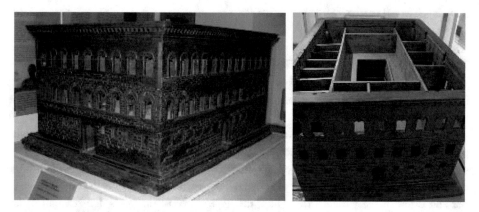

Fig. 2.6 Wooden draft model of Palazzo Strozzi in Florence, 15th century (Image: https://com mons.wikimedia.org/wiki/File:Giuliano_da_sangallo_o_bendetto_da_maiano,_modello_per_pal azzo_strozzi,_1489_ca,_01.JPG, accessed on 1.2.2023)

that in Alberti's time, model making in wood was the work of a professional cabinet-maker. Exceptionally, in the case of the given example (Figs. 2.6 and 2.7), the architect of Strozzi Palace, Giuliano da Sangallo the Younger, was a trained model maker so he was able to model his own draft.

On the representational deficit of 2D drawings, which the model can compensate for due to its three-dimensionality, the only slightly younger Sienese universal artist Francesco di Giorgio Martini (1439–1502), who was also active as an architect and additionally as an engineer, commented: "As difficult as it is to represent all things in drawings,

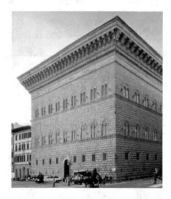 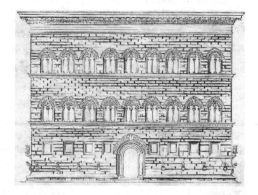

Fig. 2.7 Florence, Palazzo Strozzi, in 2021 and documentary façade elevation in orthogonal projection (Image: Teo Pollastrini, 2021; modifications: P. H. Jahn; Xylography, taken from: Gustavo Strafforello, La patria, geografia dell'Italia, Turin 1894): Compared to Fig. 2.6, the third story is heightened and topped by a more voluminous cornice

the written word is just as unsuitable to explain everything. For too many different things are interrupted and stand opposite each other, so that they overlap. Therefore, it is necessary to make models of all things. [...] in his imagination many things seem simple to the architect, and he thinks they must succeed."[4]

This statement refers to models of machines, but it can easily be applied to architectural models. In any case, 3D visualization is superior to 2D ones such as plan and elevation, it introduces depth as the third dimension and provides furthermore variability in the viewer's perspective. The given historical examples show clearly the still valid concept of modeling in architecture as a three-dimensional representation of a building structure. The modeled building is a draft only represented on paper and touches the basic question of model theory: the model refers either to an imaginary or a real object. Depending on the pragmatic purpose of visualization it ranges in size from a tiny reduced scale to models at the original scale (so-called *maquette*), and formally from schematic to fully detailed surfaces. All these different kinds of representation always refer to the idea of a spatial model.

Digital 3D modeling has the advantage over physical modeling that, if required, the classical 2D orthogonal projections of the architectural plan (floor plan, elevation/view, and sections) can be drawn from a virtual 3D model at any time, namely by switching off one dimension and projecting the model body orthogonally onto an image plane. Creating pictorial perspective views of buildings (so-called renderings) is easy to realize with digital 3D modeling software. Before the digital age, architectural perspectives had to be painstakingly derived from plans or a physical building model using the rules of descriptive geometry. To conclude: before the digital age, a drawing was turned into a model by processing a draft; in the digital age, the process is quite the reverse, from model to drawing. Nevertheless, in digital 3D reconstruction of historic architecture, the conventional modeling from drawing still has to be practiced if visual media as plans are basic sources for the reconstruction model.

Modern research in architectural history as established in the 19th century has adopted the preparatory use of architectural models during the process of drafting reconstruction models, but this not as prospective models to visualize a building project but as *post factum* models of now non-extant buildings or parts thereof, either based on reliable documentation or purely hypothetically. For example, classical archeological research has produced thousands of physical models of complete Antique temples (Fig. 2.8), other buildings of that period, or whole cities that had fallen in ruins.

[4] Florence, Biblioteca Medicea Laurenziana, manuscript 282 (Codex Ashburnham 361), fol. 33r, resp. Turin, Biblioteca Reale, Codex Saluzzianus 148, fol. 33v, edited in: Francesco Di Giorgio, Trattati di architettura, ingegneria e arte militare. A cura di Corrado Maltese. Trascrizione di Livia Maltese Degrassi (Trattati di architettura, vol. 3), 2 vols., Milan 1967, vol. I, p. 142. Thanks to Elaine Sophie Wolff, Innsbruck/Pisa, for providing this source by giving a modern translation from the Italian Renaissance idiom.

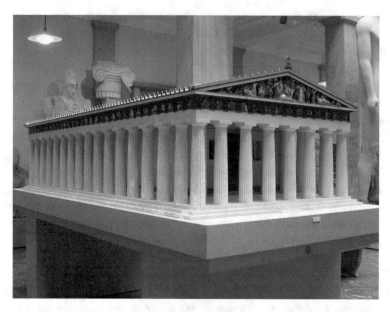

Fig. 2.8 Reconstruction 1:20 model of the Parthenon temple in Athens: manufactured 1883–89 by the modelmaker Adolfe Jolly in Paris on commission of the Metropolitan Museum of Art, New York, following a concept developed by architect Charles Chipiez with archeologist Georges Perrot, compiling contemporary research on the Parthenon of Alexis Paccard, Benoit Loviot, and Charles Simart (permanent loan from The Met NY in Munich at the State Museum for Plaster Casts of Classical Sculptural Work) (Image: P. H. Jahn)[5]

Further reading: From the physical to the digital model Physical modeling of architecture had been practiced before digital 3D modeling was invented, and it is still in use, mostly for presentation purposes, and in some cases for preparing designs [42]. Another purpose of this traditional modeling practice is to retrace and continue design processes started prior to the digital age—an example gives the model workshop at the famous La Sagrada Família church building in Barcelona (Fig. 2.9). The special and very complex mixture of neo-gothic and partially bizarre organic forms required a special effort of three-dimensional representation, which was achieved with dozens of models in different levels of detail and scales, this from the beginning of building activity in the 1880ies (cfr. blog by Samantha Hinsbey, 2020: https://www.jovinlim.com/blog/2020/6/18/modelmaking-throughout-history-sagrada-familia). As the given

[5] Inge Kader, Infoblatt: Parthenonmodell, https://www.abgussmuseum.de/de/infoblaetter/parthenon modell, accessed on 1.2.2023; additionally: https://www.abgussmuseum.de/de/das-modell-des-par thenon, accessed on 28.09.2022.

insight might imagine, modeling with physical materials has always required crafts-manship (Fig. 2.9) (sometimes near to handicraft work), and is a very complicated process, often given to trained model makers [43, esp. pp. 137–159, 44].

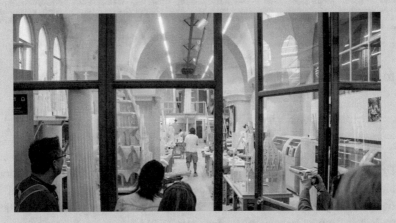

Fig. 2.9 Physical modeling: Model workshop in the La Sagrada Família, Barcelona (Image: Münster 2010)

2.6 Computer-Based 3D Modeling

Computer-based, i.e., digital, 3D technologies have become increasingly important for sustaining conservation, research, and broad accessibility of cultural heritage as knowl-edge carriers, research tools, learning materials, and means of representation over the past three decades [45–47]. An overarching consensus is that 3D modeling represents or translates either a material cultural object or an intangible cultural phenomenon into a spatial, temporal, and semantic virtual model. There are key differences in the assessment of material and immaterial objects (e.g., usages or digital data). As mentioned in the pre-vious paragraphs, another essential difference is between the reconstruction of objects that are no longer existent or that have never been realized (e.g., plans) and the digitization of objects that are still existent [48, 49].

2.6.1 3D as Reference to Space

Commonly, the prefix 3D refers to the spatial model central for digital 3D modeling. In addition to 3D, further dimensions have become established, e.g., in mathematics, computer graphics, and geosciences (Fig. 2.10).

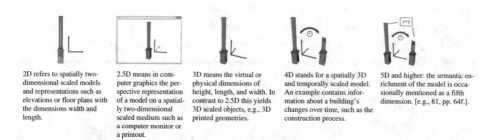

2D refers to spatially two-dimensional scaled models and representations such as elevations or floor plans with the dimensions width and length.

2.5D means in computer graphics the perspective representation of a model on a spatially two-dimensional scaled medium such as a computer monitor or a printout.

3D means the virtual or physical dimensions of height, length, and width. In contrast to 2.5D this yields 3D scaled objects, e.g., 3D printed geometries.

4D stands for a spatially 3D and temporally scaled model. An example contains information about a building's changes over time, such as the construction process.

5D and higher: the semantic enrichment of the model is occasionally mentioned as a fifth dimension. [e.g., 81, pp. 64f.].

Fig. 2.10 Model and visual dimensions of virtual 3D reconstruction (Münster 2019)

2.6.2 Digital Versus Virtual

There is a basic consensus that digital 3D models are created using computers and thus differ from physical reconstructions of artifacts or even paper-based reconstructions such as architectural drawings [50]. In this context, the terms "digital" and "virtual" reconstruction are largely used interchangeably, although the underlying concepts of the digital as "data in the form of especially binary digits" [51] are quite different from the virtual as "existing or occurring on computers or on the Internet" [52]. While the digital thus describes a materiality, the concept of the virtual is based on a reference to reality in terms of content. Empirically, in the German-speaking world, the term virtual reconstruction" is used more frequently, with 61,000 results compared to 13,000 results for "digital reconstruction" in a Google search [53]. "Digital reconstruction" predominates in English with 484,000 versus 181,000 results. In accordance with the practice described, both terms will be used synonymously in this book [54].

2.6.3 Reconstruction Versus Digitalization

3D digitization or reality-based modeling [55, 56] stands for "the process of converting something to digital form" [57]. Digitization describes the technological transfer of a real object to a digital asset. For this purpose, various data acquisition technologies are used [54, 58, 59] (→ 3D Modelling). For tangible objects, the main distinction is between light-dependent and light-independent methods [60]. Light-dependent systems emit light to retrieve information about the 3D surface. This comprises active approaches where coded light is projected onto a surface (e.g., white-light scanners using structured light to determine the surface shape and laser scanning sending laser beams at a varying angle to determine 3D surface points using the time-of-flight principle [61, 62]) and passive methods using imagery as videos or photos [63] without specifically coded light [60, 64]. The outcome is a dense 3D point cloud, which is then processed into a meshed surface [65]. Methods not using visible light comprise a large variety of tomographic methods

such as CT scanning to model the internal structures or volume of the object [61]. A taxonomy of the quality of 3D digitization of tangible heritage was developed within the EU VIGIE study [66, 67]. According to this study, the main attributes describing a digitized object are geometry, composition (as material information), and production (as the model acquisition process) [68].

3D reconstruction or virtual-based modeling: Whereas digitization refers to the technological conversion of an object into a digital representation (Fig. 2.11), a digital reconstruction or virtual-based modeling process [56] requires human interpretation of data to create a hypothesis of a past object [48, 69–71] (→ 3D Modelling). The model is then mostly created on the computer using manually controlled graphic modeling software originating from construction and engineering in the case of computer-aided design (CAD), or from design and creative industries in computer-generated imaging and graphics software (CGI). Since those processes are highly labor-intensive, approaches to reduce the workload include generative or parametric modeling (predefining objects by rulesets with changeable parameters) or semi-automated modeling (e.g., from historical imagery) [48, 70].

3D meshing and texturing: Both 3D digitization and reconstruction lead to 3D models representing surfaces and/or volumes of a tangible heritage object. Since the modeling approaches of volumetric models vary significantly depending on the methods used [72], 3D surface representation can be discrete—based on points (point clouds), triangular meshes (vertices, edges, faces), or continuous as e.g., NURBS, geometric solids (constructive solid geometry, CSG), and boundary representations (B-reps) [61] (→ 3D Modelling).

Besides the geometry features of a 3D model, its radiometric parameters and materiality representation are relevant [73]. For surfaces, the main distinction is between

Fig. 2.11 Schematic reconstruction (upper left) versus digitization (lower left) workflow, both resulting in a virtual 3D model (right) (Images: Münster, except right: Rainer Uhlemann, lightframe fx)

synthetically generated procedural textures and reality-based textures (→ Visualization). Related to the latter category, another distinction is between the acquisition of material properties [74] and digital visualization [75].

2.7 Simulation

Simulation refers to a "procedure for reproducing a system with its dynamic processes in a model that can be experimented with in order to arrive at findings that can be transferred to reality" (translated from [76], p. 1; for a definition from humanities [77], see also [78]). Law and Kelton [79] distinguish three types of simulation depending on the models used:

- Static versus dynamic: A static simulation provides a replica of a system at a specific point in time. A dynamic simulation represents a system whose states, attributes, processes, etc. are time-dependently variable [80].
- Discrete (countable) versus continuous (measurable) values.
- Deterministic (always the same output for a specific set of values) versus stochastic (random output at a certain level) values.

In the context of cultural heritage, the term "simulation" is used in various ways:

- **Simulation for analysis**. Examples include:
 - **Object behavior**, often in disaster situations, as in fluid simulation (CFD) to analyze flooding [81], to simulate structural behavior, e.g., of monuments in earthquakes [82] or fire [83], but also to prove requirements for materials in construction [84].
 - Simulation of **environmental effects**, e.g., of lighting to assess conditions in historic buildings [85, 86], degradation by climate features [87], ancient ventilation systems [88], or acoustic conditions [89].
 - Simulation of **cultural effects**, e.g., of crowds [90], mechanical processes [91], or daily cultural life [4, 92].
- **Simulation as calculation of imagery (rendering)** [93] means the computed combination of various features such as material appearance, lighting, and geometrical behavior, either of static scenes (images) or of time variate or dynamic (films or interactive games) to a visual output. This computation of a virtual model to create a visualization is called rendering [94]. Methods include ray tracing [95, 96] and global illumination [97].

A more metaphorical use of the term is the **"simulation" of a building process** when unexecuted architectural plans are analyzed. If such plans are modeled in 3D, this procedure is like an assessment of their buildability [25]. Strictly speaking the term "re-construction" does not fit this kind of architectural 3D modeling because it was not

preceded by a construction. Nevertheless, the modeling of unexecuted building plans is also commonly called "construction". As an established method of architectural history research, it is advantageous in interpreting the buildability as well as spatial and aesthetic effects of the projected buildings.

Summary This chapter introduces key concepts in digital 3D modeling of historic architecture as part of cultural heritage, the use of sources and data as a basis for any reconstruction, and modeling as a scientific method and practice. Architectural plans and models are used for 3D reconstruction of historic architecture; in our digital age, these processes are transferred from physical modeling into the digital sphere.

Concepts

- **Sources**: historical research is always based on sources (and data obtained from them), their critical analysis and interpretation, which will always be subjective views constructed in specific contexts.
- **Model**: a pragmatically reduced representation of an original [65 pp. 131–133].
- **Digital 3D Reconstruction**: "the creation of a virtual model of historic entities that requires an object-related, human interpretation" [70, p. 7].

Key literature

- Jill A. Franklin, T. A. Heslop et al. (eds.): Architecture and Interpretation. Essays for Eric Fernie. Woodbridge, Suffolk: Boydell 2012 [98].
- Petra Brouwer, Martin Bressani et al. (eds.): Narrating the Globe: The Emergence of World Histories of Architecture. Cambridge, Mass./London: MIT Press 2023 [99].
- Sander Münster: Die Begrifflichkeiten der 3D-Rekonstruktion, in: Piotr Kuroczyński/Mieke Pfarr-Harfst/Sander Münster (eds.), Der Modelle Tugend 2.0. Vom digitalen 3D-Datensatz zum wissenschaftlichen Informationsmodell. Computing in Art and Architecture 2, Heidelberg: arthistoricum.net 2019, 39–57 [54].
- Jan-Eric Lutteroth/Stephan Hoppe: Schloss Friedrichstein 2.0—Von digitalen 3D-Modellen und dem Spinnen eines semantischen Graphen. In: ibid., 185–198 [100].
- Anthony Brundage: Going to the Sources: A Guide to Historical Research and Writing. 6th edition, Hoboken, NJ: Wiley-Blackwell 2017 [23].
- Stephan Hoppe/Stefan Breitling (eds.): Virtual Palaces, Part II: Lost Palaces and Their Afterlife. Virtual Reconstruction between Science and Media. PALATIUM e-Publication 3, Munich: PALATIUM 2016 [101].

- Soraya de Chadarevian/Nick Hopwood (eds.): Models. The Third Dimension of Science. Stanford, CA: Stanford University Press 2004 [102].
- Patrick Healy: The Model and its Architecture. Delft School of Design Series on Architecture and Urbanism 4, Rotterdam: 010 Publishers 2008 [103].
- Mark Morris: Models: Architecture and the Miniature. Architecture in Practice, Southern Gate, Chichester: Wiley Academy Press 2006 [104].
- Matthew Mindrup: The Architectural Model. Histories of the Miniature and the Prototype, the Exemplar and the Muse. Cambridge, Mass./London: MIT Press 2019 [33].

References

1. Reilly P (1992) Three-dimensional modelling and primary archaeological data. In: Reilly P et al (eds) Archaeology and the information age. A global perspective. Routledge, London, pp 147–173
2. UNESCO (1989) Draft medium term plan 1990–1995
3. Kuhnke B (2016) Kulturarvspolitik (Regeringens proposition, 2016/17:116)
4. Chandler T (2013) Playing Angkor: exploring the archaeological themes of the Khmer empire through game engine technologies. In: 41st computer applications and quantitative methods in archaeology conference 2013 Perth
5. Anderson M (2010) Putting the "reality" in virtual reality: new advances through game engine technology
6. Skublewska-Paszkowska M et al (2022) 3D technologies for intangible cultural heritage preservation-literature review for selected databases. Herit Sci 10(1):3
7. Georgopoulos A (2018) CIPA's perspectives on cultural heritage. In: Münster S et al (eds) Digital research and education in architectural heritage. 5th conference, DECH 2017, and first workshop, UHDL 2017, Dresden, Germany, 30–31 March 2017, revised selected papers. Springer, Cham, pp 215–245
8. UNESCO (2018) Concept of digital heritage
9. Ch'ng E et al (2013) Visual heritage in the digital age
10. Münster S et al (2021) Digital topics on cultural heritage quantified. Built Heritage
11. European Commission (2011) Survey and outcomes of cultural heritage research projects supported in the context of EU environmental research programmes. From 5th to 7th Framework Programme
12. European Commission (2019) Common challenges and perspectives for digital cultural heritage in H2020 projects
13. Arbeitsgruppe Digitale Rekonstruktion des Digital Humanities im deutschsprachigen Raum e.V. Arbeitsgruppe Digitale Rekonstruktion des Digital Humanities im deutschsprachigen Raum e.V. http://www.digitale-rekonstruktion.info/. Accessed 12 Jan 2015
14. Arbeitskreis Digitale Kunstgeschichte Arbeitskreis Digitale Kunstgeschichte. https://www.digitale-kunstgeschichte.de/wiki/Arbeitskreis_Digitale_Kunstgeschichte. Accessed 1 Aug 2021

15. Schueckel S (2018) DFG bewilligt Wissenschaftliches Netzwerk "Digitale 3D-Rekonstruktionen als Werkzeuge der architekturgeschichtlichen Forschung". TU Dresden

16. Kuroczyński P et al (eds) (2019) Der Modelle Tugend 2.0: Digitale 3D-Rekonstruktion als virtueller Raum der architekturhistorischen Forschung. arthistoricum.net, Heidelberg

17. Kuroczyński P et al (eds) (2019) Digital art history. Computing in art and architectural history. arthistoricum.net, Heidelberg

18. Klinke H (2018) Special issue: digital space and architecture. J Digit Art Hist 3

19. Jahn PH et al (2012) Brief an Papst Leo X. betreffend die Bewahrung, Vermessung und zeichnerische Aufnahme der antiken Baudenkmäler Roms [um 1518]. In: Zeitschrift für Medien- und Kulturforschung, Heft 1/2012: Schwerpunkt Entwerfen, pp 73–95

20. Sociedad Española de Arqueología Virtual (2010) The Seville Charter. http://www.arqueolog iavirtual.com/carta/. Accessed 10 Jan 2014

21. Opgenoorth E (1997) Einführung in das Studium der neueren Geschichte

22. Lipartito K (2014) Historical sources and data. In: Organizations in time: History, theory, methods, pp 284–304

23. Brundage A (2017) Going to the sources: a guide to historical research and writing, 6th edn. Wiley-Blackwell, Hoboken, NJ

24. Dalton MS et al (2004) Historians and their information sources. Coll Res Libr 65(5):400–425

25. Münster S et al (2017) Von Plan- und Bildquellen zum virtuellen Gebäudemodell. Zur Bedeutung der Bildlichkeit für die digitale 3D-Rekonstruktion historischer Architektur. In: Ammon S et al (eds) Bildlichkeit im Zeitalter der Modellierung. Operative Artefakte in Entwurfsprozessen der Architektur und des Ingenieurwesens. eikones. Wilhelm Fink Verlag, München, pp 255–286

26. Brilliant M (2022) Primary, secondary, and tertiary sources in history

27. Alderman J (2014) Primary, secondary, and tertiary sources

28. Münster S (2016) Interdisziplinäre Kooperation bei der Erstellung geschichtswissenschaftlicher 3D-Rekonstruktionen

29. DFG (2016) DFG-Praxisregeln "Digitalisierung"

30. Bruschke J, Wacker M (2018) DokuVis – ein Dokumentationssystem für digitale Rekonstruktionen. In: Breitling S, Giese J (eds) Bauforschung in der Denkmalpflege – Qualitätsstandards und Wissensdistribution. University of Bamberg Press, Bamberg, pp 213–218

31. Pattee A et al (2022) A machine learning approach to assist architectural research by matching images directly with text. In: EUROMED 2022

32. Smith AC (2004) Architectural model as machine. A new view of models from antiquity to the present day. Elsevier, Architectural Press, Amsterdam et al

33. Mindrup M (2019) The architectural model. Histories of the miniature and the prototype, the exemplar and the muse. MIT Press, Cambridge, Mass et al

34. Sauerbier T (1999) Theorie und Praxis von Simulationssystemen. Eine Einführung für Ingenieure und Informatiker. Vieweg, Wiesbaden

35. Stachowiak H (1973) Allgemeine Modelltheorie. Springer, New York

36. Mahr B (2008) Ein Modell des Modellseins. Ein Beitrag zur Aufklärung des Modellbegriffs. In: Dirks U et al (eds) Modelle. Peter Lang, Frankfurt am Main et al, pp 187–220

37. Wilton-Ely J (1996) Architectural model. In: The dictionary of art, Bd. 2. London et al, pp 335–338

38. Lepik A (1994) Das Architekturmodell in Italien 1335–1550. Veröffentlichungen der Bibliotheca Hertziana (Max-Planck-Institut) in Rom, Bd. 9. Werner, Worms

39. Wendler R (2013) Das Modell zwischen Kunst und Wissenschaft. Wilhelm Fink, München

40. Frommel S et al (2015) Les maquettes d'architecture: fonction et évolution d'un instrument de conception et de réalisation (itinéraires - percorsi 3). Picard, Paris/Campisano, Rome

41. Millon HA (1994) Models in Renaissance Architecture. In: idem (ed) The Renaissance from Brunelleschi to Michelangelo. The representation of architecture. Thames & Hudson, London, pp 19–73

42. Ratensky A (1983) Drawing and modelmaking. Whitney Library of Design, New York

43. Moon K (2005) Modeling messages. The architect and the model. Monacelli Press, New York

44. Frankhänel T (2015) Introducing Theodore Conrad or: why should we look at the architectural model maker. In: Frommel S et al (2015) Les maquettes d'architecture: fonction et évolution d'un instrument de conception et de réalisation (itinéraires - percorsi 3). Picard, Paris/Campisano, Rome, pp 259–268

45. Sanders DH (2012) More than pretty pictures of the past. An American perspective on virtual heritage. In: Bentkowska-Kafel A et al (eds) Paradata and transparency in virtual heritage. Ashgate, Burlington, pp 37–56

46. Greengrass M et al (2008) The virtual representation of the past. Digital research in the arts and humanities

47. Favro D (2006) In the eyes of the beholder. Virtual Reality re-creations and academia. In: Haselberger L et al (eds) Imaging ancient Rome: Documentation, visualization, imagination: proceedings of the 3rd Williams symposium on classical architecture, Rome, 20–23 May 2004. J Roman Archaeol Portsmouth, pp 321–334

48. De Francesco G et al (2008) Standards and guidelines for quality digital cultural three-dimensional content creation. In: Ioannides M et al (eds) Digital heritage: proceedings of the 14th international conference on virtual systems and multimedia. Project papers. Archaeolingua, Budapest, pp 229–233

49. Doulamis A et al (2015) 5D modelling: an efficient approach for creating spatiotemporal predictive 3D maps of large-scale cultural resources. ISPRS Ann Photogram Remote Sens Spat Inf Sci II-5(W3):61–68

50. Carpo M (2001) Architecture in the age of printing. Orality, writing, typography, and printed images in the history of architectural theory. MIT Press, Cambridge, Mass et al

51. Merriam-Webster Definition of digital. https://www.merriam-webster.com/dictionary/digital. Accessed 8 Feb 2022

52. Merriam-Webster Definition of virtual. https://www.merriam-webster.com/dictionary/virtual. Accessed 2 Feb 2022

53. Google Google Search. google.com. Accessed 8 Feb 2022

54. Münster S (2019) Die Begrifflichkeiten der 3D-Rekonstruktion. In: Kuroczyński P et al (eds) Der Modelle Tugend 2.0: Digitale 3D-Rekonstruktion als virtueller Raum der architekturhistorischen Forschung. arthistoricum.net, Heidelberg, pp 38–58

55. Qin R et al (2022) Geometric processing for image-based 3D object modeling. In: Kocaman S et al (eds) 3D/4d city modelling: from sensors to applications

56. Russo M (2021) AR in the architecture domain: state of the art. Appl Sci-Basel 11(15):6800

57. Merriam-Webster Definition of digitalization. https://www.merriam-webster.com/dictionary/digitalization. Accessed 23 Aug 2017

58. Manferdini AM et al (2010) Reality-based 3D modeling, segmentation and web-based visualization. In: Paper presented at the EuroMed, Nicosia, Cyprus

59. Voltolini F et al (2007) Integration of non-invasive techniques for documentation and preservation of complex architectures and artworks. Paper presented at the ISPRS

60. Pavlidis G et al (2018) 3D depth sensing. In: Bentkowska-Kafel A et al (eds) Digital techniques for documenting and preserving cultural heritage. ARC Humanities Press, pp 195–198

61. Cieslik E (2020) 3D digitization in cultural heritage institutions guidebook

62. Di Stefano F et al (2021) Mobile 3D scan LiDAR: a literature review. Geomat Nat Haz Risk 12(1):2387–2429
63. Torresani A et al (2019) Videogrammetry vs photogrammetry for heritage 3d reconstruction. Int Arch Photogram Remote Sens Spat Inf Sci XLII-2/W15:1157–1162
64. Alliez P et al (2017) Digital 3D objects in art and humanities: challenges of creation, interoperability and preservation. White paper. Digital 3D objects in art and humanities: challenges of creation, interoperability and preservation, hal01526713v2
65. Donadio E et al (2018) Three-dimensional (3D) modelling and optimization for multipurpose analysis and representation of ancient statues. In: Remondino F et al (eds) Latest developments in reality-based 3d surveying and modelling. MDPI AG-Multidisciplinary Digital Publishing Institute, pp 95–118
66. Ioannides M et al (2020) European study on quality in 3D digitisation of tangible cultural heritage (VIGIE 2020/654)
67. Pritchard D et al (2021) Study on quality in 3D digitisation of tangible cultural heritage
68. Ioannides M (2021) VIGIE 2020/654 study - final presentation
69. Münster S (2013) Workflows and the role of images for a virtual 3D reconstruction of no longer extant historic objects. In: ISPRS annals II-5/W1 (XXIV international CIPA symposium), pp 197–202
70. Münster S et al (2016) A classification model for digital reconstruction in context of humanities research. In: Münster S et al (eds) 3D research challenges in cultural heritage II. Springer LNCS, Cham, pp 3–31
71. Dell'Unto N et al (2022) 3D models and knowledge production. In: Archaeological 3D GIS, pp 18–28
72. Grifoni E et al Multianalytical investigation and 3D Multiband modeling: an integrated survey of the Garnier Valletti pomological collection. In: 2020 IMEKO TC-4 international conference on metrology for archaeology and cultural heritage, Trento, Italy (2020)
73. Moitinho V et al (2018) An interdisciplinary discussion of the terminologies used in cultural heritage research. In: Bentkowska-Kafel A et al (eds) Digital techniques for documenting and preserving cultural heritage, pp 3–16
74. Boochs F et al (2014) Colour and space in cultural heritage: key questions in 3D optical documentation of material culture for conservation, study and preservation. In: Ioannides M et al (eds) Digital heritage. Progress in cultural heritage: documentation, preservation, and protection5th international conference, EuroMed 2014, Limassol, Cyprus, 3–8 November 2014. Proceedings. Springer, Cham, pp 11–24
75. Birn J (2007) Lighting & rendering
76. VDI (2014) Simulation von Logistik-, Materialfluss- und Produktionssystemen 3633
77. Hinterwaldner I (2010) Das systemische Bild. Ikonizität im Rahmen computerbasierter Echtzeitsimulationen. Eikones, Wilhelm Fink Verlag, München
78. Koszewski K (2021) Visual representations in digital 3D modeling/simulation for architectural heritage. In: Niebling F et al (eds) Research and education in urban history in the age of digital libraries. Springer International Publishing, Cham, pp 87–105
79. Law AM et al (2000) Simulation modeling and analysis, 3 edn
80. Chahrour R (2006) Integration von CAD und Simulation auf Basis von Produktmodellen im Erdbau
81. Grau-Bové J et al (2019) Fluid simulations in heritage science. Herit Sci 7(1):16
82. Ciocci MP et al (2018) Engineering simulations of a super-complex cultural heritage building: Ica Cathedral in Peru. Meccanica 53(7):1931–1958
83. Huang YH (2020) The use of parallel computing to accelerate fire simulations for cultural heritage buildings. Sustainability 12(23):10005

84. Levy R et al (2010) Structural analysis: a tool for testing 3D computer reconstructions of Thule whalebone houses

85. Leccese F et al (2020) Application of climate-based daylight simulation to assess lighting conditions of space and artworks in historical buildings: the case study of cetacean gallery of the Monumental Charterhouse of Calci. J Cult Herit 46:193–206

86. Michael A et al (2015) Lighting performance of urban vernacular architecture in the East-Mediterranean area: field study and simulation analysis. Indoor Built Environ 26(4):471–487

87. Leissner J et al (2015) Climate for culture: assessing the impact of climate change on the future indoor climate in historic buildings using simulations. Herit Sci 3(1):38

88. Balocco C et al (2009) Numerical simulation of ancient natural ventilation systems of historical buildings. A case study in Palermo. J Cult Herit 10(2):313–318

89. Wall JN (2014) Virtual Paul's cross: the experience of public preaching after the reformation. In: Kirby T et al (eds) Paul's cross and the culture of persuasion in England, 1520–1640. E. J. Brill, Leiden, pp 61–92

90. Gutierrez D et al (2005) Predictive crowd simulations for Cultural Heritage applications. In: Paper presented at the proceedings of the 3rd international conference on computer graphics and interactive techniques in Australasia and South East Asia - GRAPHITE '05, Dunedin, New Zealand

91. Snickars P (2019) Metamodeling. 3D-(re)designing Polhem's Laboratorium mechanicum. Der Modelle Tugend 2.0

92. Wyeld TG et al (2007) Doing cultural heritage using the torque game engine: supporting indigenous storytelling in a 3D virtual environment. Int J Archit Comput 5(2):417–435

93. Champion E (2019) From historical models to virtual heritage simulations. In: Kuroczyński P et al (eds) Der Modelle Tugend 2.0 Digitale 3D-Rekonstruktion als virtueller Raum der architekturhistorischen Forschung

94. Foley JD (1995) Computer graphics : principles and practice. Addison-Wesley systems programming series, 2nd edn

95. Encarnação JL et al (1996) Graphische Datenverarbeitung

96. Šrámek M (1998) Visualization of volumetric data by ray tracing. Dissertation

97. Larson GW (2003) Rendering with radiance. The art and science of lighting visualization, 2nd edn

98. Jill A et al (eds) (2012) Architecture and interpretation. Essays for Eric Fernie. Boydell, Woodbridge, Suffolk

99. Brouwer P, Bressani M, Armstrong CD (2023) Narrating the globe: the emergence of world histories of architecture. MIT Press, Cambridge, MA et al

100. Lutteroth J-E, Hoppe S (2018) Schloss Friedrichstein 2.0—Von digitalen 3D-Modellen und dem Spinnen eines semantischen Graphen: Digitale 3D-Rekonstruktion, 3D-Modell, Adelssitz, Architekturgeschichte, Barockschloss, CIDOC-CRM, Forschungsumgebung, Kunstgeschichte, Ostpreußen, semantische Datenmodellierung, virtuelle Rekonstruktion. In: Kuroczyński P, Bell P, Dieckmann L (eds) Computing art reader. Einführung in die digitale Kunstgeschichte. Computing in Art and Architecture, pp 184–198

101. Hoppe S et al (eds) (2016) Virtual palaces, part II: Lost palaces and their afterlife. Virtual Reconstruction between Science and Media. PALATIUM e-Publication 3, Munich

102. Chadarevian S et al (eds) (2004) Models—the third dimension of science. Stanford University Press, Stanford, CA

103. Healy P (2008) The model and its architecture. Delft School of Design Series on Architecture and Urbanism 4, 010 Publishers, Rotterdam

104. Morris M (2006) Models: architecture and the miniature. Architecture in Practice, Wiley Academy Press, Southern Gate, Chichester

Scholarly Method

3

Abstract

As this chapter shows, digital 3D reconstructions of historic architecture serve many purposes in research and related areas. This comprises answering research questions by creating a 3D model, preserving cultural heritage, communicating knowledge in education, and providing a structure for knowledge organization. The process of creating a 3D reconstruction is often challenging, for example, because of lacking or ambiguous sources. In order to create a 3D reconstruction based on scientific values, guidelines, and standards are needed.

Guiding questions
- How can a 3D reconstruction contribute to knowledge?
- Where are 3D reconstructions made?
- Why do a 3D reconstruction in a scientific context?
- When can the model be reused in other research contexts?
- How can one create a scientifically correct 3D reconstruction?
- What guidelines are there for preparing a scientific 3D reconstruction?

© The Author(s) 2024 41
S. Münster et al., *Handbook of Digital 3D Reconstruction of Historical Architecture*,
Synthesis Lectures on Engineers, Technology, & Society 28,
https://doi.org/10.1007/978-3-031-43363-4_3

Basic terms
- Epistemic
- Scholarly method
- Purposes
- Scientific principles
- Standards

3.1 Introduction

Digital 3D reconstructions are getting increasingly established as a scholarly method. In the process, the use of 3D models can support and even revolutionize various work steps. The model can be seen as a substitute, extended, or concentrated object of investigation. At the same time, it may substitute objects of investigation that are ephemeral or in danger of destruction. The model is key for communicating research results. When equipped with appropriate descriptions, the model can serve as a comprehensive documentation format for knowledge about the object. The process of creating a 3D reconstruction is complex and often involves several disciplines bringing in their own expertise and research questions. Throughout this process knowledge is generated—while new questions arise, others are answered. An overview of 3D reconstruction and its purposes in digital models of historic architecture will be given here. Challenges in the reconstruction process are discussed here regarding missing information, lack of raw 3D models, and visual research process. For scholars to produce scientifically sound 3D models, they need guidelines. This chapter shows that following these guidelines ensures that 3D reconstructions are transparent regarding the used methodology and the decision-making process. In some contexts, research questions are not the focus of 3D reconstructions, as will be explained in the following chapter.

Further reading: Research on scholarly methods Investigations on epistemic settings in visual digital humanities are widely driven by researchers originating in humanities and mostly focus on exemplification and problematization within a certain disciplinary context. On digital methods in art history, Drucker [1] sketches a historical evolution and current state of application of digital methods in humanities. Kohle defined fields of supplement by digital tools and practices in art history [2] and Heusinger describes a general visual humanities research process [3]. Similarly, many texts describe comprehensive state-of-the-art methodologies for digital archaeology [4–6]. Furthermore, there are many standards, guidelines, and rules for dealing with historical content (\rightarrow Guidelines and charters for 3D reconstruction). An

adjacent issue is general workflow modeling of the reasoning behind archaeological or architectural construction. Barceló discusses approaches to computable reasoning and artificial intelligence to support archaeological reasoning [7]. Some meta-reviews on similar aspects in museology exist [8, 9], and methodological overviews are available for adjacent disciplines, such as game research [10], editorial studies [11–13], or graphic design [14].

3.2 Purposes of 3D Modeling

Purposes of 3D modeling include research, preservation, education, culture of remembrance, and knowledge organization of cultural heritage [15] as shown in Fig. 3.1.

3.2.1 Research

An example of this category is a reconstruction to test an (existing) research question or hypothesis with a 3D model, taking a step-by-step approach to the facts related to the question. This supports the imagination of the researcher/communicator to facilitate the generation of knowledge. Often, further questions or areas of application develop during the research process and can be answered by creating a 3D model.

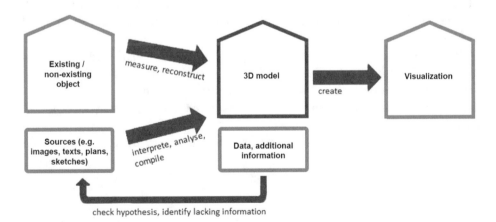

Fig. 3.1 Purposes of 3D modeling in the reconstruction process (Image: Schelbert/Messemer)

Table. 3.1 Research contexts of digital 3D models

Research objective	Source	Object	System
Data quality assessment (e.g., consistency of sources)	X		
Visualization (e.g., investigation of shape or appearance)		X	
The creative process (e.g., planning or construction)		X	
Conceptualization and contextualization (e.g., typologies, functional segments, archetypical elements, provenance)	X	X	X
Numerical analysis (e.g., structural analysis, lighting)		X	
Hypothetic simulation (e.g., of hypothetic objects deriving from an architectural system)			X

A particular strength of 3D models is to enable empathy with the (lost or planned) real spatial situation. Models have always had this function, for example, design models in Renaissance and Baroque architecture, but as a rule, this effect did not justify the high cost of constructing a model, so it remained a side effect. In the digital model, creating a spatial impression places particularly high demands on the level of detail, especially if it is to be perceived through VR devices, which is not always the case. Both the source situation and the technical and other resources rarely allow complex simulations, such as visibility and social behavior, to be truly represented and measured in three dimensions. In principle, to create realistic impressions, it would be necessary to develop methods for recording the size relationships to humans in space. Initial work on this has been done, e.g., by Bernhard Frischer on the position of the sun [16], by Peter Scholz, University of Stuttgart, on Roman rhetoric,[1] and on crowds in space [17, 18]. Research functions of 3D models are given a typology in Table 3.1, which distinguishes between research objects and objectives [19, 20].

Research object: 3D reconstruction is employed to investigate and assess objects and/ or sources. Sometimes not a specific object, but schemes and systems are the focus of research, e.g., to evaluate the Vitruvian scheme of architectural orders. Against this background, 3D reconstruction methods are often employed to derive archetypes or specific features [21].

Research objectives are the epistemic interest to be served by a 3D reconstruction (Fig. 3.2). They may include:

[1] Peter Scholz leads the audiovisual project Oratorische Prgamatik und politische Entscheidungsfindung in der griechischen Antike, funded by the German Research Foundation (DFG), https:// gepris.dfg.de/gepris/projekt/464282420?context=projekt&task=showDetail&id=464282420&, accessed 16.09.2022.

| Data quality assessment of source: medieval state of the St. Jacob grave chapel | Visualization of an unbuilt plan: Piaristenkirche in Vienna | Conceptualization: Sacral topology of the western portal of the Freiberger Dom | Numerical analysis and simulation: Lighting simulation tested for the Santiago de Compostela cathedral crypt | Hypothetical Simulation: Physically correct reconstruction of the optical illusion by M.C. Escher |

Fig. 3.2 Example research applications of 3D models in architectural history studies (Images: Muenster, [35, 36, p. 125, 37, p. 588])

- **Data quality assessment**: This is closely related to contextualization and assessment of the consistency of sources. For example, digital reconstruction of content depicted in drawings or paintings can be used to test perspective features or consistency [22].
- **Visualization**: The most common way to visualize is to formulate a hypothesis of the shape, properties, and appearance of a certain historical object. Concerning this aspect, digital reconstruction allows the noninvasive application and testing of alterations or restoration (e.g., for destroyed statues) [23–25].
- **Process investigation**: This includes research into historical preparation processes (e.g., planning or construction processes employed by artisans) [26, 27].
- **Conceptualization**: A major question for underlying concepts and intentions, e.g., structuring concepts [28], refers to functions of certain parts of an object (e.g., rooms, figuration, or proportions)[29, 30].
- **Contextualization**: The contextualization of objects (e.g., geo-location, relationship to other objects, historical circumstances, historical contextualization) and identification of archetypal characteristics may refer to artisan specifications and typologies, as well as comparison of iconographical concepts. Contextualization may lead to interest in sources, specific objects, or systems [2].
- **Numerical analysis and simulation**: This is a frequent use case, especially for 3D digitization models [31]. Occasionally, 3D reconstructions are employed to simulate and analyze no longer extant heritage and structural analysis is one area of application [32].
- **Hypothetical simulations**: Different usages are possible without making reference to concrete historical objects, e.g., the exploration of hypothetically possible objects, which derive from a certain architectural order and the (hypothetical) limits and boundaries of this system [21, 33] or the analysis of perspective drawings like M. C. Escher's [34] impossible objects.

Further reading: Digitization to preserve heritage objects 3D digitization techniques are frequently used in preservation [38] (Fig. 3.3) to:

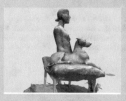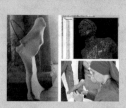

Preserve object properties in case of damage: 3D digitization of heritagein risk from citizen photographs [163].

Create replicas: Body scan and 3D printed plaster model for blind museum visitors [36].

Degradation analysis: Material loss estimation of a stonewall [37].

Fig. 3.3 Examples for preservation applications

- **Preserve object properties in case of damage**: Recent examples are the recording of surface and material properties prior to an unplanned disaster (Notre Dame in Paris [39]), in case of planned destruction, and post factum from extant images (e.g., the destroyed sites in Palmyra and Bamyan [40, 41]). In digital 3D reconstruction, the objectives of a virtual model are primarily to sort, store, and compile spatial knowledge [42]. For example, the 3D model of the Domus Severiana provided a spatial map and thus a possibility to georeference sources [43].
- **Create replicas**: Especially in museums, artifacts are frequently replaced by replicas created in fully digital workflows [36].
- **Identify art forgery** by creating a digital 3D footprint of the original [44–46],
- **Degradation analysis** to detect the degradation of surfaces and materials [37, 47, 48].

3.2.2 Education

In this category, the digital 3D model is intended to represent existing knowledge and is thus in the direct tradition of haptic models (Fig. 3.4). The focus is on a didactic extension of knowledge communication. The 3D model facilitates knowledge transfer, which previously took place through abstraction from text and/or image. This can support both imagination and cultural remembrance, which is about how people deal with their history, past, and collective memory.

Informal learning: 3D recon-
structed and printed city
model in a museum exhibition

Formal learning: Use of 3D Visu-
alizations to teach historical ar-
chitecture in a university seminar

Digital competency develop-
ment: Hackathon to educate
and apply 3D modelling skills

Edutainment: AI-generated im-
age reassembling the Assassins
Creed computer games series

Fig. 3.4 Example educational applications of 3D models in architectural history studies (Images: Left: The Foundation of Medieval Cities, exhibit (Images: Architectura Virtualis GmbH; Middle: Muenster; Right: Image generated with Dall-E)

In education, 3D models of cultural heritage are used in various settings:

- **Teaching history and heritage in informal settings** like museums, games, or television broadcasts [49, 50]. The role and effects of media like visualizations in museum education is a key focus of scientific discourse [51–56], as are settings that employ 3D models [57–60]. As one example, interactive applications for 4D city exploration [61–63] allow virtual visits and remote spatial learning [64], support guiding visitors through the city [63, 65, 66], provide access to additional information, and enable users to gather a virtual view of temporal change and historic spaces, buildings, and monuments or covered parts [66–72].
- **Teaching heritage in formal education** is another highly important scenario. A multitude of projects employ 3D models in higher education [73, 74], or evaluate the use of 3D models of cultural heritage in schools [75, 76].
- **Teaching digital competencies via heritage** focuses on educating modeling techniques or VR technologies, while the historical object is "only" a training example. This closely relates to the concept of data literacy comprising data collection, exploration, management, analysis, and visualization skills [77]. Data literacy has been defined by various recommendations and standards [78, 79].
- **Edutainment** or infotainment incorporates aspects of teaching addressed to a broader audience or linked to commercial offerings. Edutainment and infotainment are becoming increasingly important—examples are VR history tours offered as activity in several cities or museums [80] or the discovery mode in the computer game Assassins Creed [81].

Raumbuch to structure and visualize photographic-orientation in a crypt

Digital Information space comprising 3D models and sources of a palace

H-BIM comprising point clouds and simulation data for a heritage building

The Metaverse/Mirrorworld: The Metaverse Museum resides in Second Life and shows digital heritage objects

Fig. 3.5 Knowledge structuring applications using 3D models (Images: Left: Muenster; Middle left: Bruschke; Middle right: [82]; Right: Wikimedia Commons/Mirabella)

3.2.3 Knowledge Organization

In this category, the digital 3D model is intended to structure or systematize all existing knowledge about an object/topic (Fig. 3.5). It serves as a multi-layered information carrier of the object-related knowledge. 3D models are used in various disciplines to structure knowledge and information. (a) **Digital inventories** as in the spatial book (*Raumbuch*) approach [43, 83] in archaeology, similar approaches to monument documentation [84, 85], and digital cartography—"deep" or "thick mapping" [86, 87]—focus on the spatial organization of digital data. (b) **Digital information spaces** like Digital Twin in manufacturing [88] extend the inventory by fully digital simulation workflows but focus on contemporary data. (c) **4D models**, e.g., of cities, add a temporal layer to organize data in a 4D inventory [85, 89]. Finally, (d) the **Mirrorworld approach** describes a universal data integration principle, but is still hypothetical [90]. Those concepts relate to numerous overarching standards and protocols for organizing 3D cultural heritage objects and inventories, e.g., BIM [91]/H-BIM [92–97] for architectural models and 3D-GIS [98] and CityGML [99] for geo and city-scale models.

> **Further reading: Knowledge as a theoretical approach** The creation and reception of digital 3D reconstructions and the visualization of visual humanities objects are based on complex sociotechnical interaction processes. According to Barceló, we "do not understand past social actions by enumerating [all possibilities]" [7, p. 414], but need a linkage between digital tools and human interpretation. Against this background, our research focuses on aspects of knowledge transformation and transfer, within and between humans as well as between humans and—as data—computers. This is closely related to concepts of intrapersonal knowledge such as reasoning or memorization, as well as to groups of people, their communication, and joint mental modeling [100]. Moreover, concepts like visual reasoning or embodied knowledge [101, 102] focus on an object that contains and represents knowledge, e.g., architecture. A well-established and hierarchical classification of information and knowledge

is the distinction between signs, data, information, and knowledge (Fig. 3.6). In this definition, knowledge does not only include a perception and cognition of signs, but also aspects of their relevance and mental connection for a recipient [103].

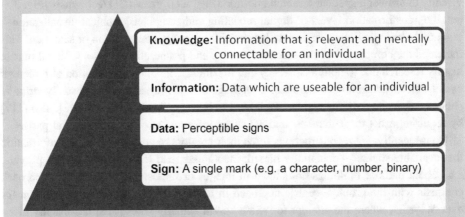

Fig. 3.6 Knowledge pyramid [103, 104]

The main intention of both research and education is to gain and transfer knowledge. According to Müller [105], knowledge in the context of visual media relates to: (1) the **production** of visual media, (2) the visual medium as an **object**, and (3) the **reception** of visual media. Digital 3D reconstruction models, as well as visualizations, act as: (1) **boundary objects**—cross-culturally understandable media [106]—for research and communication in visual humanities and (2) **embody substantial knowledge**—in terms of psychological and physiological cognition, i.e., of proportions or dimensions of objects—when creating models and visualizations [107]. From a theoretical perspective, both aspects are closely related to semiotics and model theory. According to **semiotics**, all visual entities represent a certain meaning [108]. Specific geometric shapes are recognized by humans as letters and words with a certain meaning. Graphical shapes like arrows direct human vision. These effects rely on individual cultural or professional backgrounds—i.e., an archaeologist and architectural engineer focus on different aspects when seeing a depiction of an ancient shrine [109, 110]. In addition, they are influenced by the contexts, or frames, of visual communication media (definition: [111]; research perspectives: [112]). The visual asset of knowledge is embedded or "embodied" in visual media. Lastly, visual perception and reasoning are highly influenced by the properties or **Gestalt** of visual assets [113]—e.g., color or shape—and related level of abstraction [114]. While semiotics focus on function and Gestalt on signs, model theory (→ Models and Modeling) focuses on the relation between an original and a model as its "abstraction" [115].

3.3 Epistemic Challenges of 3D Modeling in Humanities

The analog research process in history studies traditionally comprises the investigation of a historical object either directly or via historical sources, which researchers inspect visually to answer a specific research question (Fig. 3.7). Virtual 3D techniques (Fig. 3.8) add the transformation layers of digital modeling and computer graphical visualization—potentially losing, altering, or adding information, e.g., by interpretation or selection. This increases the complexity of the research process and potentially causes additional bias in history research due to nontransparency and fuzziness. The 3D reconstruction of no longer extant objects adds another main issue. Digital 3D modeling approaches usually strive to show a consistent building and "make it hard to be vague" [116], cited in [42], also [117] by requiring exact measurements and 3D shape information of all architectural parts.

Consequently, 3D reconstructions force their creators to complete missing information that available sources—potentially biased, incomplete, and low-quality—cannot provide, e.g., about parts of buildings not shown in images or impossible to read. This approach contrasts with the problem-centric approach in history studies, the leading paradigm for over 50 years, where the attempt to "show how it actually was" [118] has usually given way to basing research on available historical sources [119, 120]. A consequent issue is how to overcome this clash between sparse, questionable, partial, or missing historical

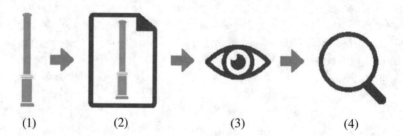

Fig. 3.7 The analog research process: A historical column (1) is either directly receivable or documented with sources (2), which is perceived by the researcher (3) to investigate a specific research question (4)

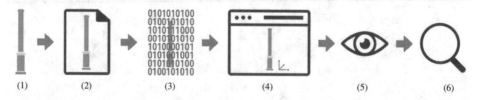

Fig. 3.8 The digital transformation process: a historical column (1) is documented with sources (2) on the basis of which a digital model is created (3), which is mapped by a visualization (4), which is perceived by the researcher (5) to investigate a specific research question (6)

information and the demands for all-embracing information to achieve digital 3D reconstruction of past architecture. Although this is still unresolved at a conceptual level, there are various attempts to document inconsistencies (\rightarrow Visualization) and make the results scientifically reproducible (\rightarrow Documentation).

Further reading: Are 3D reconstructions multi-purpose? Even after the completion of the research work, the purpose of models may change. The advantage of the all-embracing approach is that it merges different research subjects into a unified knowledge space [121].

3D models can represent valuable primary data, especially if they are based on measurements, scans, or similar survey methods in real spatial situations, which can be useful for further research. For example, additional data—such as the furnishings of a structure, or movement sequences within the spaces—could be connected to a basic model. Yet, 3D reconstruction models cultural heritage are rarely accessible online as open access. The reasons for this are manifold:

- 3D model data is due to its size and less-standardized file formats more challenging to share than images and movies.
- To date, no Current licensing models are still only limited applicable for 3D models (\rightarrow Legislation). This results in fears of losing one's own reputation by releasing data.
- Fears that one's own work could be reused in other contexts.
- Current digital repositories for 3D models are still limited e.g. with regards to interoperability (\rightarrow Infrastructure).

The problem of data sharing involves also conceptual issues, authorship could be made transparent if multiple authors made extensions to a 3D model.

3.4 Visual Research Processes and 3D Modeling

Despite several visual approaches to art and architectural history research, such as style criticism as an examination of genetic and morphological connections [122, p. 20], iconography and iconology, exploration of the content or symbols behind the visible forms [122, 123], or structural analysis [122], practices are highly researcher-specific and experience-based. They have not been connected in an overarching methodology [124, 125]. Generally, research about the use of images has been utilized in various contexts like engineering, design, architecture, or science. Visual media greatly support the

research processes of reasoning or forming ideas [102] and enable deep learning [126]. Such aspects are theorized in several approaches, such as visual decision-making [127] or visual learning theories [128–130]. Issues related to the quality of images as visual signs include similarities to a depicted object, visual styles, or creation processes [131]. The perception and visual reasoning of art historians [124, 132, 133] and archaeologists [110] have been subject to many empirical studies. Most of the investigations on architectural perception do not distinguish between laypersons and experts, and if they do, the expert group are architects [134] rather than architectural historians. Images as sources and their relevance for 3D reconstruction are a prominent topic in academic literature [135, 136], and images are the most prominent type of sources for reconstruction projects [137]. Other than in text-related disciplines, digital reconstructions usually involve multiple authors, intuitive decisions, and expertise [138]. So far, neither an academic culture nor mechanisms have been fully established for making digital models and generated images scientifically linkable and discussable (→ Documentation). This includes the capacity to quote parts or areas in models and images, and for others to modify them. In addition to a number of technical requirements, approaches are being developed to document processes and their results, as is the capacity of making a model logic transparent [20, 139].

3.5 Scientific Values

Requirements for digital 3D models to be regarded as scientific generally correspond to generally academic requirements [140]. The model must be accessible to be verifiable. It must be possible to see at least some of the data and there must be information about its provenance. Likewise, to meet scientific requirements, models must be able to provide information about the object, its nature, and its history, as well as about the origin of the model itself (→ Documentation). Required information include:

- Authorship (of each element of the 3D model)
- Versioning (of each element of the 3D model)
- Level of detail
- Online availability
- Long-term archiving
- Documentation of the reconstruction process
- Marking of hypotheses (e.g., visually, textually)
- Metadata and paradata
- Linking to sources used for the reconstruction.

Providing access to research results/authorship/publication [141] and the absence of value(s) [142] have often been addressed from both an epistemological and an empirical perspective, e.g., in the positivism controversy [143]. In addition to the well-known technical principles of objectivity, reliability, and validity of scientific work [144, p. 22], scientific knowledge must explain, justify, and be comprehensible [145, p. 17].

A similar long-running discourse on architecture and art history—especially digital images—has considered specific scientific access and value, and a tendency toward fragmentation, small form and prevailing the quantitative [146]. Scientific values implied in 3D models in humanities include:

- Authenticity (relationship to the object)
- Hypotheses or modeling (relationship to the research thesis)
- Plausibility (relationship to the cognitive process)
- Recognizability (relationship of the above values to form/design)
- Flawlessness (problems of abovementioned values in relation to form/design)
- Immersivity (relationship of object to viewer by means of visualization)
- Source fidelity (problems of object to viewer due to visualization)
- Correspondence with textual explanations (problem awareness through image-text direction).

The methods for examining models can be differentiated according to whether they are primarily focused on the sources, the structure, or the appearance of the model.

3.6 Guidelines and Standards for 3D Reconstruction

A large number of guidelines and standards cover different aspects of the scientific requirements for models. However, categories and prioritization are still necessary. 3D reconstructions within research projects and generally with a scientific claim, should be based on the principles of good scientific practice and thus be comprehensible and theoretically reproducible. A binding basis for this is provided by the DFG guidelines [147]. The following key principles of the DFG guidelines are particularly relevant for digital reconstruction, as Marc Grellert and Mieke Pfarr-Harfst noted in 2019: "From the point of view of the current challenges in the field of knowledge-based digital reconstruction, the following recommendations of the DFG are significant in terms of good scientific practice: First, to work lege artis; second, to consistently self-doubt all results; third, to document results (Recommendation 1); fourth, scientific publications are the primary medium of

accountability of scientists for their work (Recommendation 12); and fifth, to secure and preserve primary data (Recommendation 7)" [148, p. 275].

Specifically geared to the particularities of 3D projects in archaeology is the AHDS Guides to Good Practice for CAD [149], which can be applied to other disciplines. The **Reconstruction Argument Method** conceived by Mieke Pfarr-Harfst and Marc Grellert aims "to juxtapose images of reconstruction with sources and link them to a textual argument. The core is a triad of reconstruction—argument—source, which can be completed by mapping variants with the attributes 'assured', 'probable', 'possible', and 'hypothetical'" [148, p. 264]. Using this method, the creation process and visualization result of a 3D reconstruction is documented in all its individual steps, substantiated (with sources, arguments, theses), and made comprehensible.

Guidelines and charters for 3D reconstruction

- **The UNESCO Charter on Digital Heritage** [150] provides a framework for practitioners in 3D reconstruction to create scientifically sound 3D models. It is up to the people involved in the reconstruction process to make use of them and to share their work with the scientific community and beyond.
- **The AHDS Guides to Good Practice for CAD** [149] provides comprehensive information and practical advice on data creation (suitable CAD data formats, terminology conventions), documenting the 3D reconstruction process, and archiving of the resulting data.
- **The Community Standards for 3D Data Preservation (CS3DP) initiative** was established to examine 3D data documentation, dissemination, and preservation practice. On that base, it developed recommendations for standardization and 3D data preservation [150].
- **The London Charter**, initiated in 2006 [151, 152], "defines principles for the use of computer-based visualization methods in relation to intellectual integrity, reliability, documentation, sustainability and access."
- **Principles of Seville**: As stated in the London Charter, some areas of studies may refine the principles according to their specific needs. This was the case for archaeology, publishing "The Principles of Seville. International Principles of Virtual Archaeology" [153] in 2011 with the latest version in 2017 [154]. They encompass eight principles: interdisciplinarity, purpose, complementarity, authenticity, historical rigor, efficiency, scientific transparency, training, and evaluation. Unlike the London Charter, they include Principle 4: Authenticity for archeological remains, Principle 1: Interdisciplinarity, and Principle 7: Scientific Transparency.

Kuroczyński sees the use of a virtual research environment (VRE) as a fundamental method for ensuring the scientific nature of 3D reconstructions: "The basic prerequisite is that open-source applications are used and the requirements of linked data technologies are taken into account so that the digital research results can be networked and made available on a web-based basis (open science). In addition, the 3D datasets must be integrated and visualized within the VRE as part of the research data" [155, p. 176]. Related to this, it has turned out to be difficult because there are so many standards for dealing with historical contents.

The scientific nature of 3D models also depends on whether the data is machine-readable and accessible. A standard here is the **5-Star Model for Open Data** by Tim Berners-Lee [156].

For traceability and sustainable documentation (→ Documentation), a written publication in which the creation process of a 3D reconstruction is documented is still the common way to make the scientific objective and strategy behind the 3D model, as well as the argumentation and the conclusions resulting from the work with the model, comprehensible and received in the long term.

Summary This chapter offers an overview of the contexts in which 3D reconstructions are created, challenges that may arise in the reconstruction process, and how to deal with them. It shows the reader how to ensure a scientifically sound 3D reconstruction using specific charters, standards, and guidelines.

Standards and guidelines

- Denard, H. (2009) The London Charter. For the Computer-Based Visualization of Cultural Heritage, Version 2.1. [152].
- Deutsche Forschungsgemeinschaft (2016). DFG-Praxisregeln "Digitalisierung" [157].
- Deutsche Forschungsgemeinschaft (2013). Grundlagen guter wissenschaftlicher Praxis [147].
- Principles of Seville. International Principles of Virtual Archaeology. Ratified by the 19th ICOMOS General Assembly in New Delhi, December 2017 (http://sevill eprinciples.com, accessed on 1.2.2023).

Projects

- **4D-Browser**: Open online research tool to search, find, and analyze historical photographs in a spatiotemporal way within a 4D model of a city, developed by

the junior research group HistStadt4D (UrbanHistory4D) in 2016–2021, in further development at the Friedrich-Schiller-Universität and Technische Universität Dresden [158]. https://4dbrowser.urbanhistory4d.org, accessed on 1.2.2023.

- **Bamberg 4D**: The project "4D city model of Bamberg around 1300" is developing a scientifically sound reconstruction of the medieval cathedral city from around 1300. https://www.uni-bamberg.de/bauforschung/forschung/projekte/digitales-sta dtmodell/4d/, accessed on 1.2.2023.
- **Utopian Theatres**: 3D reconstruction of three theaters planned in the 1920s and 1930s, which were never built, by Rachel Hann 2006–2009 with explicit reference to the principles of the London Charter [159]. http://www.utopiantheatres.co.uk/, accessed on 1.2.2023.

Key literature

- Beacham, R.; Denard, H.; Niccolucci, F. An Introduction to the London Charter. In Papers from the Joint Event CIPA/VAST/EG/EuroMed Event, Ioannides, M., Arnold, D., Niccolucci, F., Mania, K., Eds.; 2006; pp. 263–269 [151].
- Bentkowska-Kafel, A., H. Denard and D. Baker (2012). Paradata and Transparency in Virtual Heritage. Burlington, Ashgate [160].
- Kuroczyński, P.; Pfarr-Harfst, M.; Münster, S., (Eds.) Der Modelle Tugend 2.0: Digitale 3D-Rekonstruktion als virtueller Raum der architekturhistorischen Forschung. Heidelberg University Press: Heidelberg, 2019 [161].
- Münster, S. Digital 3D Technologies for Humanities Research and Education: An Overview. Applied Sciences 2022, 12, 2426 [162].

References

1. Drucker J (2013) Is there a "digital" art history? Vis Resour 29(1–2):5–13
2. Kohle H (2013) Digitale Bildwissenschaft
3. Heusinger L (1989) Applications of computers in the history of art. In: Hamber A et al (eds) Computers and the history of art. Mansell Publications, London and New York, pp 1–22
4. Evans TL et al (2006) Digital archaeology. Bridging method and theory
5. Frischer B et al (2008) Beyond illustration. 2D and 3D digital technologies as tools for discovery in archaeology. BAR international series 1805
6. Kansa EC et al (2011) ARCHAEOLOGY 2.0. New approaches to communication & collaboration
7. Barceló JA (2010) Towards a true automatic archaeology: integrating technique and theory
8. Huvila I (2014) Archives, libraries and museums in the contemporary society: perspectives of the professionals. In: iConference 2014 proceedings. Berlin, pp 45–64

9. Romanelli M (2015) Museums. New technologies for change. In: Schiuma G (ed) Proceedings of IFKAD 2015. International forum on knowledge asset dynamics, Bari, pp 1745–1755
10. Lankoski P et al (2015) Game research methods. An overview
11. Sahle P (2013) Digitale Editionsformen. Zum Umgang mit der Überlieferung unter den Bedingungen des Medienwandels. Band 2: Befunde, Theorie und Methodik, vol 9. Schriften des Instituts für Dokumentologie und Editorik
12. Sahle P (2013) Digitale Editionsformen. Zum Umgang mit der Überlieferung unter den Bedingungen des Medienwandels. Band 3: Textbegriffe und Recodierung, vol 7. Schriften des Instituts für Dokumentologie und Editorik
13. Sahle P (2013) Digitale Editionsformen. Zum Umgang mit der Überlieferung unter den Bedingungen des Medienwandels. Band 1: Das typografische Erbe, vol 9. Schriften des Instituts für Dokumentologie und Editorik
14. Noble I et al (2014) Visual research/an introduction to research methodologies in graphic design. 2nd edn., reprint. edn
15. Georgopoulos A (2018) CIPA's perspectives on cultural heritage. In: Münster S et al (eds) Digital research and education in architectural heritage. 5th conference, DECH 2017, and first workshop, UHDL 2017, Dresden, Germany, March 30–31, 2017, Revised selected papers. Springer, Cham, pp 215–245
16. Frischer B, Fillwalk J (2012) The digital Hadrian's Villa project. Using virtual worlds to control suspected solar alignments. In: Guidi G, Addison AC (eds) Proceedings of the VSMM 2012. Virtual systems in the information society, 2–5 September 2012, Milano, pp 49–55
17. Maim J et al (2007) Populating ancient Pompeii with crowds of virtual Romans. In: Arnold D et al (eds) 8th international symposium on virtual reality, archaeology and cultural heritage (VAST 2007). Eurographics Association, Brighton, pp 109–116
18. Thalmann D et al (2014) Geometric issues in reconstruction of virtual heritage involving large populations. In: Ioannides M et al (eds) 3D research challenges in cultural heritage a roadmap in digital heritage preservation. Springer Berlin, Heidelberg
19. Pfarr-Harfst M (2013) Virtual scientific models. In: Ng K et al (eds) Electronic visualisation and the arts. London, pp 157–163
20. Günther H (2001) Kritische Computer-Visualisierung in der kunsthistorischen Lehre. In: Frings M (ed) Der Modelle Tugend. CAD und die neuen Räume der Kunstgeschichte. Weimar, pp 111–122
21. Ling Z et al (2007) Rule-based 3D modeling for Chinese traditional architecture. In: Remondino F et al (eds) 3D-ARCH 2007. Zürich
22. Carrozzino M et al (2014) Virtual reconstruction of paintings as a tool for research and learning. J Cult Herit 15(3):308–312
23. Fontana R et al (2002) Three-dimensional modelling of statues: the Minerva of Arezzo. J Cult Herit 3(4):325–331
24. Arbace L et al (2013) Innovative uses of 3D digital technologies to assist the restoration of a fragmented terracotta statue. J Cult Herit 14(4):332–345
25. Erdmann L et al (2016) Lukas aus der Asche - Auferstandenes Kulturerbe aus dem 3D-Labor
26. Frommel CL et al (2000) Le facciate di San Carlino. In: Frommel CL et al (eds) Francesco Borromini. Electa, Milan, pp 45–67
27. Camerlenghi N (2018) St paul's outside the walls. A Roman Basilica, from antiquity to the modern era
28. Saft S et al (2012) Computational approach towards structural investigations for the restoration of historical keyboard instruments. J Cult Herit 13(3):165–174

29. Wiemer W (2005) Harmonie und Maß – Ergebnisse der Proportionsanalysen der Abteikirche Ebrach. In: Archaeology in architecture: studies in honor of Cecli L. Striker. Mainz, pp 199–216

30. Masini N et al (2004) An algorithm for computing the original units of measure of medieval architecture. J Cult Herit 5(1):7–15

31. Koller D et al (2009) Research challenges for digital archives of 3D cultural heritage models. J Comput Cult Herit 2(3):1–17

32. Mele E et al (2003) Modelling and analysis of a basilica under earthquake loading. J Cult Herit 4(4):355–367

33. Wagener O et al (2016) Medieval castles and their landscape. A case study towards historic reconstruction. In: Hoppe S et al (eds) Virtual palaces, part II. Lost palaces and their afterlife. Virtual reconstruction between science and the media, pp 170–200

34. Penrose LS et al (1958) Impossible objects: a special type of visual illusion. Br J Psychol 49(1):31–33

35. Barbutev A (2022) 3D Digitization service for Heritage-in-risk

36. Neumüller M et al (2014) 3D printing for cultural heritage: preservation, accessibility, research and education. In: 3D research challenges in cultural heritage. Springer, pp 119–134

37. Kolokoussis P et al (2021) 3d and hyperspectral data integration for assessing material degradation in medieval masonry heritage buildings. Int Arch Photogram Remote Sens Spat Inf Sci 43:583–590

38. Gomes L et al (2014) 3D reconstruction methods for digital preservation of cultural heritage: a survey. Pattern Recogn Lett 50:3–14

39. De Luca L (2020) Towards the semantic-aware 3D digitisation of architectural heritage: the "Notre-Dame de Paris" digital twin project. In: Proceedings of the 2nd workshop on structuring and understanding of multimedia heritage contents, pp 3–4

40. Grün A et al (2004) Photogrammetric reconstruction of the great buddha of Bamiyan, Afghanistan. Photogram Rec 19:177–199

41. Wahbeh W et al (2016) Combining public domain and professional panoramic imagery for the accurate and dense 3D reconstruction of the destroyed bel temple in Palmyra. ISPRS Ann Photogram Remote Sens Spat Inf Sci 3:81

42. Sachse P (2002) Idea materialis. Entwurfsdenken und Darstellungshandeln. über die allmähliche Verfertigung der Gedanken beim Skizzieren und Modellieren

43. Wulf U et al (2006) Investigating buildings three-dimensionally. The "Domus Severiana" on the Palatine. In: Haselberger L et al (eds) Imaging ancient Rome: documentation, visualization, imagination: Proceedings of the 3rd Williams symposium on classical architecture, Rome, 20–23 May 2004. J Roman Archaeol Portsmouth, pp 221–233

44. Lindley J (2020) Preventing art forgery and fraud through emerging technology: application of a regulatory pluralism model. In: Research handbook on art and law. Edward Elgar Publishing

45. Sidorov O et al (2019) Craquelure as a graph: application of image processing and graph neural networks to the description of fracture patterns. In: Proceedings of the IEEE/CVF international conference on computer vision workshops

46. Guerra MG et al (2020) Standard quantification and measurement of damages through features characterization of surface imperfections on 3D models: an application on architectural heritages. Procedia CIRP 88:515–520

47. Sitnik R et al (2019) Monitoring surface degradation process by 3D structured light scanning. In: Optics for arts, architecture, and archaeology VII. International Society for Optics and Photonics, p 1105811

48. Grilli E et al (2018) Supervised segmentation of 3D cultural heritage. In: 2018 3rd digital heritage international congress (DigitalHERITAGE) held jointly with 2018 24th international conference on virtual systems & multimedia (VSMM 2018), 26–30 October 2018, pp 1–8

49. Münster S (2011) Militärgeschichte aus der digitalen Retorte - Computergenerierte 3D-Visualisierung als Filmtechnik. In: Kästner A et al (eds) Mehr als Krieg und Leidenschaft. Die filmische Darstellung von Militär und Gesellschaft der Frühen Neuzeit (Militär und Gesellschaft in der frühen Neuzeit, 2011/2). Potsdam, pp 457–486

50. Ott M et al (2011) Towards a new era for cultural heritage education: discussing the role of ICT. Comput Hum Behav 27(4):1365–1371

51. Flaten A (2008) Ashes2Art: a pedagogical case study in digital humanities. In: CAA

52. Sanders DH (2004) Virtual archaeology: yesterday, today, and tomorrow. In: Niccolucci F et al (eds). CAA2004. Prato 13–17 April 2004, p n.a.

53. Fisher CR et al (2009) Integrating new technologies into established systems: a case study from Roman Silchester. Computer applications to archaeology 2009 Williamsburg, Virginia, USA, 22–26 March 2009

54. Doukianou S et al (2020) Beyond virtual museums: adopting serious games and extended reality (XR) for user-centred cultural experiences. In: Liarokapis F et al (eds) Visual computing for cultural heritage. Springer Series on Cultural Computing. Springer International Publishing, Cham, pp 283–299

55. Daniela L (2020) Virtual Museums as learning agents. Sustainability 12(7):2698

56. Haynes R (2018) Eye of the Veholder: AR extending and blending of museum objects and virtual collections. In: Augmented reality and virtual reality. Progress in IS, pp 79–91

57. Ferrara V et al (2013) Reusing cultural heritage digital resources in teaching. In: Digital heritage international congress (DigitalHeritage), 28 October 2013–1 November 2013, pp 409–412

58. Gicquel PY et al (2013) Design and use of CALM: an ubiquitous environment for mobile learning during museum visit. In: Digital heritage international congress (DigitalHeritage), 28 October 2013–1 November 2013, pp 645–652

59. Motejlek J et al (2019) A taxonomy for virtual and augmented reality in education

60. ViMM WG 2.2 (2017) Meaningful content connected to the real world (report)

61. Kim K et al (2009) Augmented reality tour system for immersive experience of cultural heritage. Paper presented at the Proceedings of the 8th international conference on virtual reality continuum and its applications in industry - VRCAI '09, Yokohama, Japan

62. Ioannidi A et al (2017) Flaneur: augmented exploration of the architectural urbanscape. In: 2017 IEEE symposium on computers and communications (ISCC), 3–6 July 2017, pp 529–533

63. Ioannidis C et al (2020) A multi-purpose cultural heritage data platform for 4d visualization and interactive information services. Int Arch Photogram Remote Sens Spat Inf Sci XLIII-B4-2020:583–590

64. Mortara M et al (2018) 3D Virtual environments as effective learning contexts for cultural heritage. Ital J Educ Technol 26(2):5–21

65. De Fino M et al (2020) Virtual tours and informational models for improving territorial attractiveness and the smart management of architectural heritage: the 3d-Imp-Act project. Int Arch Photogram Remote Sens Spat Inf Sci XLIV-M-1-2020:473–480

66. Chatzidimitris T et al (2013) Mobile augmented reality edutainment applications for cultural institutions. In: Proceedings of the 4th international conference on information, intelligence, systems and applications, Mikrolimano, Greece, 10–12 July 2013

67. Vicent N et al (2015) Arqueología y tecnologías digitales en Educación Patrimonial. Educatio Siglo XXI 33(1):83–102

68. Petrucco C et al (2016) Teaching our cultural heritage using mobile augmented reality. J E-Learn Knowl Soc 12:115–128
69. Luna U et al (2019) Augmented reality in heritage apps: current trends in Europe. Appl Sci-Basel 9(13):2756
70. Bekele MK et al (2018) A survey of augmented, virtual, and mixed reality for cultural heritage. ACM J Comput Cult Herit 11(2):Article 7
71. Torres M et al (2011) Picture the past from the present. In: 3rd international conference on internet multimedia computing and service, Chengdu, China. ACM, pp 51–54
72. Chang YL et al (2015) Apply an augmented reality in a mobile guidance to increase sense of place for heritage places. Educ Technol Soc 18(2):166–178
73. Köhler T et al (2015) Smart communities in virtual reality. A comparison of design approaches for academic education (reprint). In: Köhler T et al (eds) Virtual enterprises, communities & social networks. TUDpress, Dresden, pp 25–38
74. Gerth B et al (2005) 3D modeling for non-expert users with the castle construction kit v0.5. In: Mudge M et al (eds) 6th international symposium on virtual reality, archaeology and cultural heritage (VAST 2005). Eurographics Association, Pisa, pp 49–57
75. Di Blas N et al (2005) 3D worlds and cultural heritage: realism vs virtual presence
76. Di Blas N et al (2009) Digital storytelling as a whole-class learning activity: lessons from a three-years project. In: Iurgel IA et al (eds) Interactive storytelling, Berlin, Heidelberg. Springer Berlin Heidelberg, pp 14–25
77. Schüller K et al (2019) Future Skills: Ein Framework für Data Literacy. HFD position paper 47
78. Ridsdale C et al (2015) Strategies and best practices for data literacy education knowledge synthesis report
79. Arbeitsgruppe Curriculum 4.0 (2018) Curriculumentwicklung und Kompetenzen für das digitale Zeitalter. Thesen und Empfehlungen der AG Curriculum 4.0 des Hochschulforum Digitalisierung. HFD position paper 39
80. Bekerman R (2017) The TIMERIDE VR experience
81. McMillan M et al (2019) Assassin's creed, an analysis. In: Lee N (ed) Encyclopedia of computer graphics and games. Springer International Publishing, Cham, pp 1–11
82. Yang X et al (2019) HBIM modeling from the surface mesh and its extended capability of knowledge representation. ISPRS Int J Geo Inf 8(7):301
83. Heine K et al (2006) WWW-based building information system for "Domus Severiana" palace at Palatine in Rome by open source software
84. Messaoudi T et al (2018) An ontological model for the reality- based 3D annotation of heritage building conservation state. J Cult Herit 29:100–112
85. Breitling S et al (2018) Digitale Kartierungen in der Bauforschung und Baudenkmalpflege. In: Breitling S et al (eds) Bauforschung in der Denkmalpflege. Qualitätsstandards und Wissensdistribution, vol 5. Forschungen des Instituts für Archäologische Wissenschaften, Denkmalwissenschaften und Kunstgeschichte, Bamberg, pp 163–180
86. Camerlenghi N et al (2018) Learning from Rome: making sense of complex build environments in the digital age. JSAH (J Soc Archit Hist) 77:256–266
87. Presner T et al (2014) HyperCities: thick mapping in the digital humanities
88. Glaessgen E et al (2012) The digital twin paradigm for future NASA and U.S. air force vehicles. In: 53rd AIAA/ASME/ASCE/AHS/ASC structures, structural dynamics and materials conference
89. Jaillot V (2020) 3D, temporal and documented cities: formalization, visualization and navigation
90. Kaplan F et al (2020) The advent of the 4D mirrorworld. Urban Plan 5(2):307–310

91. ISO BIM – The present EN ISO 19650 standards provide the construction industry with an approach to manage and exchange information on projects. https://group.thinkproject.com/de/ressourcen/bim-standards-und-praktiken/. Accessed 2 Feb 2022

92. Diara F et al (2019) Evaluation of an integrative approach between HBIM and architecture history, vol XLII-2/W11

93. Barazzetti L et al (2015) HBIM and augmented information: towards a wider user community of image and range-based reconstructions. Int Arch Photogram Remote Sens Spat Inf Sci XL-5/W7:35–42

94. Jouan P et al (2019) Digital twin: a Hbim-based methodology to support preventive conservation of historic assets through heritage significance awareness. Int Arch Photogram Remote Sens Spat Inf Sci XLII-2/W15:609–615

95. Dore C et al (2019) Historic building information modelling (HBIM). In: Architecture and design, pp 49–92

96. Murphy M (2017) Historic building information modelling (HBIM). Innovation in intelligent management of heritage buildings (i2MHB) - TD cost action TD1406

97. Schulz O et al (2021) Image-documentation of existing buildings using a server-based BIM collaboration format workflow.

98. Dell'Unto N et al (2022) Archaeological 3D GIS

99. OGC (2012) OGC city geography markup language (CityGML) encoding standard, version 2.0.0

100. Cannon-Bowers JA et al (1993) Shared mental models in expert team decision making. In: N. J. Castellan J (ed) Individual and group decision making: current issues. Lawrence Erlbaum Associates, Inc., Hillsdale, pp 221–246

101. Arnheim R (1969) Visual thinking

102. Gooding DC (2004) Cognition, construction and culture. Visual theories in the sciences. J Cogn Cult 4:551–593

103. Hasler Roumois U (2010) Studienbuch Wissensmanagement. Grundlagen der Wissensarbeit in Wirtschafts-, Non-Profit- und Public-Organisationen. vol 2954

104. Frické M (2018) Knowledge pyramid

105. Müller MG et al (2015) Grundlagen der visuellen Kommunikation. Theorieansätze und Analysemethoden

106. Star SL et al (1989) Institutional ecology, "translations" and boundary objects. Amateurs and professionals in Berkeley"s museum of vertebrate zoology 1907–1939. Soc Stud Sci 19(4):387–420

107. Wilson RA et al (2015) Embodied cognition. In: Stanford encyclopedia of philosophy. Stanford

108. Morris CW (1938) Foundations of the theory of signs

109. Simon HA (1990) Invariants of human behavior. Annu Rev Psychol 41:1–19

110. Goodwin C (1994) Professional vision. Am Anthropol 96(3):606–633

111. Scheufele DA (1999) Framing as a theory of media effects. J Commun 49(1):103–122

112. Geise S et al (2014) What is visual framing research? a systematic overview of an emerging field of (visual) communication research. In: Paper presented at the annual meeting of the international communication association 64th annual conference, Seattle

113. Gerrig RJ et al (2010) Psychology and life, 19th edn.

114. Tversky B (2005) Visuospatial reasoning. In: Holyoak K et al (eds) Handbook of reasoning. Cambridge University Press, Cambridge, pp 209–249

115. Mahr B (2004) Das Wissen im Modell

116. Fish JC (1994) Why do designers sketch? Visual cognition and computer assisted visualisation. In: Trappl R (ed) Proceedings of the 12th European meeting on cybernetics and systems research. World Scientific, pp 499–506
117. Vogel G-H (2019) Die Sichtbarmachung des Unsichtbaren: Ästhetische Konventionen in Rekonstruktionsmodellen. In: Kuroczyński P et al (eds) Der Modelle Tugend 2.0: Digitale 3D-Rekonstruktion als virtueller Raum der architekturhistorischen Forschung. Heidelberg, pp 98–122
118. von Ranke L (1824) Geschichten der romanischen und germanischen Völker von 1494 bis 1514. Zur Kritik neuerer Geschichtsschreiber.
119. Wengenroth U (1998) Was ist Technikgeschichte?
120. Raphael L (2012) Geschichtswissenschaften im Zeitalter der Extreme: Theorien, Methoden, Tendenzen von 1900 bis zur Gegenwart
121. Schelbert G (2019) Ein Modell ist ein Modell ist ein Modell – Brückenschläge in der Digitalität. In: Kuroczyński P et al (eds) Der Modelle Tugend 2.0: Digitale 3D-Rekonstruktion als virtueller Raum der architekturhistorischen Forschung, Heidelberg
122. Seippel R-P (1989) Architektur und Interpretation. Methoden und Ansätze der Kunstgeschichte in ihrer Bedeutung für die Architekturinterpretation
123. Panofsky E (1939) Studies in iconology. Humanistic themes in the art of the renaissance
124. Brieber D et al (2014) Art in time and space: context modulates the relation between art experience and viewing time. PLoS ONE 9(6):e99019
125. Münster S et al (2018) Image libraries and their scholarly use in the field of art and architectural history. Int J Digit Libr 19(4):367–383
126. Mintzberg H et al (2010) Decision making: it's not what you think. In: Nutt PC et al (eds) Handbook of decision making. Wiley-Blackwell, Oxford, pp 73–82
127. Nutt PC et al (2010) Handbook of decision making
128. Gagné RM et al (1988) Principles of instructional design, 3rd edn.
129. Pahl J-P et al (1998) Didaktische Vereinfachung. Eine kritische Reprise des Werkes von Dietrich Hering
130. Schwan S et al (2006) VirtuelleRealität und E-Learning. Accessed 10 Jan 2014
131. Bresciani S (2013) Understanding the visual in team communication. A collaborative dimensions approach. In: International communication association (ICA) annual meeting, 17–21 June 2013, London
132. Bullot NJ et al (2013) The artful mind meets art history: toward a psycho-historical framework for the science of art appreciation. Behav Brain Sci 36(2):123–137
133. Kapoula Z et al (2009) Effect of title on eye-movement exploration of cubist paintings by Fernand Leger. Perception 38(4):479–491
134. Stamps AE et al (1997) Design review and public preferences: effects of geographical location, public consensus, sensation seeking, and architectural styles. J Environ Psychol 17(1):11–32
135. Hermon S (2008) Reasoning in 3D. A critical appraisal of the role of 3D modelling and virtual reconstructions in archaeology. In: Frischer B (ed) Beyond illustration: 2D and 3D digital technologies as tools for discovery in archaeology, vol 1805. Tempus Reparatum, Oxford, pp 36–45
136. Remondino F et al (2009) 3D virtual reconstruction and visualization of complex architectures - the 3D-ARCH project. In: Remondino F et al (eds) 3D-ARCH 2009. Zürich
137. Münster S (2016) Interdisziplinäre Kooperation bei der Erstellung geschichtswissenschaftlicher 3D-Rekonstruktionen
138. Münster S et al (2014) Beyond software. Design implications for virtual libraries and platforms for cultural heritage from practical findings. In: Ioannides M et al (eds) Digital heritage. Progress in cultural heritage: documentation, preservation, and protection, vol LNCS 8740. Springer International Publishing Switzerland, Cham, pp 131–145

139. Hoppe S (2001) Die Fußnoten des Modells. In: Frings M (ed) Der Modelle Tugend. CAD und die neuen Räume der Kunstgeschichte. Weimar, pp 87–102

140. Frommel S, Schlimme H (eds) (2020) Editorial. Virtual models and scientific value. In: SCIRES-IT SCIentific RESearch and Information Technology 10(1):1–4. http://www.sciresit.it/issue/view/830

141. Keul H-K (1999) Der Wert der Wertfreiheit. Zu M. Webers theoretischem Postulat und seiner universal-pragmatischen Transformation. In: Znepolski I (ed) Max Weber - Relectures l Ouest, relectures l st. Actes du colloque de Sofia

142. Weber M (1988) Die 'Objektivität' sozialwissenschaftlicher und sozialpolitischer Erkenntnis. In: Winckelmann J (ed) Gesammelte Aufsätze zur Wissenschaftslehre. Tübingen

143. Ritsert J (2010) Der Positivismusstreit. In: Kneer G et al (eds) Soziologische Kontroversen. Eine andere Geschichte von der Wissenschaft vom Sozialen. Suhrkamp, Berlin, pp 102–130

144. Peterßen WH (1987) Wissenschaftliches Arbeiten. nicht leicht, aber erlernbar

145. Meinsen S (2003) Konstruktivistisches Wissensmanagement

146. Schelbert G (2015) Kohle, Hubertus: Digitale Bildwissenschaft, Glückstadt: Verlag Werner Hülsbusch 2013 (Rezension). ArtHist

147. Deutsche Forschungsgemeinschaft (2013) Grundlagen guter wissenschaftlicher Praxis

148. Grellert M et al (2019) Die Rekonstruktion – Argument – Methode: Vorschlag für einen minimalen Dokumentationsstandard im Kontext digitaler Rekonstruktionen. In: Kuroczyński P et al (eds) Der Modelle Tugend 2.0: Digitale 3D-Rekonstruktion als virtueller Raum der architekturhistorischen Forschung. Heidelberg

149. Eiteljorg H (2003) CAD: a guide to good practice (Ahds guides to good practice)

150. UNESCO (2003) Charter on the preservation of digital heritage

151. Beacham R et al (2006) An introduction to the London charter. In: Ioannides M et al (eds) Papers from the joint event CIPA/VAST/EG/EuroMed event, pp 263–269

152. Denard H (2009) The London charter. For the computer-based visualisation of cultural heritage, version 2.1

153. León AG (2011) The implementation of an international charter in the field of Virtual Archaeology. In: XXIII CIPA Symposium - Proceedings

154. Principles of Seville. International principles of virtual archaeology. Ratified by the 19th ICOMOS General Assempbly in New Delhi DHSC

155. Kuroczyński P (2018) Neuer Forschungsraum für die Kunstgeschichte: Virtuelle Forschungsumgebungen für digitale 3D-Rekonstruktionen. In: Kuroczyński P et al (eds) Computing Art Reader: Einführung in die digitale Kunstgeschichte. Computing in art and architecture, 1 edn., Heidelberg, pp 160–181

156. Berners-Lee T (2012) 5 Star Open Data. https://5stardata.info/de/. Accessed 20 Oct 2023

157. DFG (2016) DFG-Praxisregeln "Digitalisierung"

158. Münster S et al (2021) Where are we now on the way to 4D urban history research and discovery? ISPRS Ann

159. Hann RC-bDvftrtauouutaftsas, Diss. Leeds 2010, o. O. 2010, online zuganglich über. http://www.utopiantheatres.co.uk/

160. Bentkowska-Kafel A et al (2012) Paradata and transparency in virtual heritage

161. Kuroczyński P et al (eds) (2019) Der Modelle Tugend 2.0: Digitale 3D-Rekonstruktion als virtueller Raum der architekturhistorischen Forschung. Heidelberg University Press, Heidelberg

162. Münster S (2022) Digital 3D technologies for humanities research and education: an overview. Appl Sci 12(5):2426

163. Münster S (2023) Advancements in 3D heritage data aggregation and enrichment in Europe: implications for designing the Jena Experimental Repository for the DFG 3D viewer. Appl Sci 13:9781

Scholarly Community

4

Abstract

This chapter provides an overview of the scholarly communities in which the digital 3D reconstruction is used as a method. (Visual) digital humanities—besides digital heritage and humanities disciplines such as digital art history or digital archaeology—marks the disciplinary space in which 3D reconstruction in the humanities is discussed and methodologically anchored. The chapter describes whether the method of digital 3D reconstruction can be considered an individual scholarly field and how it would be determined.

Guiding questions
- How can scholarship be structured?
- What are visual approaches in the humanities?
- Is there an ideal structure for the 3D reconstruction process?
- Where can digital 3D reconstruction be located within disciplines?

Basic terms
- Visual humanities
- Scholarly culture
- Communities
- Disciplines

© The Author(s) 2024
S. Münster et al., *Handbook of Digital 3D Reconstruction of Historical Architecture*,
Synthesis Lectures on Engineers, Technology, & Society 28,
https://doi.org/10.1007/978-3-031-43363-4_4

4.1 Introduction

Further reading: Research on Scientific Communities
Various social empirical methods have been used during the last decades to **evaluate, quantify, and qualify the usage of digital 3D modeling** for particular fields of humanities. Most of these approaches focus on qualitative analysis, e.g., by expert boards or surveys. The EPOCH network of excellence (2004–2008) employed focus group discussions and perspectives on digital 3D techniques in cultural heritage studies [1]. While qualitative approaches are appropriate to identify and explain [2] phenomena in terms of evolutions, current states, and perspectives, they show only limited usefulness for quantifying uncovered phenomena or investigating scientific structures. The VIA project organized a series of workshops and questionnaire-based surveys to investigate visualization in archaeology in the UK [3]. From 2012, the Enumerate project has performed bi-annual monitoring of digitization activities of cultural heritage institutions within the EU—primarily museums and archives [4, 5]. The DARIAH DIMPO workgroup is periodically monitoring the digital humanities community [6]. Recently, several monitoring actions were conducted by the European Commission [7, 8], e.g., to investigate digital competency in cultural institutions [9]. Several associations surveyed the consequences of the COVID-19 pandemic for cultural institutions and their digital transition [10].[1]

Research regarding scholarly behavior often relies on analyzing **the publication record**. With regards to a scholarly area of visual digital humanities and its adjacent fields like digital heritage, Hicks et al. [11] stated that publication and research habits are widely spread between single disciplines in the (digital) humanities. Similarly, Leydesdorff et al. [12] examined the disciplinary canon in humanities and digital humanities employing bibliometric methods. With regards to a scholarly community within the digital humanities, Terras [13] reported that until 2006, US, Canada, and UK-based researchers contributed most to academic discourse. Similarly, Grandjean performed a social network analysis of Twitter to map the digital humanities community [14]. Specifically for digital heritage, Scollar [15] investigated the Conference on Computer Application in Archaeologies from 1973 until 1996. Secondly, **information habits** of visual digital humanities scholars are the focus of various studies. Since older investigations found large differences in information behavior between scholars in different disciplines [16], nowadays, many scholars in art history and architecture rely heavily on digital information and perform visual search strategies [17, 18].

[1] An overview: https://pro.europeana.eu/page/organisational-approaches, accessed 01.01.2022

Scientific structures can be classified according to various criteria. One common approach is to distinguish different disciplines as branches of science. Another approach is to identify scientific communities as groups of scholars "[...] who have agreed to accept a paradigm" [19] by analysing their research outcomes. Thus, an important object of study is the author cohorts of publications, and the classification of topics of interest.

4.2 Disciplines Which Benefit from the Method

Disciplines are characterized by common methods and theories. Furthermore, they usually share comparable "reference systems, disciplinary ways of thinking, quality criteria, publication habits and bodies" [20, p. 6] and a similar institutionalization. Similarly, Knorr-Cetina thought that each discipline has its own "epistemic culture" in the sense of different "architectures of empirical approaches, specific constructions of the referent, particular ontologies of instruments, and different social machines" [21, p. 3]. Disciplines and their boundaries are social constructions [22] and a number of phenotypic fields can be identified [23]. One basic classification scheme is the distinction between humanities and sciences. In a more elaborate classification the Organization for Economic Co-operation and Development lists six scientific fields containing around 40 disciplines [24, 25]; library classification delivers highly sophisticated categorization schemes [26].

4.2.1 Visual Approaches in the Humanities

Digital 3D models are used in several humanities disciplines with highly differing settings. In comparison to text-related disciplines, the employment of digital methods related to image or object analysis recently became a major trend. Possible reasons may be the diverse nature of the methods used in disciplines focusing on these types of artifacts [27], but also the heterogeneous level of establishment of digital research methods in those disciplines [11]. Although all disciplines in the humanities are dealing with vision and visualization, some disciplines are particularly engaged here:

- **Digital humanities**, despite various attempts [28–32], is still defined in a blurred and heterogeneous way [31, 33]. From a historical perspective, the digital humanities have evolved since the mid-2000s through the development of an independent epistemic culture from historical computer science and "humanities computing" [34–38]. There is a broad consensus that digital humanities deal with "the application of technology to humanities work" [33].The data foci of digital humanities are texts, audio-visual content, images, and objects. While the use of digital methods in the text-oriented disciplines is currently widely established and standardized [39, p. 10], the scope of

digital methods related to images and other visual objects based on vision rather than close reading remains—despite various attempts [1, 40–43]—essentially uncharted.

- **Art and architectural history studies** investigate mainly works of art and architecture from the late Antiquity to the modern age [44] to provide insights into their origin and meaning [45], their spatial, social, and political preconditions and effects [46]. Methods for investigating genetic and morphologic connections are covered by analyzing style [47] and structure [48]. Another important range of methods is concerned with the meaning of the works of art (iconography) and systems of meaning (iconology) [47].

- **Museology** focuses on the presenting and collecting of cultural heritage, and ways to educate the public [49]. Digital technologies are used to enhance museum visits, e.g., visitor information systems and didactically enhanced applications. Other scenarios are virtually accessible collections and virtual museums, which have no counterpart in the real world [50].

- **Archaeology** investigates tangible remains and evidence of human culture [51, p. 11] to generate a representation of what exists now and closely approximates what may have once been [52]. Often, it is not possible to physically preserve the archaeological site, making thorough documentation and data collection highly relevant. Surveying techniques [53–57] and traditional photos and plans are used to document excavations.

- **Architecture** deals with the design and construction of built environments. Architecture is usually part of engineering or design sciences and deeply linked to the processes of design and of understanding, learning, and teaching spatial imagination. Although digital 3D models are frequently used, especially the creation of haptic architectural models has not yet fully shifted into the virtual world [58].

- **Heritage studies** comprise a variety of approaches to human culture and behavior related to heritage [59, 60]. Relevant strands are derived from humanities, social sciences, design and engineering, most frequently anthropology, history, and architecture [61].

Citizen Science and 3D Models A large amount of 3D heritage content is user-generated. Sketchfab, currently the largest repository for 3D content, hosted 100,000 3D cultural heritage models in 2019, representing 30% of all 3D models on this platform [62]. User creation is strongly supported by the availability of ready-to-use photogrammetric applications and open-source 3D modeling tools. In terms of level of participation (Fig. 4.1), most citizen science projects use crowdsourcing as the involvement of "non-scientists to help to analyze or collect data as part of a researcher-led project" [63] p. 259]. Examples include collecting and processing images as a prerequisite for 3D photogrammetry [64], or crowd-based creation of 3D models [65, 66]. Co-design "involves citizens into the research process from its beginnings, or the stimulus for the research project originates from the citizens" [67 p. 4]. Although more

prominent in humanities research [68], co-design is frequently used for 3D content and experience design for museums [69, 70] or (serious) history games [71]. Besides the challenges of participatory processes such as user activation and management, task definition or quality control [72], citizen science in the humanities has to handle complex, non-standardized, and knowledge-intensive tasks, which are challenging to operationalize and to assess for scientific quality of processes and outcomes [73, 74]. Other activities involving citizens in open science processes related to 3D modeling include metadata enrichment and annotation of 3D models [75].

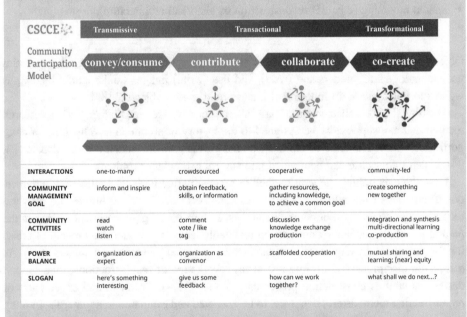

Fig. 4.1 The CSCCE Community Participation Model distinguishes between several types of citizen engagement [76]

4.2.2 Visual Digital Humanities

Digital humanities disciplines dealing with the visual share a grounding in visual literacy, that is "the abilities to understand (read), and use (write) images (and spatial objects), as well as to think and learn in terms of images (and spatial objects)" [77, p. 26]. Against this background, the term "visual digital humanities" [78] was coined to cover research approaches in the digital humanities dependent on both consuming and producing pictorial and spatial, rather than textual, information to answer research questions [79]. Visual

digital humanities encompass computational-supported research on complex visual information to treat research questions and interests from the humanities (e.g., a composition of complex figurative paintings), concerning aspects of data collection; data retrieval; reconstructing, simulating, and producing objects (e.g., 3D models); administering and organizing people and objects [80, 81]. Tasks include the collection, semantic enrichment, and analysis of complex visual information, and the creation of imagery:

- Image analysis (e.g., pattern analysis of large-scale image collections)
- Perception-based techniques (e.g., visuospatial analysis of architectural objects)
- Spatial modeling (e.g., 3D reconstruction of historical architecture)
- Visualization (e.g., sketching for visuospatial reasoning)

Objects are cultural heritage artifacts and images, and scholars in visual digital humanities use technologies to "understand (read), and use (write) images [and spatial objects], as well as to think and learn in terms of images [and spatial objects]" [82].

The digital 3D reconstruction of past, altered, or never-realized buildings is a research method that can supposedly be assigned to the history of architecture. This kind of categorization within academic disciplinary boundaries is part of a much broader debate [83, 84], which in our case can be divided into several exemplary problems.

First, the overarching, general method of reconstruction finds its application in numerous disciplines of the humanities (of course subjects outside of the humanities also use reconstruction to arrive at or communicate research results, e.g., experimental setup in the natural sciences). Since a reconstruction inevitably leads to a model, the process of creating the model can be cited as part of the method, especially in technical subjects [85]. As a research discipline, architecture has always worked with reconstructions, models, and design- as well as construction processes [86, pp. 73–74]. Criticism and experiences of reconstruction methods are, therefore, to be expected and evaluated in an interdisciplinary way.

Secondly, despite limiting our case to historical architecture, no sharp disciplinary boundary can be drawn. The thematic intersection of the archaeological subjects, architectural history from the perspective of art history, building research from the perspective of the architectural faculties at technical universities as well as the sciences of monument preservation and museum didactics, is simply too large. Differences can at best be found in the academic tradition rather than in the subject matter. Since the epistemological differences mostly relate to the questions posed before or during the reconstruction process, the motives for the differences are not clear. The motives for creating digital 3D models are directly dependent on the creator's professional tradition.

Thirdly, in digital 3D reconstruction, team members of different academic backgrounds and specialist traditions usually work together. Clients have certain expectations and prior knowledge about the object to be reconstructed and thus set the necessary framework conditions. 3D modelers possess both the technical skill and craft to create the reconstruction. Again, the professional tradition of the 3D modeler can have a considerable influence on the process and outcome (i.e., the 3D model), not least on the choice of modeling software. As a user, not a developer, the 3D modeler has no influence on the 3D modeling software. Therefore, computer graphics is an aspect of digital 3D reconstruction that sometimes receives too little attention but has a decisive influence on its result. The mediator between the client and the 3D modeler is often a technical expert who structures the knowledge about the reconstruction object in terms of their own specific field. All these roles may be taken by people in the same professional tradition or even the same person. Nevertheless, the resulting 3D reconstruction is highly dependent on the experience gained from the individual steps.

In an ideal scenario, the client controls the entire reconstruction process according to their requirements, the 3D modeler has the technical and professional prerequisites, and a computer scientist guarantees individual computer graphic requirements. The latter applies to the virtual environment (i.e., modeling software) in which the 3D model is created and the communication of the results (→Workflows). The technical expert also accompanies the entire process, from the research on which to base the reconstruction to evaluating and documenting the results.

In view of these idealized, highly specialized steps, disciplinary boundaries are obstacles that must be overcome in the collective work process. Therefore, digital 3D reconstruction should possibly even be treated as an interdisciplinary research field of its own. As is evident from the history of models (→Basics and Definitions), digital 3D reconstruction developed from a long-established specialist tradition. It remains to be clarified whether an independent culture of knowledge is developing across that will reach its full potential beyond existing academic disciplinary boundaries.

4.3 Scholars and Topic Areas

Another approach to study scientific communities starts from the assumption that publications such as conference papers and journals are main podia for knowledge sharing in academia [87]. What is the background of people who are actively publishing in the field of cultural heritage? Despite various attempts to attract researchers from other parts of the world, e.g. at conference locations in non-European countries, the community is primarily European.

Within Europe the majority of researchers in the field of digital heritage are Italian, followed by Germans and Greek (Fig. 4.2). What are disciplinary backgrounds of authors? Concerning findings shown in Fig. 4.3, a majority of participants assorted themselves to humanities. Most frequently named within this discipline was archaeology [88].

Concerning the individual topic areas (Fig. 4.4), data management was most frequently named, ranging from GIS and BIM to metadata schemes and data architecture. These were followed by data acquisition, photogrammetry, laser scanning, and other surveying technologies. Many responses to the survey on topic areas did not fit into the predefined categories and were subsumed in "Others"—in most cases, specific methods, or objects

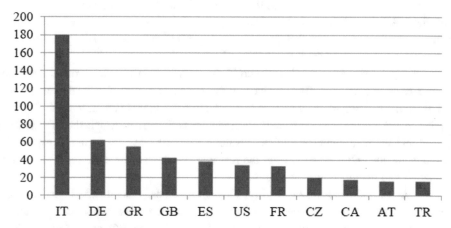

Fig. 4.2 Nationality of scholars in the field of digital heritage (Online Survey, conducted in 2016, Top 10 out of n = 693) [87]

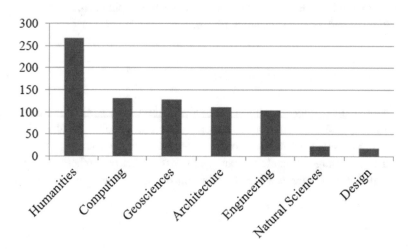

Fig. 4.3 Disciplinary background of conference participants (Online survey, conducted in 2016, n = 752) [87]

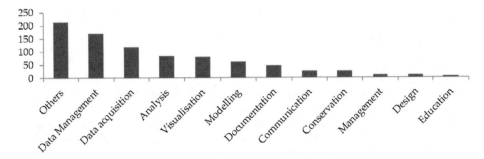

Fig. 4.4 Topic areas in 3D modeling in the humanities (Online survey, n = 825 conducted in 2016) [90]

of research. A discourse in conference publications is primarily driven by technologies, and the most common keywords refer to the technologies used. Most research is around data concerned with acquisition and management, visualization, or analysis. Moreover, the observed scientific discourse closely refers to practical projects relating to specific cultural objects, technologies, or practices [87]. Both indications lead to the assumption that the observed scientific community is foremost a community of practice [89].

4.4 Scholarly Culture

Does an independent epistemic culture exist apart from historiography and historical culture? That is, is digital 3D reconstruction an independent discipline? A comparison of the characteristics of scholarly fields by Armin Krishnan [84] shows that digital 3D construction has these characteristics. Counterexamples assign these characteristics to existing research fields (Table 4.1).

Due to the persistence of established disciplinary traditions, no clear demarcation or independent research field can be clearly derived for the digital 3D reconstruction, much less for the digital 3D reconstruction of historical architecture. It remains equally questionable whether it makes sense to subdivide academic disciplines, as interdisciplinary or within an existing discipline, makes sense, or creates new obstacles. The most serious obstacle that limits the development of 3D digital reconstruction is interdisciplinary (→Workflows).

The challenge is to bridge historical research tradition and information technological developments in application. This is about a discrepancy regarding the use of the 3D reconstruction. Is it a means to answer a research question, which is written down or visualized, published, and in this traditional way integrated into academic discourse? In this case, the digital 3D reconstruction would be a sub-discipline of historical sciences and its academic traditions. Or can the 3D model itself represent knowledge, in that as

Table. 4.1 Characteristics of scholarly fields [84] and assessment for digital 3D reconstruction in the German-speaking area

Criteria for an independent scholarly field:	Assessment
Is there a particular topic of research?	● The digital 3D model and not the facts represented by it can be seen as the overarching object of research. ● The digital 3D model can just as well be seen as an extended digital form of a haptic architectural model, which is part of architectural history as a research object and source.
Can one observe an accumulation of specialized knowledge?	● The high degree of specialization of the individual actors in the creation process highlights the accumulation of specific knowledge and experience in digital 3D reconstruction. ● Much of this specialized knowledge and experience is developed from the interaction of sub-disciplines of existing disciplines such as architecture, computer graphics, archaeology, architectural history, building research, monument preservation, and museum didactics.
Have specific theories and concepts been developed?	● Although many theories and concepts are not yet fully established, examples can be named: representational concepts of historical uncertainties; immersion in 3D space; unifying 3D models for comparative reasoning; semantic modeling of cultural heritage, etc. ● The theories and concepts listed are already being discussed in some cases in the respective disciplines.
Does an independent terminology exist?	● This is borrowed from existing subject traditions, but often culminates in an independent terminology due to technical intermingling.
Has a specific research method been established?	● Due to the creation process of the 3D models in virtual space, this is a given, but it cannot yet be grasped as an established method. Best practice does not yet exist, which leads to a variety of approaches. ● The research method could be seen as a technical advancement of established forms of haptic modeling or 2D reconstruction.
Can institutionalization be observed?	● Departments of visual architecture exist but are subordinate to traditional fields of research.

an information carrier it makes accessible an incalculable number of research questions and findings in a fundamentally different way than the narrative text, thereby changing the research process as a whole?

In addition to its function as a medium of communication, either internally within a project or to the specialist community, the 3D model is above all a dataset that can both be interpreted by humans in a very intuitive and location-independent way and calculated by computers. The areas of application cannot yet be fully specified, but a possible future can already be postulated.

Regarding an epistemic culture, a wide variety of research and application topics are related to 3D reconstruction, each with specific conferences, journals, and frequently contributing researchers and institutions [87]. With Nowotny et al. and De Solla Price, one could see 3D reconstruction as a mode 2 research [91–93] that is interdisciplinary, uses machines, and has joint intellectual property. Consequently, 3D reconstruction shares its disciplinary culture with both, engineering and the humanities [78].

Summary This chapter gives the reader a basic understanding of the scholarly communities that deal in the broadest sense with 3D reconstructions, the opportunities and challenges involved in interdisciplinary research within these communities. It also introduces the prerequisites for working on a 3D reconstruction, explored in detail in the following chapter.

Key literature

- Becher, T., *Academic Disciplines*, in *Academic Tribes and Territories: Intellectual Enquiry and the Cultures of Disciplines*, T. Becher, Editor. 1989, OPEN UNIVERSITY PRESS: Milton Keynes. p. 19–35 [83].
- Krishnan, A., *What are academic disciplines. Some observations on the Disciplinarity vs. Interdisciplinarity debate.* 2009, Southampton: University of Southampton. National Centre for Research Methods [84].
- Münster, S., *Digital Cultural Heritage as Scholarly Field—Topics, Researchers and Perspectives from a bibliometric point of view.* Journal of Computing and Cultural Heritage, 2019. 12(3): pp. 22–49 [87].

References

1. Arnold D et al (2008) EPOCH research agenda – final report
2. Dilthey W (1970) Der Aufbau der geschichtlichen Welt in den Geisteswissenschaften
3. Gibbons G (2012) Visualisation in archaeology project. Final report
4. Stroeker N et al (2012) Survey report on digitisation in European Cultural Heritage Institutions 2012
5. Stroeker N et al (2014) Survey report on digitisation in European Cultural Heritage Institutions 2014
6. DARIAH-EU European Research Infrastructure Consortium Digital Methods and Practices Observatory Working Group. https://www.dariah.eu/activities/working-groups/wg-digital-methods-and-practices-observatory-dimpo/. Accessed 9 June 2014
7. Münster S et al (2021) Digital topics on cultural heritage quantified. Built Heritage
8. Ulutas Aydogan S et al A (2021) framework to support digital humanities and cultural heritage studies research. In: Research and education in urban history in the age of digital libraries. Springer International Publishing, Cham, pp 237–267

9. Roche N et al (2019) Fostering cooperation in the European Union on skills, training and knowledge transfer in cultural heritage professions. Report of the OMC (Open Method of Coordination) working group of member states' experts
10. NeMo (2021) Follow-up survey on the impact of the COVID-19 pandemic on museums in Europe. Final report
11. Hicks D (2006) The four literatures of social science. In: Moed HF et al (eds) Handbook of quantitative science and technology research: the use of publication and patent statistics in studies of S&T systems. Springer Science & Business Media, Heidelberg, pp 473–496
12. Leydesdorff L et al (2011) The structure of the arts & humanities citation index: a mapping on the basis of aggregated citations among 1,157 journals. J Am Soc Inform Sci Technol 62(12):2414–2426
13. Terras MM (2006) Image to interpretation. An intelligent system to aid historians in reading the Vindolanda texts
14. Grandjean M et al (2016) A social network analysis of Twitter: Mapping the digital humanities community. Cogent Arts & Humanit 3(1):1171458
15. Scollar I (1997) 25 years of computer applications in archaeology. CAA 1997
16. Tenopir C et al (2008) Electronic journals and changes in scholarly article seeking and reading patterns. D-Lib Mag 14(11/12):1–13
17. Beaudoin JE et al (2011) Finding visual information: a study of image resources used by archaeologists, architects, art historians, and artists. Art Doc 30(2):24–36
18. Münster S et al (2018) Image libraries and their scholarly use in the field of art and architectural history. Int J Digit Libr 19(4):367–383
19. Jacobs S (2006) Models of scientific community: Charles Sanders Peirce to Thomas Kuhn. Interdisc Sci Rev 31(2):163–173
20. Schophaus M et al (2003) Von Brücken und Einbahnstraßen. Aufgaben für das Kooperations-management interdisziplinärer Forschung. Discussion paper Nr. 08/03
21. Knorr-Cetina K (1999) Epistemic cultures. How the sciences make knowledge
22. Weingart P (1987) Interdisziplinarität als List der Institutionen. In: Kocka J (ed) Interdisziplinar-ität. Praxis - Herausforderung - Ideologie. Suhrkamp, Frankfurt a. M., pp 159–166
23. Knorr-Cetina K (2002) Die Fabrikation von Erkenntnis
24. Organisation for Economic Co-operation and Development (2002) Frascati manual. Proposed standard practice for surveys on research and experimental development
25. Organisation for Economic Co-operation and Development (2007) Revised field of science and technology (FOS) classification in the Frascati manual
26. Semenova E et al (2007) Eine Ontologie der Wissenschaftsdisziplinen. Entwicklung eines Instrumentariums für die Wissenskommunikation. In: Ball R (ed) Wissenschaftskommunikation der Zukunft, 4. Konferenz der Zentralbibliothek im Forschungszentrum Jülich, 6–8 November 2007, vol Band 18. Reihe Bibliothek/Library edn. Schriften des Forschungszentrums Jülich, Jülich, pp 61–69
27. Long MP et al (2014) Supporting the changing research practices of art historians
28. Terras M et al (2013) Defining digital humanities. A reader
29. Carter BW (2013) Digital humanities: current perspective, practices, and research
30. Gold MK (2012) Debates in the digital humanities
31. Alvarado R (2011) The digital humanities situation. The transducer May 11th, 2011
32. Kirschenbaum MG (2010) What is digital humanities and what's it doing in English depart-ments? ADE Bull 150:55–61
33. Gibbs FW (2011) Digital humanities definitions by type. In: Terras M et al (eds) Defining digital humanities. A reader, vol 19. Taylor & Francis, Milton Park
34. Svensson P (2009) Humanities computing as digital humanities. Digit Humanit Q 3(3)

35. Davidson CN et al (2008) Humanities 2.0: promise, perils, predictions. PMLA-Publ Mod Lang Assoc Am 123(3):707–717
36. Hockey S (2004) The history of humanities computing. In: Schreibman S et al (eds) A companion to digital humanities. Blackwell, Oxford
37. Svensson P (2010) The landscape of digital humanities. Digit Humanit Q 4(1)
38. Nyhan J et al (2016) Computation and the humanities. Towards an oral history of digital humanities
39. Bundesministerium für Bildung und Forschung (2014) Rahmenprogramm Geistes-, Kultur- und Sozialwissenschaften
40. Bodenhamer DJ et al (2010) The spatial humanities. GIS and the future of humanities scholarship
41. Bentkowska-Kafel A et al (2006) Digital visual culture. Theory and practice. Computers and the history of art, yearbook
42. Frischer B et al (2008) Beyond illustration. 2D and 3D digital technologies as tools for discovery in archaeology. BAR international series 1805
43. Ch'ng E et al (2013) Visual heritage in the digital age. arthistoricum.net, Heidelberg
44. Dilly H (1979) Kunstgeschichte als Institution. Studien zur Geschichte einer Disziplin
45. Locher H (2010) Kunstbegriff und Kunstgeschichte – Schlosser, Gombrich, Warburg. In: Bałus W (ed) Die Etablierung des Faches Kunstgeschichte in Deutschland, Polen und Mitteleuropa. Warszawa, pp 391–410
46. Held J et al (2007) Grundzüge der Kunstwissenschaft. Gegenstandsbereiche, Institutionen, Problemfelder
47. Seippel R-P (1989) Architektur und Interpretation. Methoden und Ansätze der Kunstgeschichte in ihrer Bedeutung für die Architekturinterpretation
48. Suckale R (2001) Stilgeschichte. Kunsthistorische Arbeitsblätter 11:17–26
49. Carrozzino M et al (2010) Beyond virtual museums: Experiencing immersive virtual reality in real museums. J Cult Herit 11(4):452–458
50. Schweibenz W (2004) The development of virtual museums. ICOM News 3:3
51. Renfrew C et al (2005) Archaeology. The key concepts
52. Rua H et al (2011) Living the past: 3D models, virtual reality and game engines as tools for supporting archaeology and the reconstruction of cultural heritage - the case-study of the Roman villa of Casal de Freiria. J Archaeol Sci 38(12):3296–3308
53. Christofori E et al (2013) Recording cultural heritage using terrestrial laserscanning – dealing with the system, the huge datasets they create and ways to extract the necessary deliverables you can work with. Int Arch Photogram Remote Sens Spat Inf Sci XL5-W2:183–188
54. Clini P et al (2013) All-in-one laser scanning methods for surveying, representing and sharing information on archaeology. Via Flaminia and the Furlo tunnel complex. Int Arch Photogram Remote Sens Spat Inf Sci XL-5/W2:201–206
55. Lasaponara R et al (2011) Flights into the past: full-waveform airborne laser scanning data for archaeological investigation. J Archaeol Sci 38(9):2061–2070
56. Brutto ML et al (2012) Computer vision tools for 3d modelling in archaeology. In: Ioannides M (ed) Progress in cultural heritage preservation – EUROMED 2012, pp 1–6
57. Martin-Beaumont N et al (2013) Photographer-friendly work-flows for image-based modelling of heritage artefacts. Int Arch Photogram Remote Sens Spat Inf Sci XL-5/W2; XXIV international CIPA symposium, 2–6 September 2013, Strasbourg, pp 421–424
58. Morris M (2006) Models: architecture and the miniature (architecture in practice). Southern Gate, Chichester
59. Silverman H (2014) Heritage theory. In: Smith C (ed) Encyclopedia of global archaeology. Springer, New York, New York, NY, pp 3332–3337

60. Harrison R (2013) Heritage: critical approaches
61. Wells J (2017) What is critical heritage studies and how does it incorporate the discipline of history?
62. Flynn T (2019) Over 100,000 cultural heritage models on Sketchfab
63. Gura T (2013) Citizen science: amateur experts. Nature 496(7444):259–261
64. Bonacchi C et al (2014) Crowd-sourced archaeological research: the micropasts project. Archaeol Int 17:61–68
65. Vincent ML et al (2015) Crowd-sourcing the 3D digital reconstructions of lost cultural heritage. In: 2015 digital heritage. IEEE, pp 171–172
66. Gerth B et al (2005) 3D modeling for non-expert users with the castle construction kit v0.5. In: Mudge M et al (eds) 6th international symposium on virtual reality, archaeology and cultural heritage (VAST 2005). Eurographics Association, Pisa, pp 49–57
67. Umweltbundesamt (2017) Konzept zur Anwendbarkeit von Citizen Science in der Ressortforschung des Umweltbundesamtes
68. Popple S et al (2016) Tools you can trust? Co-design in community heritage work. In: Borowiecki KJ et al (eds) Cultural heritage in a changing world. Springer International Publishing, Cham, pp 197–214
69. Claisse C et al (2017) Containers of stories: using co-design and digital augmentation to empower the museum community and create novel experiences of heritage at a house museum. Des J 20(sup1):S2906–S2918
70. Avram G et al (2016) Co-designing encounters with digital cultural heritage. In: Paper presented at the proceedings of the 2016 ACM conference companion publication on designing interactive systems, Brisbane, QLD, Australia
71. Cyberpiper 1867 Historical role play. https://www.roblox.com/games/3030166262/1867-Historical-Role-Play. Accessed 29 Jan 2022
72. Münster S et al (2017) How to involve inhabitants in urban design planning by using digital tools? An overview on a state of the art, key challenges and promising approaches. Procedia Comput Sci 112:2391–2405
73. Elliott KC et al (2019) Philosophical foundations for citizen science. Citiz Sci: Theory Pract 4(1)
74. Prats López M et al (2020) A knowledge perspective on quality in complex citizen science. Citiz Sci: Theory Pract 5(1):15
75. Lozana Rossenova ZS, Vock R, Sohmen L, Günther L, Duchesne P, Blümel I (2022) Collaborative annotation and semantic en-richment of 3D media: a FOSS toolchain. In: Proceedings of the 22nd ACM/IEEE joint conference on digital libraries (JCDL '22). Association for Computing Machinery, New York, NY, USA, Article 40, pp 1–5. https://doi.org/10.1145/3529372.3533289
76. Woodley L, Pratt K (2020).' The CSCCE community participation model – a framework to describe member engagement and information flow in STEM communities'. Zenodo. https://doi.org/10.5281/zenodo.3997802
77. Avgerinou M (2001) Towards A visual literacy index. In: Griffin RE et al (eds) Exploring the visual future: art design, science & technology. IVLA, Loretto, PA, pp 17–26
78. Münster S et al (2020) The visual side of digital humanities: a survey on topics, researchers, and epistemic cultures. Digit Scholarsh Humanit 35(2):366–389
79. Sattler M (2014) The visual humanities and the future of communication. Review of graphesis: visual forms of knowledge production by Johanna Drucker. Harvard University Press. ZETEO (10.21.2014)
80. Heusinger L (1989) Applications of computers in the history of art. In: Hamber A et al (eds) Computers and the history of art. Mansell Publications, London and New York, pp 1–22

81. Bentkowska-Kafel A (2013) Mapping digital art history
82. Horton J (1983) Visualliteracy and visual thinking. In: Burbank L et al (eds) Contributions to the study of visual literacy. International Visual Literacy Association, Bloomington, pp 92–106
83. Becher T (1989) Academic disciplines. In: Becher T (ed) Academic tribes and territories: intellectual enquiry and the cultures of disciplines. OPEN UNIVERSITY PRESS, Milton Keynes, pp 19–35
84. Krishnan A (2009) What are academic disciplines. Some observations on the Disciplinarity vs. Interdisciplinarity debate
85. Sachse P (2002) Idea materialis. Entwurfsdenken und Darstellungshandeln. über die allmähliche Verfertigung der Gedanken beim Skizzieren und Modellieren.
86. Messemer H (2020) Digitale 3D-Modelle historischer Architektur. Entwicklung, Potentiale und Analyse eines neuen Bildmediums aus kunsthistorischer Perspektive. Computing in Art and Architecture edn.
87. Münster S (2019) Digital cultural heritage as scholarly field – topics, researchers and perspectives from a bibliometric point of view. J Comput Cult Herit 12(3):22–49. https://doi.org/10.1145/3310012
88. Münster S (2017) A Survey on topics, researchers and cultures in the field of digital heritage. ISPRS annals of the photogrammetry. Remote Sens Spat Inf Sci IV-2/W2:157–162. https://doi.org/10.5194/isprs-annals-IV-2-W2-157-2017
89. Lave J et al (1991) Situated learning: legitimate peripheral participation
90. Eiteljorg H (2003) CAD: a guide to good practice (Ahds guides to good practice)
91. Nowotny H, Scott P, Gibbons M (2003) Introduction. Minerva 41:179–194
92. Hessels LK, Lente HV (2007) Re-thinking new knowledge production: A literature review and a research agenda. Utrecht, Utrecht University
93. De Solla Price D (1963) Little science - big science

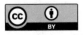

Workflows

5

Currently, digital reconstructions are mainly a process in one single context by interdisciplinary workgroups using expert technologies. 3D reconstructions in the humanities are primarily created within long-term interdisciplinary projects. This chapter provides an overview of the team processes and workflows to create 3D reconstructions. Interdisciplinary teamwork creates specific challenges due to the different work processes of the disciplines involved—e.g., humanities, design, and computing. Since 3D reconstructions are projects, both processes and quality need to be managed. This chapter contains a set of empirically grounded recommendations for the organization and management of 3D reconstruction projects.

Guiding questions
- What are generic process models for 3D reconstruction projects?
- What are typical project settings?
- What are the recommendations for those projects?

Basic terms
- Interdisciplinarity
- Project management

As highlighted in the previous chapter, interdisciplinary collaboration is a key feature of many 3D modeling projects in the humanities; this chapter highlights some key features and strategies for cooperation.

© The Author(s) 2024
S. Münster et al., *Handbook of Digital 3D Reconstruction of Historical Architecture*,
Synthesis Lectures on Engineers, Technology, & Society 28,
https://doi.org/10.1007/978-3-031-43363-4_5

Further reading: Research on Workflows

In contrast to philosophical approaches, little empirical research exists on practices and users of digital 3D modeling in the humanities [1]. As an example, Huvila investigated user roles and practices in archaeology [2, 3] as well as certain practices within the ARKDIS project [4]. Another empirical perspective is the research on usability and requirements for software design for humanities researchers, which were investigated within the VERA project [5, 6].

5.1 The Process of 3D Reconstruction

The process of digital 3D reconstruction encompasses the creation of a virtual modelby means of software tools, which is mostly done by specialized modelers, followed by visualization, through which the model is rendered into a presentation format. This process is usually closely accompanied by historical research through which a sound understanding of the object to be modeled is developed on the basis of sources that provide information from the past [7–9].

Further reading: The 3D Digitization Process

For 3D digitization, process, and workflow schemes [10–13] differ greatly by application scenario parameters, e.g., retrieval technology and heritage object parameters. Workflows involve two key aspects: documentation (data acquisition, e.g., of image or range data, and registration) and 3D modeling (computing into a 3D model, including point cloud generation, structuring and modeling, and texture mapping) [14, 15].

Data Acquisition

Data acquisition quality is influenced by several attributes [16, 17]:

- Resolution: size and granularity of the samples.
- Accuracy of the measure: variation from the original.
- Repeatability.
- Environmental sensitivity including robustness of the acquisition method under different climate conditions (e.g., light, wind, temperature).

Framework conditions are set by acquisition time, portability of the equipment, flexibility (e.g., to retrieve at different conditions), and price [15]. Depending on attributes, framework conditions and purpose different technologies are used for 3D data acquistion (Figs. 5.1 and 5.2).

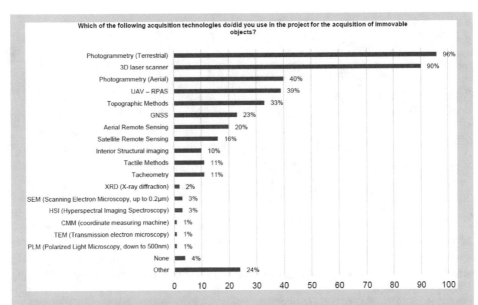

Fig. 5.1 Acquisition technologies used in projects relating to immovable objects [18, p. 30]

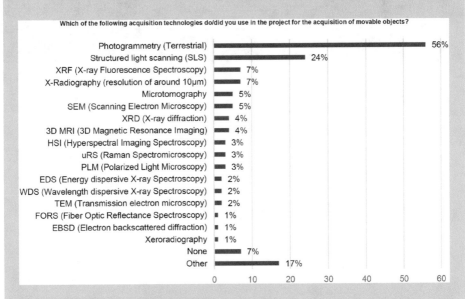

Fig. 5.2 Acquisition technologies used in projects relating to immovable objects [18 p. 31]

Data Processing

Data processing comprises a wide range of mostly algorithmic approaches to creating a 3D model out of the acquired data. The aim of related workflows is to set up a multi-stage data processing pipeline, which varies by data type, quality, expected results, and object(recent examples for museum artifacts [19], monuments [20]). Pipeline design is influenced by objectives including levels of output quality, velocity, reproducibility, flexibility, robustness, and automation [21, 22]. This contradicts with the huge variety of cultural heritage qualities [23, 24]. Recent achievements use data fusion [21] to improving model quality.

In view of the resulting division of labor, it is essential to consider cooperation, communication, and quality management. The entire working process of virtual 3D reconstruction can roughly be divided into sources, modeling, and visualization (Fig. 3.1), which may be made up of numerous steps and tasks and take on different forms (Fig. 5.3).

Further reading: 3D Reconstruction Step-By-Step Tutorial
This tutorial was recorded in 2020 as a video screencast and describes the 3D reconstruction of a historical townhouse from a cadastral plan and photography for the web. Tools and services used are the Overpass Service,[1] QGIS,[2] and Maxon Cinema 4D (Fig. 5.3).[3]

[1] https://wiki.openstreetmap.org/wiki/Overpass_API/Overpass_QL#out, accessed on 1.2.2023.

[2] https://www.qgis.org, accessed on 1.2.2023.

[3] https://www.maxon.net, accessed on 1.2.2023.

Fig. 5.3 Example workflow: printout of a video tutorial for the 3D reconstruction of a historical townhouse from a cadastral plan and photography for the web [25]

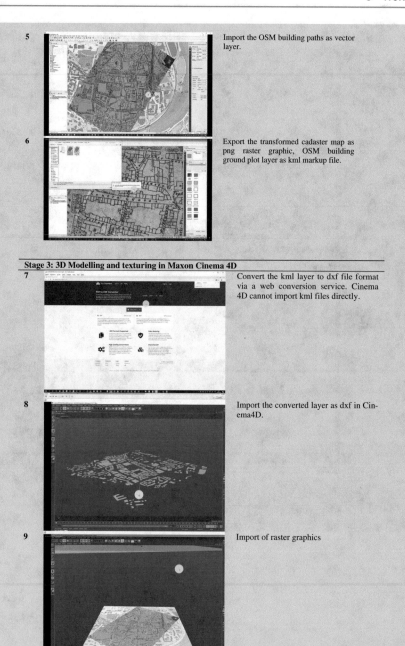

| 5 | Import the OSM building paths as vector layer. |
| 6 | Export the transformed cadaster map as png raster graphic, OSM building ground plot layer as kml markup file. |

Stage 3: 3D Modelling and texturing in Maxon Cinema 4D

7	Convert the kml layer to dxf file format via a web conversion service. Cinema 4D cannot import kml files directly.
8	Import the converted layer as dxf in Cinema4D.
9	Import of raster graphics

Fig. 5.3 (continued)

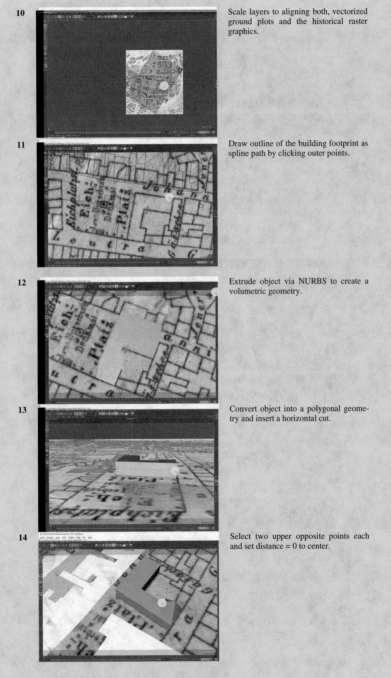

10 Scale layers to aligning both, vectorized ground plots and the historical raster graphics.

11 Draw outline of the building footprint as spline path by clicking outer points.

12 Extrude object via NURBS to create a volumetric geometry.

13 Convert object into a polygonal geometry and insert a horizontal cut.

14 Select two upper opposite points each and set distance = 0 to center.

Fig. 5.3 (continued)

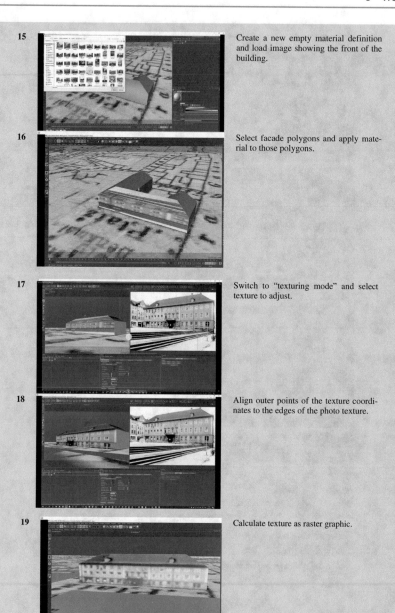

15 Create a new empty material definition and load image showing the front of the building.

16 Select facade polygons and apply material to those polygons.

17 Switch to "texturing mode" and select texture to adjust.

18 Align outer points of the texture coordinates to the edges of the photo texture.

19 Calculate texture as raster graphic.

Fig. 5.3 (continued)

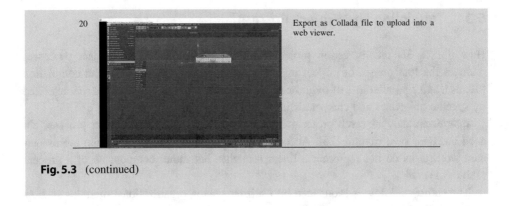

20 | Export as Collada file to upload into a web viewer.

Fig. 5.3 (continued)

5.2 Interdisciplinarity

Interdisciplinarity refers to a "confrontation of several disciplines with a [joint] topic or issue" [26. p. 7]. Related to this, Schelsky speaks of a "partial scientific development unit at the empirical object" [27, p. 72]. Interdisciplinary collaboration is characterized by developing a joint terminology and methodology [28, 29]. Interdisciplinary institutionalization ranges from temporary collaborations to the creation of new "hybrid" research disciplines [30, p. 16], such as the digital humanities as a combination of applied computing fostering research in humanities.

An important distinction, shown schematically in Fig. 5.4, relates to forms of disciplinary collaborations. Multidisciplinarity refers to independent research on a topic by different disciplines. Transdisciplinarity names collaborative development and research on a topic including scientific disciplines as well as other stakeholders, such as non-governmental organizations or special interest groups. This concept is mainly associated with a research on complex and highly social relevant issues such as environmental protection or societal changes [32].

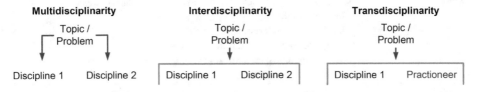

Fig. 5.4 Types of disciplinary cooperation [31, p. 7]

5.3 Modeling the Project Process

How does a 3D reconstruction project work? A general model of project processes includes the four phases of project initiation, planning, implementation, and completion [33, 34], and a parallel task of monitoring and control [35], each of which is characterized by specific objectives and characteristics (Figs. 3.4 and 5.5).

Interdisciplinary research projects do not follow a standardized project process, but each has their own rhythm [26]. Accordingly, the phases named below, and the associated work tasks do not represent a linear sequence but rather components of a process (Table 5.1).

The entire workflow is sequenced into substeps using organizational modules such as work tasks or work packages. Milestones are agreed as transition points between organizational elements, to create deadlines for work actions and to evaluate actual progress compared to planning [38].

Fig. 5.5 Project life cycle [36, 310, p. 91]

Table. 5.1 Phases of interdisciplinary research [26, p. 29f., 37]

Phase	Common goals and questions
Start	Coordinating the project team (interests, positions, competencies) Operationalizing the project goals Drafting the cooperation structure Assigning roles (moderation, work packages) Developing a project plan, selecting dates for evaluation Defining quality criteria
Implementation	Elaborating intermediate and partial steps (detailed planning)
Completion	Securing results and publication Accounting for the cooperation

During intensive work phases in the run-up to "more selective events" (milestones, presentations, reports, etc.) most of the project work is done [26, p. 30]. Tasks that are not essential for achieving results, such as communication work, are neglected in these intense phases. 3D reconstruction projects are Innovative and research-intensive and are thus difficult to plan [39], so unplanned cuts—due to personnel changes or unexpected difficulties—may come to light, creating the need to adjust objectives. A particularly important aspect of academic projects is the sensible design of the overall duration of the project. Newly constituted and interdisciplinary project teams need time to build the team and set up the project [38].

5.4 3D Reconstructions as Interdisciplinary Projects

In digital reconstructions, information technologies serve to produce virtual historical models. Computer science provides the tools, while archaeology and the history of culture, art and architecture, architectural research, and museum studies provide perspectives on the content. Owing to the highly specialized nature of the tools, the model is usually not created by the persons responsible for the content, but, in interdisciplinary projects, by modelers who come from computer science, architecture, geosciences, engineering, and design. The disciplines involved in the 3D reconstruction projects have very different approaches [40]. This requires synchronization and is often the source of problems in practice.

> **Further reading: Generic Process Models of Disciplines Involved in 3D Reconstructions**
> *A computer science view of the visualization process*
>
> From the point of view of computer science, 3D reconstruction is a visualization project. An associated procedure ideally includes the successive steps of data input and data selection, modeling and simulation, and output (Figs. 3.5 and 5.6).
>
>
>
> **Fig. 5.6** Generic visualization process model [41]

Data: The starting point of a visualization is data. Schumann and Brodlie classify data based on their origin: as empirically measured values from a real-world or a theoretical world such as mathematics, or as designed data such as artistic representations from an artificial world, e.g. textual sources or drawn images [42, 43].

Data selection: In terms of process theory, in a historical 3D reconstruction data is selected from sources. Deduction is usually less of a problem than the extrapolation of incomplete source data. In addition to data reduction as proposed by Schumann, the following aspects of data selection arise [42]:

1. Removal of irrelevant data
2. Dataset abstraction
3. Indication of an area of interest
4. Interpolation or extrapolation of missing data
5. Compilation of the required data
6. Selection of subsets.

Modeling: A model is created using computer tools: the geometric shape is defined, virtual lighting and the material properties of the reference object simulated.

Simulation: This step comprises the creation of a geometric model, a definition of texturing, i.e., the assignment of surface color and structure or animation.

Output: The virtual 3D model is available as a digital dataset and as such is only indirectly accessible to both the editor and the viewer. To make it visible and editable, it must therefore be mapped and thus converted into static individual images or more complex mapping contexts such as animations or interactive display formats.

The design process

In the strict sense, design includes finding the form. In a 3D reconstruction, this process involves both architectural design—reconstructing a plan of the building structures [44],—and graphic design of visualizations (Fig. 5.7).

Fig. 5.7 Analysis-synthesis-evaluation model of the design

More recent design theories understand the phases of analysis and synthesis as a unit and thus explain design in terms of a complex circle (Fig. 3.6), which borrows from hermeneutics and systems theory [45]. Reference is made to the principle of "analysis through synthesis" [46, 47, p. 6]. While the ideal technical process has a clear target or termination criteria, design difficulties are generally counted among the "wicked problems" for which no clear endpoint or solutions are possible [48, 49, p. 7]. The process therefore does not end when a goal is achieved, but when the approach to the goal or external termination criteria is deemed sufficient (Fig. 5.8).

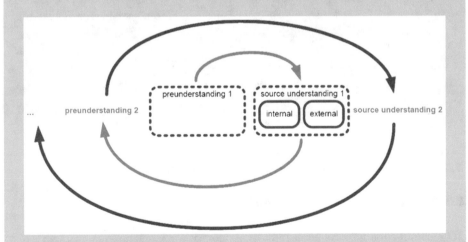

Fig. 5.8 Hermeneutic model of historical science

The historical processes

Similarly, to design processes, the historical research process has a cyclical struc-ture (Fig. 3.7). Since the mid-1950s historical research has become primarily problem-focused [50]. This research paradigm is strongly linked to the emergence of constructivist explanatory models, based on interpreting historical facts and reassessing historical sources. In a constructivist view, each "action […] is pre-ceded by intentions" [51, 52], whereby a source as a residue or tradition represents the intention of its historical creator. In their entirety, historical sources provide an incomplete and often contradictory picture of the past and thus an incomplete database for a 3D reconstruction. This insoluble dilemma ultimately led to the view that historical science is a limited construction [50], and as such cannot provide a reliable, holistic picture of the past. Hermeneutics represents the classic and most widespread investigation paradigm of historical sciences [53], where this qualitative method is understood as a cyclical interplay between the researcher's prior under-standing and understanding of the sources. In terms of process, the latter is based on the former and, by examining sources using the methodical steps of formal "ex-ternal" and content-related "internal" source criticism, the researcher expands their (pre-)understanding.

Since all three modes of work are combined in a 3D reconstruction project this can cause conflicts. A central mark of visualization processes is their decreasing flexibility over a time—with high costs in case of applying unplanned fundamental changes at late stage. Vice versa, hermeneutic processes are generating fundamental insights often late in a research process. Consequently, 3D modelling require balanc-ing between these different work modes and mitigation e.g. by defining parameters which are most likely to become subject of change at later stages.

5.5 3D Reconstruction Project Management

5.5.1 Definition of Project Work

3D reconstruction projects are a form of temporary work organization characterized by systems of rules for coordinating the achievement of goals based on the division of labor [38]. Projects according to DIN 69,901 represent tasks which are "essentially character-ized by the uniqueness of the conditions in their entirety" [54]. Central features of this form of work are task orientation, teamwork, a time limit, and transition [38, 55, 56]. All aspects of controlling projects are conceptually covered by project management. While the project as a phenomenon is at least as old as modernity, the term project management only dates back to the 1970s [57]. In general, project management offers a number of

comprehensive classification schemes and standards [35]. Economics, in particular, provides an almost unmanageable multitude of recommendations and "success factors" for project management [39] as well as countless descriptions of inhibiting factors/ Kerzner defines nine possible reasons for project failure [57]: (1) poor morale, (2) poor motivation, (3) poor human relations, (4) poor productivity, (5) no employee commitment, (6) no functional commitment, (7) delays in problem solving, (8) too many unresolved policy issues, and (9) conflicting priorities between executives, line managers, and project managers.

Aspects of project management essential for theoretical consideration here include organization, goals, planning, quality, and quality management, which are discussed in the following sections.

5.5.2 Project Organization

From an economic perspective, digital 3D reconstruction projects are innovative because they are knowledge- and research-intensive, mostly prototypical, and produce new results and processes [39]. Historical 3D reconstruction projects are often cooperations between academic institutions that are largely independent of one another. Accordingly, such projects are usually organized as a "matrix" [39, 58]. A general feature of a matrix is that employees involved in the project report to several superiors, both in the sending organizational unit and the project coordinator. Such an organizational form has a high success rate and generally high efficiency compared to other organizational models [39], but requires a high level of coordination effort: the project manager's great influence over the superior of the sending institution is beneficial for project processing, though disciplinary powers, responsibility for task delegation, and control should be assigned to the project manager.

Academic projects are a particular form of matrix organization, since disciplinary powers, at least in the academic field, usually lie exclusively with the sending institution. Projects may fail due to the high risk of competing priorities being set by managers of the project and independent institutions involved [57]. According to Hausschild and Salomo [39], another key factor in the success of innovation projects is the physical proximity of participants. Hoegl and Proserpio [59] show that physical proximity not only increases community building and the frequency and variety of information transfer between project members, but also promotes their self-directed coordination; remarkably, spatial proximity does not lead to an improvement in transactional knowledge.

5.5.3 Goals

As innovation projects, 3D reconstruction projects are often a "process in which it is often not at all clear which goal is to be achieved" [38, p. 18]. Such a lack of clarity of purpose results from the high complexity of the task and the associated lack of clarity about the problem structure and unpredictability of problem components [39]. Characteristics of a lack of clear goal include "constant trying, approaching, very often connected with repetition steps" until a result "is selected as useful" [38, p. 18]. From a conflict theory perspective, lacking a clear objective potentially leads to conflicts with regard to the interpretation of a work procedure [39]. In most cases, projects do not pursue a single goal, but a whole series of goals. Such goals can not only have different qualities and priorities, but sometimes also compete [39]—for 3D reconstructions e.g. academic quality vs. completeness vs. impressing results. Finally, different objectives or priorities are often linked to individual or collective perspectives of the persons and institutions involved [39].

5.5.4 Planning and Control

An overarching and general model shows that project planning includes a trade-off between the influencing variables of time, budget, and goals (Fig. 3.8). Limited resources mean that "the 'ideal' solution cannot always be sought for scientific projects" [26, p. 33]. A major problem in the advance planning of innovation processes such as 3D reconstruction projects is the lack of knowledge about the quality of the achievable goal and the path leading there. Information and knowledge deficits require an approximate approach, which is based on a suitable sequencing and prioritization of work tasks.

The question of organizational structures and tools for controlling results, which is closely related to quality management, is closely linked to planning work steps. Delegation and monitoring of tasks and staff is part of vertical organization [60]. Closely related to this is what Kräkel calls the "dilemma of organizational theory" [60, p. 116]: delegation of decision-making authority enables efficient problem solving but requires comprehensive control and coordination to achieve a common overall goal (Fig. 5.9).

Fig. 5.9 Planning parameters of project management [38, p. 116]

There is a broad consensus that, the project manager is of outstanding importance to the success of any project. Other factors are budgets that can be managed flexibly; intensive, informal, and formalized communication; suitable sequencing and monitoring of progress [39]. Hauschildt and Salomo propose a three-step procedure for monitoring project processes [39, p. 505]:

- Ongoing determination of deviations
- Review to determine the cause
- Evaluation of deviations and, if necessary, corrections.

Who does this monitoring, and at what stages, is discussed next in a theoretical consideration of quality management. Another issue is how the people involved in such work are organized. In 3D reconstruction, this includes the organizational structures and forms of cooperation relevant to both the project and the scientific institution or community.

5.5.5 Quality

Quality is the "degree to which a set of inherent characteristics fulfill requirements" [35, p. 180]. Such requirements include, both the outcomes, i.e., **result quality** and compliance with framework conditions on the way to achieving a goal, i.e., **process quality**. Another important distinction is between **quality**, which refers to errors and inconsistencies, and **grade**, which indicates the scope or quality level of a result. Theoretical concepts of quality are presented here with two aims: to consider quality in the work process, one needs to consider approaches to quality management.

Further reading: Recommendations for interdisciplinary 3D reconstruction projects [61]

Workflow
1. run pre-projects to test cooperation, approaches, and support competence development
2. align the project early on with budgets and requirements of funding providers
3. consider the time needed for interpretation and corrections
4. set deadlines promote efficient work
5. make deadlines binding and include incentives or sanctions

Sources
6. finalize collection and analysis of sources best as possible before starting reconstruction

7. if source findings are unclear, make a first draft model to support decision-making

8. decide iteratively in case of unclear findings

9. set editorial deadlines for the inclusion of further sources

Modeling

10. consider easy editing of the model

11. develop, document, and adhere to the model system and structure

12. structure the model based on spatial, temporal, functional, and model organizational aspects (\rightarrow3D Modeling)

13. sort and locate existing source information in space and time, e.g., in plans

Quality management

14. synchronize the quality expectations of all stakeholders at an early stage and recheck frequently

15. in case of multiple sources, define a primary modeling source

16. present omissions or several alternative hypotheses in the model if the findings are unclear

17. develop quality standards, e.g. on detailing, early and maintain them as far as possible

18. develop a strategy for the frequency and timing of corrections

19. make visual comparisons, e.g., of model views and sources

20. to support a visual assessment

Project management

21. subordinate management and coordination tasks in terms of time and personnel

22. allocate tasks and fill positions depending on needed and existing competencies

23. promote intrinsic motivation through "healthy" competition, public perception, and group motivation

Technology

24. allow individual software decisions in case of prior knowledge

25. use widely established exchange formats that are accessible to all stakeholders

Learning

26. in interdisciplinary projects, only teach competencies relevant to the cooperation, i.e., interface knowledge

Sustainability

27. involve participants in opening project processes

28. assign minute takers and create minutes of meetings

Communication

29. communicate too much rather than too little

30. actively communicate and broadly base decisions
31. keep stakeholders regularly informed
32. describe complex problems in several ways when communicating at a distance
33. draw up structured problem lists and communicate them in advance of a meeting
34. use simple language and intuitive formats such as pictures
35. ensure understanding e.g., by asking/repeating
36. use pictures and language as a combined medium of communication
37. use sketches and drawings as aids
38. draw or write comments directly in model visualizations

Presentation of Results

39. present sources and procedures appropriately in the presentation medium
40. carry out usability testing to determine the suitability for the target group

5.5.6 Quality Management

Quality management within a project includes all activities so that a project satisfies the requirements [35]. This includes the aspects of quality planning, its practical application and control. Quality management is thus closely linked to project planning and management. Schmidt identifies comparisons with other projects, points in a project, normative standards and quality models as essential procedures or "reference models" of quality management specifically in academic contexts [62, p. 11ff.]. Especially regarding reference models, it is essential to make the individual quality ideas of all relevant stakeholders transparent and to develop a common idea in this regard [35]. Likewise, quality management includes establishing tools for quality control, which can be done internally or externally and periodically or continuously. One merit of **continuous internal quality assurance** is that project teams have a high degree of social control. A monitoring group integrated into the project structure but outside the actual project work, or filling the role of a quality officer [35], whose tasks include checking compliance with goals or identifying defaults. Alternatively, **external quality control** can be done by people who are completely outside the project structure, such as supervisors from the institutions involved [39]. In contrast, **quality audits** are instruments of **periodic** quality control [62]. In these cases, objectives are used to monitor the status of the work and identify the need for action. Such audits as work meetings or group reviews, can be carried out both internally and by external expert commissions [35, 39]. While primarily aimed at quality assurance in the specific work context, **quality circles** [58] aim to sensitize employees and thus create a generic awareness of quality.

5.6 Phenomena and Strategies for Cooperation

Further reading: Example strategies

- **Competence development through preliminary projects:** The most important characteristics for adequate planning, adjustment, and control are the expertise and experience of the project planner [39]. While only rarely discussed in the literature in this context, it is essential for a subsequent empirical consideration to reduce the complexity of a problem, acquire skills, and test organizational structures through prototypical pilot projects.
- **Project sequencing:** Irrespective of any previous experience, a project plan is usually broken down into organizational units such as work packages and sub-tasks that are limited in terms of time and resource availability. Ideally, these are provided with a defined target level and endpoint, or milestone, enabling deviations from planning to be determined comparatively quickly and the project schedule to be adjusted [38, 39]. 3D reconstruction projects also involve a large number of previously unplanned incisions and changes [61], due to their innovative character and unpredictability, but also to organizational changes such as personnel reshuffles, which creates the need for permanent project control and the adjustment of plans in relation to these changes.
- **Priority lists:** Because innovation and research projects do not usually have a foreseeable target, an order of priorities essential instrument for planning. An important element here is weighing up decision alternatives, to identify and define the most important subgoals that need to be prioritized [39].

As proven empirically [63], many challenges for 3D reconstruction projects are connected to a lack of interdisciplinary understanding. Due to the high complexity and team-based workflows, aspects, and usage practices for communication, cooperation, and quality management are highly relevant within 3D reconstruction projects. Intensive support by images during a reconstruction process could foster interdisciplinary communication, and could be used as "creoles" [64] to exchange and share mental models. For that, it is necessary to synchronize terminologies or to employ common grounds like symbols, colors, or tags [7]. Especially if people with different disciplinary backgrounds are involved, visual media fosters communication and quality negotiations, e.g., by comparing source images and renderings of the created virtual reconstruction. Furthermore, several projects successfully adopted highly standardized conventions from architectural drawings for interdisciplinary exchange. Such decisions and tasks should be started at an early project stage and should be controlled and adapted throughout the entire process. Ideally, such visual coding schemes would be a mental model shared by all members of the project team and would be documented and based on either extant coding schemes, e.g., from

engineering, or would use **natural coding** like physical analogies or concrete depictions [65] to make these issues recognizable and even accessible later. In all cases, images would only support communication and, especially for complex tasks and interdisciplinary exchange, personal contact would be more useful than communicating information over long distances. Resulting challenges include access to and evaluation of models and images to make authorship transparent, as well as references between reconstruction and (explainable) fundamental knowledge such as sources. A specific challenge is the division of the labor that is usually involved in the project. It is evident from published project reports that interpretative 3D reconstruction projects are almost always interdisciplinary in nature, with the teams mostly only coming together temporarily, unlike the situation in companies or institutions [38]. The tasks are usually divided between historical research and creation of the model. Consequently, aspects such as the organization of work, the distribution of tasks, cooperation, and communication, are important [61].

Summary

3D reconstructions are carried out within interdisciplinary innovation projects, which comprise challenges such as open-ended workflows and the need to synchronize different terminology and work processes. With regards to the latter, a big challenge is raised by the different stepping in humanities, computing, and design. Since humanities research refines with the analysis and contextualization of further sources, the technical view of 3D reconstruction seeks a clear problem definition, where fundamental changes at a late stage—common in humanities—cause a huge workload for changing a 3D model.

Concepts

- **Interdisciplinarity:** 3D reconstructions in the humanities are primarily created within long-term interdisciplinary projects. Intensive support by images during a reconstruction process could foster interdisciplinary communication, and could be used as "creoles" [64] to exchange and share mental models. To do this, it is necessary to synchronize terminologies or to employ common grounds like symbols, colors, or tags [7].
- **Project management:** In academic interdisciplinary cooperation, efficient strategies and routines of self-organization often fail to develop. Differing interests and quality expectations as well as weak incentives to finish projects efficiently often cause severe and long-lasting friction, delays, budget overruns, and conflicts between stakeholders. Moreover, team members are mostly matrix organized—in both teams and institutional structures—and multiple tasks are assigned. Even if leaders of academic projects widely influence the setting of general objectives, they have few instruments to motivate or penalize employees and to assign

individual time capacities. As a paradoxon, academic projects are often infinite, where missed deadlines and exceeded budgets are often compensated by other resources and which prioritize "perfect" quality above fit to resources.

Key literature

- Project Management Institute. A Guide to the Project Management Body of Knowledge. PMBOK Guide; PMI: Newtown Square, 2004 [35].
- Hauschildt, J.; Salomo, S. Innovationsmanagement; Vahlen: München, 2007 [39].

References

1. Huvila I (2014) Archives, libraries and museums in the contemporary society: perspectives of the professionals. In: iConference 2014 Proceedings. Berlin, pp45–64
2. Huvila I (2010) To whom it may concern? The users and uses of digital archaeological information
3. Huvila I (2006) The ecology of information work – a case study of bridging archaeological work and virtual reality based knowledge organisation
4. ARKDIS - Archaeological information in the digital society. http://www.abm.uu.se/research/Ongoing+Research+Projects/ARKDIS/. Accessed 9 May 2014
5. Warwick C (2012) Studying users in digital humanities. In: Warwick C et al (eds) Digital humanities in practice. Facet Publishing, London, pp 1–21
6. Fisher CR et al (2009) Integrating new technologies into established systems: a case study from Roman Silchester. Computer applications to archaeology 2009 Williamsburg, Virginia, USA, 22–26 March 2009
7. Münster S (2013) Workflows and the role of images for a virtual 3D reconstruction of no longer extant historic objects. In: ISPRS annals II-5/W1 (XXIV international CIPA symposium), pp197–202
8. Münster S et al (2017) Von Plan-und Bildquellen zum virtuellen Gebäudemodell. Zur Bedeutung der Bildlichkeit für die digitale 3D-Rekonstruktion historischer Architektur. In: Ammon S et al (eds) Bildlichkeit im Zeitalter der Modellierung. Operative Artefakte in Entwurfsprozessen der Architektur und des Ingenieurwesens. eikones. Wilhelm Fink Verlag, München, pp 255–286
9. Bakaoukas AG (2020) Virtual reality reconstruction applications standards for maps, artefacts, archaeological sites and monuments. In: Liarokapis F et al (eds) Visual computing for cultural heritage. Springer International Publishing, Cham, pp 161–176
10. Amico N et al (2021) Ontological entities for planning and describing cultural heritage 3D models creation. ACM J Comput Cult Herit (JOCCH)
11. Letellier R et al (2007) Recording, documentation, and information management for the conservation of heritage places. Guiding principles
12. Boardman C et al (2018) 3D Laser scanning for heritage. Advice and guidance on the use of laser scanning in archaeology and architecture

13. European Commission (2011) Commission recommendation of 27.10.2011 on the digitisation and online accessibility of cultural material and digital preservation
14. Gomes L et al (2014) 3D reconstruction methods for digital preservation of cultural heritage: a survey. Pattern Recogn Lett 50:3–14
15. Remondino F et al (2010) Reality-based 3D documentation of natural and cultural heritage sites—techniques, problems, and examples. Appl Geomat 2(3):85–100
16. Weber M (1988) Die 'Objektivität' sozialwissenschaftlicher und sozialpolitischer Erkenntnis. In: Winckelmann J (ed) Gesammelte Aufsätze zur Wissenschaftslehre. Tübingen
17. Claisse C et al (2017) Containers of Stories: using co-design and digital augmentation to empower the museum community and create novel experiences of heritage at a house museum. Des J 20(sup1):S2906–S2918
18. Ioannides M et al (2020) Study on quality in 3D digitisation of tangible cultural heritage: mapping parameters, formats, standards, benchmarks, methodologies, and guidelines. VIGIE 2020/654 Final Study Report
19. Medina JJ et al (2020) A rapid and cost-effective pipeline for digitization of museum specimens with 3D photogrammetry. PLoS ONE 15(8):e0236417
20. Pepe M et al (2020) An efficient pipeline to obtain 3D model for HBIM and structural analysis purposes from 3D point clouds. Appl Sci-Basel 10(4):1235
21. Pamart A et al (2020) A robust and versatile pipeline for automatic photogrammetric-based registration of multimodal cultural heritage documentation. Remote Sens 12(12):2051
22. Stathopoulou EK et al (2019) Open-source image-based 3d reconstruction pipelines: review, comparison and evaluation. Int Arch Photogram Remote Sens Spat Inf Sci XLII-2/W17:331–338.
23. Ramos MM et al (2015) Data fusion in cultural heritage – a review. Int Arch Photogram Remote Sens Spat Inf Sci XL-5/W7:359–363.
24. Remondino F et al (2017) A critical review of automated photogrammetric processing of large datasets. Int Arch Photogram Remote Sens Spat Inf Sci XLII-2/W5:591–599
25. Münster S (2020) 3D reconstruction for the web with QGIS and Maxon Cinema 4D (Videotutorial)
26. Schophaus M et al (2003) Von Brücken und Einbahnstraßen. Aufgaben für das Kooperationsmanagement interdisziplinärer Forschung (Discussion paper Nr. 08/03)
27. Schelsky H (1966) Das Zentrum für interdisziplinäre Forschung. In: Mikat P et al (eds) Grundzüge einer neuen Universität. Bertelsmann, Gütersloh, pp 71–87
28. Gibbons M (1994) The new production of knowledge. The dynamics of science and research in contemporary societies
29. Münster S et al (2014) Common grounds and representations in cross-disciplinary processes. In: Carlucci D et al (eds) Knowledge and management models for sustainable growth. Institute of Knowledge Asset Management, Basilicata, pp 579–589
30. Klein JT (2000) A conceptual vocabulary of interdisciplinary science. In: Weingart P et al (eds) Practising interdisciplinarity. University of Toronto Press, Toronto, pp 3–24
31. OGC (2012) OGC City Geography Markup Language (CityGML) Encoding Standard, Version 2.0.0
32. Defila R et al (1999) Projektbericht. Panorama Sondernummer: Transdisziplinarität evaluieren – aber wie?:5–11
33. Meredith JR et al (2000) Project management. A managerial approach, fourth edn.
34. Havila V et al (2013) Project-ending competence in premature project closures. Int J Project Manage 31(1):90–99

35. Project Management Institute (2004) A guide to the project management body of knowledge. PMBOK Guide
36. Vargas-Quesada B et al (2007) Visualizing the structure of science
37. Loibl MC et al (2001) Fragen zur Steuerung inter- und transdisziplinärer Forschung nach Aufgabenpaketen und Projektphasen. http://www.ecology.at/projekt/detail/IuT/html/Steuerseiten/quellenmain.htm. Accessed besucht am on 10.1.2014
38. Nausner P (2006) Projektmanagement. die Entwicklung und Produktion des Neuen in Form von Projekten
39. Hauschildt J et al (2016) Innovations management. 6th edn. Vahlen, München.
40. Hou H et al (2007) The structure of scientific collaboration networks in scientometrics. Scientometrics 75(2):189–202
41. Haber RB et al (1990) Visualization idioms. A conceptual model for scientific visualization systems. In: Shriver BD et al (eds) Scientific visualization. IEEE Computer Society, Los Alamitos, pp 149–177
42. Schumann H et al (2000) Visualisierung. Grundlagen und allgemeine Methoden
43. Brodlie KW (1992) Scientific visualization. Techniques and applications; with 15 tables
44. Steinmann F (1997) Modellbildung und computergestütztes Modellieren in frühen Phasen des architektonischen Entwurfs (Dissertation).
45. Loh Uv (2005) Designprozesse als Kommunikation antizipativer Prozesse
46. Gedenryd H (1998) How designers work. Making sense of authentic cognitive activity
47. Jonas W (2004) Designforschung als Argument
48. Roberts NC (2000) Wicked Problems and Network Approaches to Resolution. Visual Argum – Tools Collab Educ Sense-Mak 1(1):1–19
49. Castorph M (2008) Bauteilorientierte Entwurfsprozesse, Architekturlehre, BOE, Sammlung 2002–2008
50. Wengenroth U (1998) Was ist Technikgeschichte?
51. Goering DT (2013) D. Timothy Goering über Gerber, Doris. Analytische Metaphysik der Geschichte. Handlungen, Geschichten und ihre Erklärung. H-Soz-u-Kult 08.01.2013:o. Angabe
52. Gerber D (2012) Analytische Metaphysik der Geschichte. Handlungen, Geschichten und ihre Erklärung
53. Goetz H-W (1993) Proseminar Geschichte. Mittelalter, vol 1719
54. DIN Deutsches Institut für Normung e. V (2009) DIN 69901–5 Projektmanagement – Projektmanagementsysteme – Teil 5. Begriffe
55. Pilbeam C (2013) Coordinating temporary organizations in international development through social and temporal embeddedness. Int J Project Manage 31(2):190–199
56. Lundin RA et al (1995) A theory of the temporary organization. Scand J Manag 11(4):437–455
57. Kerzner H (2003) Project management. A systems approach to planning, scheduling, and controlling, 8th edn.
58. von Rosenstiel L et al (2005) Grundriss der Psychologie. Organisationspsychologie, 9th edn
59. Hoegl M et al (2004) Team member proximity and teamwork in innovative projects. Acad Manag Proc 1:A1–A6
60. Kräkel M (2012) Organisation und Management
61. Münster S (2016) Interdisziplinäre Kooperation bei der Erstellung geschichtswissenschaftlicher 3D-Rekonstruktionen
62. Schmidt U (2010) Wie wird Qualität definiert? In: Winde M (ed) Von der Qualitätsmessung zum Qualitätsmanagement. Praxisbeispiele an Hochschulen. Edition Stifterverband, Essen, pp 10–17

63. Münster S et al (2015) 3D modeling technologies as tools for the reconstruction and visualization of historic items in humanities. A literature-based survey. In: Traviglia A (ed) Across space and time. papers from the 41st conference on computer applications and quantitative methods in archaeology, Perth, 25–28 March 2013. Amsterdam University Press, Amsterdam, pp 430–441
64. Styhre A (2010) Disciplining professional vision in architectural work. Learn Organ 17(5):437–454
65. Tversky B (2002) Spatial schemas in depictions. In: Gattis M (ed) Spatial schemas and abstract thought. MIT Press, Cambridge, pp 79–112

3D Modeling

<div style="text-align:right">6</div>

Abstract

The chapter introduces the concepts of the raw model and informative model; it clarifies the concept of semantic segmentation and defines the digital representation methods and 3D modeling techniques; finally, it lists the different configuration spaces of a 3D model in different software packages.

Guiding questions
- What are the methods of digital representation?
- What are the 3D modeling techniques?
- What are the differences between representation methods and 3D modeling techniques?

Basic terms
- Raw Model (acquisition/digitization)
- Informative Model (information enriched reconstruction)
- Discrete and Continuous modeling
- Semantic segmentation
- Mesh
- Non-Uniform Rational B-Spline (NURBS)
- Tessellation (discretization)
- Level of Detail (LoD)

© The Author(s) 2024
S. Münster et al., *Handbook of Digital 3D Reconstruction of Historical Architecture*,
Synthesis Lectures on Engineers, Technology, & Society 28,
https://doi.org/10.1007/978-3-031-43363-4_6

6.1 The Raw Model and the Informative Model

Retro-digitization is the process of conversion into the digital format of a work designed and published in an earlier era. There are several approaches for converting a real object into digital form; sometimes, the raw data captured from reality has to be interpreted and manipulated to produce a critical digital version of the object. At other times the object is no longer extant or was never realized and the 3D information must be extracted from documental sources, critically analyzed, and used as a starting point to reconstruct the 3D model [1].

According to this premise, two main models within retro-digitization can be defined in this context: the digitization, or Raw Model, and the reconstruction, or Informative Model. This classification is proposed for the first time in this book, and it is aimed to emphasize their different natures. **The Raw Model (RM) is the unprocessed digital survey of real sources** (e.g., the point cloud/textured mesh resultant from the laser scanning of the remains of a Roman theatre). **The Informative Model (IM) is the critical rationalized hypothetical virtual reconstruction**.

The RM is based on data that can now be obtained almost automatically using the tested digital methodologies of architectural survey. Raw means unprocessed, thus this model is based on the captured original data and it is not equivalent to the ultimate result of an architectural survey which is usually interpreted and processed by the operator (e.g., the points that are coplanar or colinear in a point cloud are approximated with a plane or a line [2]). The RM is data obtained with automated procedures. The precision and accuracy of this data are linked to the correctness of the survey procedures adopted and the tools used.

The two most used techniques to generate a RM are **digital photogrammetry** and **digital scanning**. Both produce a **3D point cloud** that can be automatically (or semi-automatically) transformed into a textured polygonal 3D model. Digital photogrammetry calculates 3D information of the displayed objects from photographs taken at different angles and returns 3D models of remarkable graphic quality that embed information even on the material surface of the artifact. The technique is based on capturing and processing photographs; therefore, it is relatively inexpensive because the tools needed are a camera and a computer to run the processing program, which is less expensive than a laser scanner. There are several applications on the market and the cost is easily managed by any architectural firm or university research department. Digital scanning uses **laser scanners** which gathers information about the geometry of objects by sending a laser beam at different angles and measuring the distance between the laser emitter and the object's surface by the beam's time of flight. The cost and quality of the scans are related to the type of scanner used. These tools are considerably more costly than photogrammetry but return metrically very accurate data. Today when it is economical and practical, these two techniques are used together. Those techniques are described in the literature [3–6].

The IM is built from a series of inferences based on reference data. This concept, therefore, can be compared to what is known as **reverse engineering**. This process starts from a reference in its final form with missing data and tries to deduce what was the

process that generated it. The RM lacks any semantic segmentation and organization and can be used as a source to build the IM. Several studies are attempting to automate the creation of a semantically structured IM starting from the RM data, e.g. by identfying architectural segments from point clouds by using AI [7]. To date, these studies have not produced satisfactory results, at least for application to architectural cultural heritage. The current algorithms are not capable of identifying with sufficient efficiency the complexity and the variety of architectural typologies. Will it be possible to automate this step in the future? This question cannot be answered now, but the complexity of virtual reconstructions is similar to the complexity of any creative act; therefore, it requires a certain amount of creative and analogical intelligence which is typical of the complexity of the human mind.

Further reading: Research on modeling The research on technologies for 3D modeling and 3D digitization has been important for decades. In recent decades, various large-scale projects on the EU level on 3D modeling in cultural heritage primarily focused on 3D digitization from contemporary survey data [8]. A major objective during the FP7 to Horizon 2020 framework programs was to ease use, reduce costs, and increase quality. With the following transition to the Horizon Europe framework, valorization, and wide use became the focus. As recent projects on the EU level, the VIGIE study [9] examines use cases for 3D/4D digitization of tangible heritage and the EU DT–20 competence center [10] investigates and develops support structures for 3D digitization from contemporary survey data. Various articles were published to provide an overview of particular technologies of relevance for 3D modeling and visualization, recently on laser scanning [11], photogrammetry [12], machine learning [13, 14], and extended reality technologies [15].

6.2 Semantic Description of the 3D Model

Semantic segmentation/organization of data is the act of logically subdividing and structuring information by making groups and naming each element according to similarities (shape, type, position, etc.). It is rooted in the scientific organization and systematization of knowledge, or taxonomy, which means a scheme of (hierarchical) classification in which things are organized into groups or types, uniquely named and identified. It allows for knowledge to be indexed and organized (e.g., a search engine taxonomy), so users can more easily find the information they are searching for (Fig. 6.1).

The semantic segmentation/organization of data is not only a matter of digital representation; it rather intrinsically belongs to architecture [16]. This structure must be linked to the *language* and type of architecture and must be as simple as possible. It is,

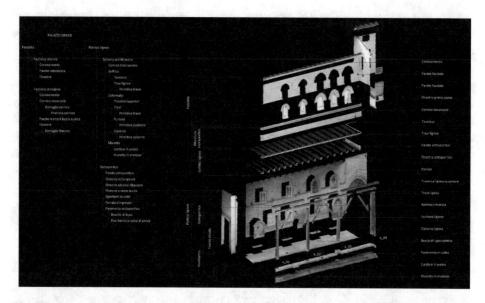

Fig. 6.1 Semantic segmentation of a 3D photogrammetric model (Image: Foschi)

therefore, important to build the Informative Model by individually modeling its archi-
tectural elements and keeping them well organized. The parts should be named clearly
and unequivocally and grouped hierarchically [17, 18]. A building could be semantically
segmented into its elements as follows: the roof, the attic, the base, the window, the
door, the column, the wall, etc. Each element could be differentiated from the others
by adding to its name an indication of the positioning or numbering it in the group of
analogous elements. This first semantic structure is extremely important because it allows
anyone to clearly name each part of the analyzed architecture and refer to it unequivocally.
Only through clear and rational identification of these architectural elements it is possible
to appropriately decoding the model. Building a 3D model by assembling single ele-
ments also simplifies and rationalizes the process of 3D modeling: it allows copy-pasting
instances of parts that are equal/analogous, speeding up the modeling and analysis pro-
cess, and decreasing the file size. Semantic reading, therefore, has its digital equivalent
in the structure of 3D models like in any CAD and BIM software. This simple 3D model
structure can be refined and hierarchically organized at a later stage. This second level
of the semantic organization of the model can follow various paths, which are generally
also linked to the purpose of virtual reconstruction. For example, in an antique building,
the architectural elements could be organized according to the architectural order. We
could create a column level, and below this column level, insert the elements of the shaft,
the base, and the capital. Or we could divide and organize the elements according to the
floors of the building, etc. Of course, these choices are linked to the architectural typology
analyzed and the semantic choices must rationally reflect this important relationship.

Further reading: Algorithmic modeling and machine learning

- **Algorithmic modeling**: Traditional algorithmic-only approaches, as in photogrammetry, employ algorithms to complete a specific operation, e.g., to detect, describe, and match geometric features in images [19]. In contrast, machine learning uses algorithmic approaches to train a statistical model in a supervised or unsupervised way via training data—e.g., to detect features [20]. Current evolvements in computer vision are closely coupled to the massive renaissance in machine learning [21] with the use of convolutional neural networks (CNNs) [22] since 2012. Machine learning approaches are currently heavily researched and used for image and 3D point cloud analytics in cultural heritage [13], but also increasingly for 3D modeling tasks.

- **3D/4D model generation via machine learning**: In 3D reconstruction of cultural heritage, machine learning-based technologies are primarily used for specific tasks within the modeling process: to preselect imagery [23, 24], in semantic segmentation to classify parts of images [25–27], and to recognize specific objects.[27–30] Another strand—bypassing the modeling stage—is generating visualizations directly from imagery [28, 31, 32]. Machine-learning-based technologies currently require large-scale training data [13, 27, 28] only capable of recognizing well-documented and visually distinctive landmark buildings [33]. Machine learning fails to deal with less distinctive architecture, such as houses of similar style. Regarding transparency, most machine learning approaches are applied within black box settings in a non-standardized way [13, 34]. Specifically, generative adversarial networks (GAN) as a combination of proposal and assessment components of machine learning are frequently employed in 3D modeling. Application scenarios are single photo digitization [35], completion of incomplete 3D digitized models [36, 37], or photo-based reconstructions [38]. Neural Radiance Fields (NeRF), which use viewpoint cuing [39], have gained importance since 2020. Although primarily an image transformation-based approach to calculate new viewpoints, NeRF enables, e.g., lighting changes [40] or 3D mesh calculation from sparse imagery.

The semantic construction of the 3D model is linked to the knowledge of architecture; not only its history but also all those qualities that define it: type, geometry, shape, architectural orders, etc. Therefore, the culture of the creator of the 3D model is an important aspect. A scholar reconstructing a Renaissance building will have to study the design of the architectural orders and the history of Renaissance architecture. The quality of a virtual reconstruction depends primarily on the scholar's discipline culture and experience. For this reason, a multidisciplinary approach from different expertise is desirable: architects, historians, engineers, archaeologists, etc.

6.3 Traditional and Digital Representation Methods

Digital representation has somehow closed a cycle between the real physical model and its representation. From a 2D drawing, it is possible to construct a digital 3D model; this 3D model can be printed into a physical model (\rightarrow Media and Interfaces); this physical model or maquette can be scanned and transformed into a digital point cloud; this point cloud can be transformed into a mesh model; the process can go on and the cycle repeats itself. Therefore, digital representation has not only increased the accuracy of the drawings but has also allowed transformations between the real physical model and its representation in a more fluid and versatile way.

Despite its importance, while there are shared standards and norms for traditional 2D drawings (plans and elevations), for the construction and evaluation of digital 3D models these norms have not yet been fully defined.

Scholars that use 3D models as tools hardly ever make explicit reference to the *methods of representation* and *techniques* they adopted to build them. Nevertheless, it would be advisable for scientists and researchers to always declare the techniques and methods used, to enhance transparency and interoperability of the 3D models (\rightarrow Documentation). This is also an important prerequisite for the scientific reuse of 3D models, made by others, as a source of knowledge. In the next few paragraphs, the representation methods and 3D modeling techniques are defined and illustrated.

The **methods of digital representation** concern the intrinsic mathematical/geometrical nature of the 3D models and are either continuous or discrete (Fig. 5.5):

- **Continuous methods**: the geometry is described in a continuous way with mathematical /Surface Modelling is part of this category (e.g., Non-Uniform Rational B-Spline (NURBS) modeling)
- **Discrete methods**: the geometry is described in a discrete way, not with equations, but with points described by coordinates (vertices), lines (edges), and planar faces (polygons); numerical/polygonal modeling is part of this category (e.g., mesh modeling).

All the other methods mostly used in the architectural world can be considered subsets of one of these two. For example, point cloud modeling is a subset of mesh modeling, and spline and Bezier modeling are subsets of NURBS modeling (Fig. 6.2).

Parametric modeling, handmade modeling, digital sculpting, etc. are not methods of digital representation, they are 3D modeling techniques (\rightarrow 6.4 3D Modeling Techniques) to create models of continuous or discrete nature.

Continuous and discrete modeling have analogies with the **traditional methods of representation**. Some scholars [41] propose to consider them as a direct addition to the traditional representation methods which are:

Fig. 6.2 Continuous (NURBS, on the left) and discrete (mesh) 3D models with different tesselation (Image: Foschi)

- Double orthogonal projection
- Axonometric projection
- Perspective projection
- Topographic terrain projection (with contour lines).

Choosing between the discrete or continuous method has similar implications as choosing to use an axonometry or a perspective. What is this method useful for? Why is it more useful than the other/s? What aspects are you highlighting by choosing it? Even if the final appearance of an object represented with one method or the other might be similar (or even the same), the implications of using one or the other methods are different, due to the scope and the data that the method carries.

For example, if we represent the front view of the same cube in double, axonometric, and perspective projections, the resulting image is the same, a square. Yet, the constructions that generated those results are different, and so are the purposes that lead us to choose one method over the other. We use double orthogonal projections to study and check the measurements and proportions of the object; we use axonometric projection to represent the relationship between volumes or the mechanism of the object; we use perspective projection to mimic how the object is perceived by human eyes. Axonometric and double projections are widely used in mechanical drawings and executive architectural drawings, while perspective projection is widely used in painting and architectural renderings. Similarly, we use the digital methods of **mathematical representation** (NURBS) to describe the form accurately and continuously. Instead, we use the **polygonal method** (mesh) to build organic shapes or produce renderings.

3D models can also be generated with **hybrid methods**, i.e., a model can be formed from mathematical solids and mesh solids. This also happens in traditional representation methods: for example, a perspective section includes both the section in true form,

as in double orthogonal projections, and the perspective view to formally evaluate the space (Fig. 6.3). Mastering all representation methods (both digital and traditional) is important because each of them has a specific vocation and is more effective than another only in some contexts.

To sum up, the methods of digital representation can be classified into two distinct families: continuous and discrete. Continuous methods describe the shape continuously and accurately through mathematical equations; the NURBS mathematical representation is the most popular today. Discrete methods describe the shapes in an approximate and discrete way through a list of vertices, described through their coordinates, and a list of edges/faces that connect them; mesh polygonal modelling is the most popular today. The point cloud is a subset of the numerical representation in which the shape is described solely by a list of points in space (Fig. 6.4).

To give a clarifying example, imagine modeling a sphere. With the continuous method, the sphere will consist of a mathematical equation that describes the surface continuously and accurately. With the discrete method, the sphere will consist of a set of vertices connected by edges filled with triangular faces (some applications support polygonal faces with more than three edges but they always hide triangles inside) which discretizes the surface with a certain approximation (Fig. 6.2). Naturally, the more tessellated the surface of the sphere (more vertices, or smaller triangular faces), the less approximated the surface will be with respect to the ideal sphere.

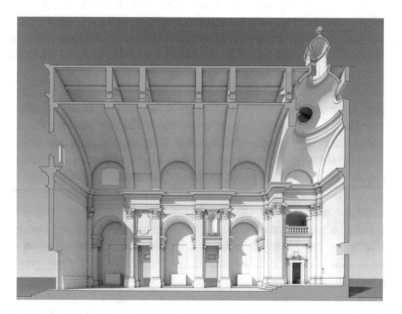

Fig. 6.3 Perspective section of the never-built church of S. Margherita, Bologna, 1685 (Agostino Barelli), informative reconstructive model (Image: Fallavollita)

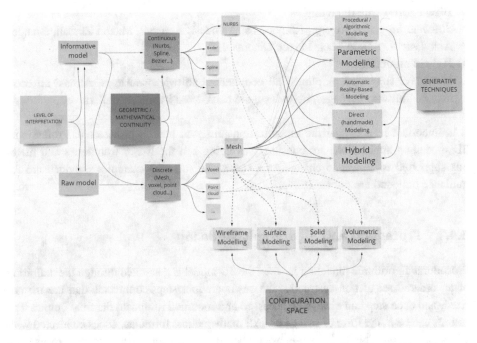

Fig. 6.4 Conceptual scheme of 3D modeling classification (Image: Fallavollita and Foschi)

6.4 3D Modeling Techniques

3D modeling techniques are the practices, processes, and norms used to create the 3D models described with any of the digital representation methods (continuous or discrete). To make an analogy with traditional drawing: the watercolor technique can be applied to realize perspective views, axonometric views, or double projections and it is used to obtain a shaded image. Analogously, the technique of parametric modeling can be used to generate both mesh and NURBS models. The 3D modeling techniques describe the act of constructing the shapes. These must not be confused with the digital representation methods that define how the computer represents the mathematical nature of the shapes.

Given this assumption we can define the following 3D modeling techniques:

- **Procedural algorithmic modeling**
 Software programs are e.g., McNeel Rhinoceros + Grasshopper, Autodesk Revit + Dynamo, Blender + Geometry Nodes;
- **Parametric modeling**
 Software programs are e.g., Autodesk Inventor, Dassault Catia, PTC Creo Parametric;
- **Automatic reality-based modeling**
 Software programs are e.g., Agisoft Metashape, Reality Capture;

- **Direct handmade modeling**
 Software programs are e.g., Rhinoceros, Autodesk Autocad, Maxon Zbrush, Blender, Autodesk 3D Studio Max, Maxon Cinema 4D;
- **Hybrid modeling**
 Nowadays supported by almost all commercial software packages. Almost all commercial software packages, nowadays, are considered hybrid modellers.

It is important to note that the classification proposed here is provisional. Professional 3D modelling applications are constantly evolving and the list of techniques and methods supported is subject to change.As a result, the software examples provided are for guidance only and are not exclusive.

6.4.1 Procedural and Algorithmic Modeling

Procedural/algorithmic modeling is when the 3D model is generated through the definition of an ordered set of non-destructive actions/operations/steps/commands that are memorized, and each step can always be accessed and modified to update the final output. The actions can be in the form of strings of text, mathematical formulas, nodes connected with wires, and so on. This technique is used when dynamic manipulation of the process is a key factor in defining the final form (Fig. 6.5).

Applications that allow modeling through a graphical programming interface, such as Revit + Dynamo, Houdini, Blender + Geometry Nodes, and Rhinoceros + Grasshopper [42], are considered algorithmic modelers. All these applications share the same approach, where each command is in the form of a node that is connected chronologically to other operations through wires. This makes the algorithm easier to create, explore, investigate, modify, and share. More apps are nowadays integrating this type of interface because

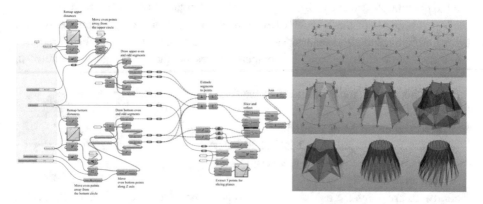

Fig. 6.5 Creating a 3D model with an algorithm in a graphical scripting language (Image: Foschi)

it enables modeling very complex 3D objects with much less effort than hand-made direct approaches. Furthermore, the algorithms can be shared, to allow others to reuse and modify them without needing to reproduce the same process step by step.

"Procedural" means made with/through a procedure, so **procedural modeling** should be synonymous with algorithmic modeling, but is sometimes used with a different connotation. For example, in software such as Cinema 4D and 3DS Max, it is possible to model in a non-destructive way by applying and stacking modifiers on simpler starting 3D geometries. This approach is much less versatile than that with a graphical programming interface. Nevertheless, both methods can be used to store the whole modelling process, and access and modify it at each point, so they can be considered as part of the same category.

MathWorks, MATLAB and GeoGebra can be used to generate a 3D model through a sequence of non-destructive commands that are always accessible and modifiable, but the command needs to be inputted in the form of strings of text or mathematical formulas, so they are less popular for digital 3D reconstruction of cultural heritage but are still part of the same category.

Each modeling technique has algorithms or code hidden inside its commands, but in 3D modeling in the past few decades **algorithmic modeling** has acquired a specific connotation with applications that focus on the algorithm, and it is findable, accessible, and modifiable at any time. If the algorithms are hidden from users and a lot of manual interaction is needed to create the 3D model, the technique would rather be categorized as direct handmade modeling.

6.4.2 Parametric Modeling

Parametric modeling is similar to algorithmic/procedural modeling and sometimes these terms are interchangeable, despite slight differences. In parametric modeling, it is not always possible to access each step of the process and modify it non-destructively. For example, in applications such as Autodesk Fusion 360, PTC Creo, and Inventor, it is possible to create a 3D object and change the initial parameters (size, position, generative curves, etc.). However, it is not possible to access the chronological sequence of the operations performed on the model from the beginning; only some parameters are modifiable, and it is not possible to add additional operations in between other operations already performed. This is what differentiates parametric modeling from algorithmic/procedural 3D modeling, although each technique could be used to produce similar results [43]. Their focus is different: parametric modeling focuses on the input parameters and the outcome; algorithmic/procedural modeling focuses on the process (Fig. 6.6).

Fig. 6.6 Parametric
modeling of a Ionic column,
by chaning the parameter of
the height we can update the
3D model (Image: Fallavollita
and Foschi)

6.4.3 Automatic Reality-Based Modeling

In automatic reality-based modeling, the 3D model is generated through the application of a set of computer-based analyses and elaborations (Fig. 6.7), predefined by the developer of the software, starting from a set of input data (e.g., point clouds or images) captured by the user from reality with minimal manual interaction. Two main approaches that make use of automatic reality-based modeling are photogrammetry and laser scanning.

Someone could claim that user interaction is still necessary to tell the computer how to use the captured data and to validate the result, however, the polygonal shape and textures of the model could potentially be automatically generated from start to finish without needing any interaction. Every other manipulation of the point cloud or the mesh model itself is not part of the automatic reality-based modeling algorithm, but it rather must be considered as direct handmade modeling.

6.4.4 Direct Handmade Modeling

Direct handmade 3D modeling is probably the most popular way to generate a shape with a computer. It consists of generating the 3D model manually by using the tools provided by the software (Fig. 6.8). It requires constant mouse and keyboard navigation of the 3D space and interaction of the 3D model, and most of the changes to the model are destructive, meaning that the model cannot be updated by changing parameters that were inputted in previous steps. For example, the CAD modeling of a house, the 3D mesh sculpting of a character, or the low poly polygonal modeling for video games assets can be

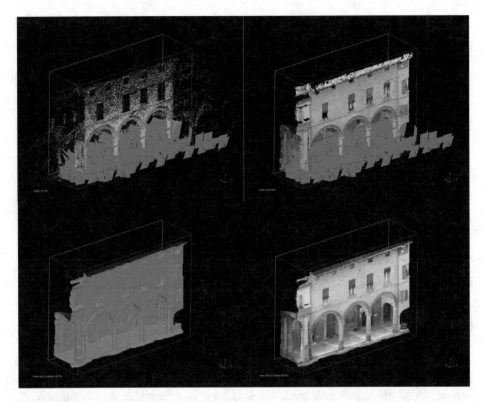

Fig. 6.7 Automatic reality-based modeling using photogrammetry. Top left: aligned photo and sparse point cloud; top right: aligned photo and dense cloud; bottom left: mesh; bottom right: textured model (Image: Foschi)

performed entirely through direct handmade modeling. Digital sculpting is also considered as direct handmade modeling because the tools that are mainly used specifically resemble the tools of a sculptor (e.g., scalpel, brushes, scrapers).

Nowadays applications that only provide direct handmade modeling tools are hard to find; almost every application integrates some non-destructive workflows for specific operations because they speed up the shape-finding process. The reverse is also true: modeling applications that define themselves as algorithmic, automatic reality-based, or parametric modelers almost always integrate direct handmade modeling tools.

Fig. 6.8 Handmade modeling through digital sculpting and polygonal modeling (Image: Foschi)

6.4.5 Hybrid Modeling

All the modeling techniques that make use of multiple approaches are considered hybrids. For example, a model can be generated by using direct handmade modeling for the preliminary shape and algorithmic modeling for adding more complex details. So basically, most of the software packages and applications nowadays are probably adopting hybrid approaches.

Among hybrid techniques, **building information modeling** (BIM) has to be considered as a special case. It deals with modeling, because the BIM method is more about data organization, automatization, and interoperation, including information about materials, prices, forces, technical systems, and construction site facilities. Thus, BIM is mainly used for the holistic management of architectural projects, and it is not exclusively dedicated to modeling.

6.5 Configuration Space

Other than classifying the models by their level of interpretation (raw or informative), the digital representation method adopted (continuous or discrete), and the technique used to generate them (procedural, algorithmic, etc.), we can also differentiate models by how the software considers their **configuration space**. There are four main ways that applications are used to describe the configuration space of 3D models (Fig. 6.9):

- **Surface modeling** (B-rep)
- **Solid modeling** (closed and manifold B-rep)
- **Wireframe modeling** (interlinked edges)
- **Volumetric modeling** (voxels).

Surface modeling or boundary modeling (B-rep) describes the models as collections of connected surfaces. This way of considering the models allows open and non-manifold geometries, in other words, geometries that do not have a clear distinction between the inside and the outside and thus have no calculable volume.

Solid modeling describes shapes as volumes and has a predilection for Boolean operations. It can also be generated by B-reps: this changes how the software checks the validity of the geometry generated, which basically would not allow generating any open or non-manifold geometry.

Most 3D modeling applications adopt hybrid approaches. Computer applications that define themselves as **surface modelers** can be used to connect single surfaces and generate closed poly-surfaces to then apply Boolean operations that by definition can only be performed between watertight solids. Other applications that define themselves as **solid modelers** allow the user to split the solids into the single boundary surfaces that enclose the volume. These ambiguities that can be observed in many applications are mostly

Fig. 6.9 Surface, solid, wireframe, and volumetric modeling (Image: Foschi)

due to the fact that software developers try to meet users' needs by implementing new commands.

Volumetric models and wireframes of 3D models are other two ways of describing the configuration space. In **volumetric modeling**, the volume is usually occupied by points (points sometimes are shaped like cubes or spheres: then they are called **voxels** and thus there is a discrete volume), and each of these points is enriched with specific data, such as structural stresses, temperature, type of material, density, and so on. This type of model is mostly used to store and visualize data from tomographic surveys in engineering, archeology, and medicine, or for physical simulations (fluids, rigid bodies, etc.). Lastly, **wire modeling** only provides the cage of a 3D model, made of edges that meet at vertices. In this case, there is no distinction between the outside and inside of the configuration space and thus it has no calculable volume.

6.6 Best Practices

There are five main aspects to consider for properly designing the model:

- Semantic organization
- Scale and level of detail
- Solid modeling
- Model tessellation
- Interoperability

The **semantic organization** of a 3D model mostly uses one of two methods: philological and constructive/semantic. The two options may be coincident in some cases but in most cases, they return differently segmented models. The creator has to decide which path to choose and how to organize the semantic and logical structure of the model. To give an example, think of a reconstruction of a column of an Ionic order (it could be a Corinthian or Doric order, it does not matter). In **constructive semantic logic**, the base of the column generally includes the initial part of the column, the attachment to the base formed by a strip (listello) and an arched connection (apophyge/cavetto/fillet). In **philological logic**, however, the base will stop exactly below the shaft of the column and the listello + apophyge will be part of the shaft and not of the base (Fig. 6.10).

Fig. 6.10 Different segmentation of the column base: constructive semantic approach on the left, philological approach on the right (Image: Fallavollita and Foschi)

The second aspect concerns the **scale** and the **level of detail (LoD)**. It is generally said that in virtual space one draws on a scale of 1:1. This statement is misleading because in architecture the representation is generally on a reduced scale, also in 3D digital modeling. As in traditional drawing, there are different scales of representation, and thus of LoD. For example, we could define that a certain model has a LoD comparable to a scale of 1:100 while another 3D model is equivalent to a scale of 1:20 because it has greater detail. Certain modeling applications, e.g., BIM applications and game engines, allow for multiple LoDs within the same model. It must be remembered that these different levels are nothing more than different models that are displayed when different scales are requested. Again, the analogy with traditional methods is still valid both in theory and in practice.

Further reading: Level of detail

Level of detail and/or development (LoD) is used to differentiate between multiple variants of the same model with a different number of polygons or different levels of complexity [44]. Some systems distinguish between five gradations (Fig. 6.11). Since these are only roughly described in terms of graduation, in practice this often leads to intermediate levels, such as LoD 2.5 as a model of the building exterior envelope including window partitioning. Specific LoD classifications have been developed in some fields of application, as described for BIM [45] or, with different LoD scales, CityGML for GIS [46].

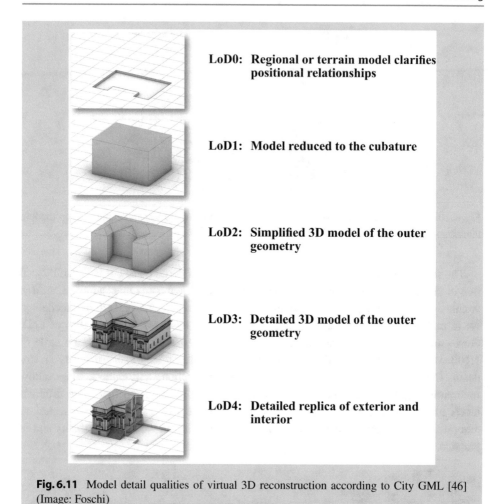

Fig. 6.11 Model detail qualities of virtual 3D reconstruction according to City GML [46] (Image: Foschi)

LoD0: **Regional or terrain model clarifies positional relationships**

LoD1: **Model reduced to the cubature**

LoD2: **Simplified 3D model of the outer geometry**

LoD3: **Detailed 3D model of the outer geometry**

LoD4: **Detailed replica of exterior and interior**

Solid modeling is the third aspect of architectural modeling [47]. One way to obtain traditional and manageable models is to conceive and draw a 3D model composed of **closed, non-self-intersecting solids**. There are two main reasons for following this procedure: conceptual and technical. The conceptual is most important and concerns the **logical construction of architecture**. The real world of constructions is made up of solid objects that cannot under any circumstances interpenetrate or be "floating": physical and static laws do not allow exceptions. Of course, in the virtual world, these exceptions are allowed: we can construct two solids that intersect or are hovering in space; moreover, we can conceive objects composed of single surfaces or open poly-surfaces. These exceptions must be avoided because they would have no possible equivalent in architectural reality. The technical reason concerns some consequences that these exceptions could have in digital representation. If a 3D model contains some parts composed of open surfaces or **open meshes**, they will **not be 3D printable**. In addition, open or self-intersecting poly-surfaces

may cause errors and glitches in the rendering phase. If two **surfaces overlap**, they will be likely **displayed as a patchy or flickering surface;** this is because the computer does not know which surface is on top and returns a confused surface (known as z-fighting effect). Moreover, where the light hits **open poly-surfaces** there may be unrealistic shadow effects or **light leaking**. For these technical reasons, it is useful to conceive and build architectural digital 3D models according to non-self-intersecting closed and manifold solids. The possible objection to this simple solid modeling principle could be that in some cases computer graphics requires specific measures to obtain rendering effects or to lighten the model. For example, when you need to render a glass object that contains a liquid such as a glass of wine, the element of the wine should slightly be interpenetrated to (or moved away from) the solid of the glass. Or in video games, all the surfaces that are not visible are eliminated to make the game lighter to run. These exceptions should not undermine or weaken the solid modeling principle as they are usually implemented at a later stage if needed.

The fourth aspect concerns **tessellation, the process of transforming mathematical models into polygonal models**. Switching from a mathematical environment to a polygonal one is easy because it is just a matter of populating the continuous surfaces with points and connecting them with edges and planar faces. The inverse is hard because as soon as they are converted into polygonal models, NURBS models lose all the information about the curvature of their surfaces. Nevertheless, even if this conversion is destructive and passes from a continuous to a discretized model, it is necessary both to produce shaded rendered images and to eventually be able to 3D print the model. In fact, each 3D modeling software that handles NURBS internally converts them into meshes in real time to allow the graphic cards to shade and display the models in the interactive view while working on the model. Because of that, someone might say that to produce images it is more convenient to directly model with discretized surfaces. This might be true sometimes, but if the discretized model turns out to be too much or too little tessellated at the end of the modeling process, the only way to update it is to entirely remodel it from scratch, which is why the NURBS model is almost always preferable at least when aiming to accuracy and versatility.

Summary
The chapter deals with the concepts of raw model and informative model; it clarifies the concept of semantic segmentation and defines the digital representation methods and 3D modeling techniques; finally, it lists the different configuration spaces of a 3D model in different software packages.

Standards and guidelines

- Beacham, R.; Denard, H.; Niccolucci, F. An Introduction to the London Charter. In Papers from the Joint Event CIPA/VAST/EG/EuroMed Event, Ioannides, M., Arnold, D., Niccolucci, F., Mania, K., Eds.; 2006; pp. 263–269.

- Denard, H. (2009) "The London Charter. For the Computer-Based Visualization of Cultural Heritage, Version 2.1." (https://www.londoncharter.org, accessed on 1.2.2023).
- Principles of Seville. International Principles of Virtual Archaeology. Ratified by the 19th ICOMOS General Assembly in New Delhi, December 2017 (http://sevilleprinciples.com, accessed on 1.2.2023).

Key literature

- Albisinni, P. and L.D. Carlo, eds. Architettura disegno modello: Verso un archivio digitale dell'opera di maestri del XX secolo. 2011, Gangemi Editore (2011) [47].
- Aubin, P.F. (2013). *Renaissance Revit: Creating Classical Architecture with Modern Software*. G3B Press [43].
- Apollonio, FI. (2012). *Architettura in 3D. Modelli digitali per i sistemi cognitivi*. Milano: Bruno Mondadori [16].
- Migliari, R., *Geometria Descrittiva—vol. 1, vol. 2—Metodi e costruzione*. 2009: Città Studi Edizioni [48].
- Pottmann, H., *Architectural geometry*. 2007: Bentley institute press [49].
- AAD_ALGORITHMS AIDED DESIGN, *Parametric Strategies using Grasshopper*. 2014: Le Penseur [50].

References

1. Spallone R (2015) Reconstruction modeling, animation and digital fabrication of 'architectures on paper'. Two ideal houses by Carlo Mollino. SCIRES-IT-SCIentific RESearch and Information Technology 5(1):101–114
2. Bianchini C et al (2014) Survey m, interpretation as multidisciplinary components of a Knowledge System. SCIRES-IT-SCIentific RESearch and Information Technology 4(1):15–24
3. Shan JT (2008) C. Topographic laser ranging and scanning: principles and processing. CRC, Boca Raton, FL, USA, p 590
4. Luhmann T et al (2006) Close range photogrammetry: principles, techniques and applications. Whittles Publishing, Dunbeath, Scotland, UK
5. Remondino F et al (2005) 3D modeling of close-range objects: photogrammetry or laser scanning? In: Beraldin JA et al (eds) Proceedings SPIE 5665, videometrics VIII, p 56650M. https://doi.org/10.1117/12.586294
6. Alshawabkeh Y et al (2021) Integration of laser scanner and photogrammetry for heritage BIM enhancement. ISPRS Int J Geo Inf 10(5):316
7. Tamke M et al (2014) From point clouds to definitions of architectural space-potentials of automated extraction of semantic information from point clouds for the building profession
8. Münster S, Utescher R, Ulutas Aydogan S (2021) Digital topics on cultural heritage investigated: how can data-driven and data-guided methods support to identify current topics and trends in digital heritage? Built Heritage 5(1):25. https://doi.org/10.1186/s43238-021-00045-7
9. Ioannides M et al (2020) European study on quality in 3D digitisation of tangible cultural heritage (VIGIE 2020/654)

10. 4CH - Competence Centre for the Conservation of Cultural Heritage (2021)
11. Di Stefano F et al (2021) Mobile 3D scan LiDAR: a literature review. Geomat Nat Haz Risk 12(1):2387–2429
12. Remondino F et al (2017) A critical review of automated photogrammetric processing of large datasets. Int Arch Photogram Remote Sens Spat Inf Sci XLII-2/W5:591–599
13. Fiorucci M et al (2020) Machine learning for cultural heritage: a survey. Pattern Recogn Lett 133:102–108
14. Münster S, Maiwald F, Lenardo ID, Henriksson J, Isaac A, Graf M et al (2024) Artificial Intelligence for Digital Heritage Innovation. Setting up a R&D roadmap for Europe. MDPI Heritage
15. Russo M (2021) AR in the architecture domain: state of the art. Appl Sci-Basel 11(15):6800
16. Apollonio FI (2012) Architettura in 3D. Modelli digitali per i sistemi cognitivi. Milano, Bruno Mondadori
17. Pfarr-Harfst M (2010) Dokumentationssystem für Digitale Rekonstruktionen am Beispiel der Grabanlage Zhaoling, Provinz Saanxi, China. Dissertation
18. Pattee A et al (2022) A machine learning approach to assist architectural research by matching images directly with text. In: EUROMED 2022
19. Lowe DG (2004) Distinctive image features from scale-invariant keypoints. Int J Comput Vis 60(2):91–110
20. Yi KM et al (2016) LIFT: learned invariant feature transform. In: Leibe B et al (eds) Computer vision – ECCV 2016. Springer International Publishing, Cham, pp 467–483
21. Krizhevsky A et al (2017) ImageNet classification with deep convolutional neural networks. Commun ACM 60(6):84–90
22. Jahrer M et al (2008) Learned local descriptors for recognition and matching. Proc Comput Vis Winter Worksh 2008:39–46
23. Münster S et al (2019) Digital cultural heritage meets digital humanities. Int Arch Photogram Remote Sens Spat Inf Sci XLII-2/W15:813–820
24. Bell P et al (2019) Computer Vision und Kunstgeschichte – Dialog zweier Bildwissenschaften. In: Kuroczynski P et al (eds) Digital art history. Heidelberg, pp 61–78
25. Martinovic A et al (2015) 3D all the way: semantic segmentation of urban scenes from start to end in 3D. IEEE Comput Vis & Pattern Recogn 4456–4465
26. Hackel T et al (2016) Fast semantic segmentation of 3D point clouds with strongly varying density. ISPRS Ann 3(3):177–184
27. Aiger D et al (2017) Large-scale 3D scene classification with multi-view volumetric CNN
28. n.b. (2019) ArchiMediaL. Enriching and linking historical architectural and urban image collections. http://archimedial.net/
29. Radovic M et al (2017) Object recognition in aerial images using convolutional neural networks. J Imaging 3(2)
30. Khademi S et al (2021) Deep learning from history. In: Niebling F et al (eds) Research and education in urban history in the age of digital libraries. Springer International Publishing, Cham, pp 213–233
31. 4dReply Closing the 4D Real World Reconstruction Loop. https://cordis.europa.eu/project/id/770784. Accessed 8 Feb 2022
32. Martin-Brualla R et al (2021) NeRF in the wild: neural radiance fields for unconstrained photo collections
33. Münster S, Maiwald F, Bruschke J, Kröber C, Sun Y, Dworak D, Munir I, Komorowicz D, Beck C, Münster DL (2024) A digital 4D information system at world scale: Research challenges, approaches and preliminary results. MDPI Appl. Sciences
34. Zielke T (2020) Is Artificial Intelligence Ready for Standardization?
35. Kniaz VV et al (2019) Generative adversarial networks for single photo 3d reconstruction. Int Arch Photogram Remote Sens Spat Inf Sci XLII-2/W9:403–408

36. Hermoza R et al (2018) 3D Reconstruction of incomplete archaeological objects using a generative adversarial network. Proc Comput Graph Int 2018:5–11
37. Nogales Moyano A et al (2021) ARQGAN: an evaluation of generative adversarial networks' approaches for automatic virtual restoration of Greek temples
38. Microsoft In Culture (2021) See ancient Olympia brought to life
39. Mildenhall B et al (2021) Nerf: representing scenes as neural radiance fields for view synthesis. Commun ACM 65(1):99–106
40. Srinivasan PP et al (2021) Nerv: neural reflectance and visibility fields for relighting and view synthesis, pp. 7495–7504
41. Geometria Descrittiva - vol. 1 - Metodi e costruzione RM, CittàStudiEdizioni, 2009, ISBN 9788825173291
42. AAD_ALGORITHMS AIDED DESIGN PSuGPLP, 2014. ISBN 978–88–95315–30–0
43. Aubin PF (2013) Renaissance revit: creating classical architecture with modern software. G3B Press
44. Luebke DP (2003) Level of detail for 3D graphics. The Morgan Kaufmann series in computer graphics and geometric modeling, 1st edn.
45. Martens B (2019) Virtuelle Rekonstruktion: Building Information Modelling (BIM) als Rahmenbedingung für eine langfristige Nutzung von digitalen 3D-Gebäudemodellen. In: Kuroczyński P et al (eds) Der Modelle Tugend 2.0: Digitale 3D-Rekonstruktion als virtueller Raum der architekturhistorischen Forschung. Heidelberg University Press, Heidelberg
46. OGC (2012) OGC city geography markup language (CityGML) Encoding standard, version 2.0.0
47. Albisinni P et al (eds) (2011) Architettura disegno modello: Verso un archivio digitale dell'opera di maestri del XX secolo. Gangemi Editore (2011), ISBN 9788849220988
48. Migliari R (2009) Geometria Descrittiva - vol. 1 - Metodi e costruzione
49. Pottmann H (2007) Architectural geometry
50. AAD ALGORITHMS AIDED DESIGN (2014) Parametric strategies using grasshopper

Visualization

7

Abstract

3D computer-based visualization refers to all those methodologies adopted to produce, represent, describe, transmit, and present graphically/visually digital 3D models in a way that is perceivable by the human eye. Visualization is one of the core aspects of 3D reconstruction because it is the most effective medium to synthesize complex data in a visual way and makes the results more accessible and comprehensible not only to professionals but also to laypersons.

Guiding questions
- What is digital visualization?
- What are the media methods and techniques?
- How can it be used as a scientific tool?
- How can it be used to communicate information?
- What are the potentials/challenges of digital and physical visualization?
- What technologies present and interact with digital 3D reconstructions?

Basic terms
- Texturing
- Photo-realistic and abstract shading
- False colors

© The Author(s) 2024
S. Münster et al., *Handbook of Digital 3D Reconstruction of Historical Architecture*,
Synthesis Lectures on Engineers, Technology, & Society 28,
https://doi.org/10.1007/978-3-031-43363-4_7

- Perspective and axonometric projection
- Interactive, linear, and static visualization
- Rapid prototyping
- Extended reality.

7.1 From Digits to Visuals

Anything in modern computers is stored as **sequences of ones and zeroes**, however, binary code is not practical to be read by humans, so any data of such type needs to be converted in some other language and displayed on an interface that is easier for humans to read. Digital 3D models are no exception: to be able to interact with, experience, and present them, their **binary description needs to be processed and output visually**, e.g., as RGB (red, green, blue) values on a display. The visualization is such an important aspect of the 3D model that someone might say that 3D modeling, and 3D visualization are entangled concepts and one has no reason to exist without the other. In 3D reconstruction of cultural heritage, it would probably not even be possible to generate the 3D model in the first place without constant visual feedback on a display. The most popular interfaces used to view digital 3D models are 2D displays (computer, smartphone, TV screen, projector, etc.). But in the past few decades, many other technologies are beginning to be considered valid alternatives: VR, AR, 3D displays, holograms, and so on.

The use of different interfaces and our needs can radically change the way we perceive, present, experience, and interact with 3D model. **Three main ways to present the 3D models virtually** are listed below:

- **Static presentation** (single image/static rendering).
- **Linear presentation** (scripted video/precomputed animation).
- **Interactive presentation** (real-time exploration/computer games).

In **static presentation**, the 3D model is projected in a 2D medium and captured as in a photograph. These types of pictures are fast to make through modern rendering engines, but they are limited in terms of interaction/navigation freedom within the 3D space, because the points of view from which the viewer can experience the 3D model are predetermined.

In **linear presentation**, the 3D model is experienced through a pre-arranged tour in the form of an animated video. Interaction/navigation within the 3D space is limited also in this case because the observer cannot move freely. However, the level of engagement/ comprehension of the 3D shapes can be higher than in static presentation since the depth perception is enhanced through motion.

In **interactive presentation**, the model can be explored in a self-guided way through a specifically designed digital 3D environment such as a gaming platform or a web app. This type of presentation is for sure the most versatile one because the models can be perceived from every possible point of view. Users need a basic understanding of how to move in the digital space, usually with gamepads, touch screens, or mice and keyboards. Visualizing high-resolution models interactively is a much more hardware-demanding task than static and linear presentations, which can run on any device with a display. 360° panoramas can be considered a hybrid type because they are made with a static 360° image projected onto a sphere (or a cube), but they can be experienced through VR headsets or navigated with mice and keyboards. The limit of the navigation in this kind of panorama is that the point of view is always in the center of the sphere.

Visualization can also be useful as an **analysis tool** to highlight certain formal or super-ficial aspects. According to Ware, visualization can support research and understanding in five ways [1, cited from 2, p. V]:

- It may facilitate the cognition of large amounts of data.
- It can promote the perception of unanticipated emergent properties.
- It sometimes highlights problems in data quality.
- It clarifies the relationships between large- and small-scale features.
- It helps in the formulation of hypotheses.

7.2 Digital 2D-3D Visualization

Digital 2D-3D visualization is the process of creating graphics and renderings by com-bining 2D and 3D modeling and rendering software. It is used in many industries and applications ranging from architecture, film and games industries, engineering and man-ufacturing, to advertising and fashion. Until the advent and subsequent widespread use of digital 3D modeling and visualization systems, knowledge relating to the 3D world was studied, transmitted, and analyzed in physical forms through the projection of the 3D objects onto 2D media (paper, wooden tables, cloth, etc.) or through the creation of 3D physical mock-ups (in wood, cardboard, clay, or other materials), usually made by hand by artists, architects, or engineers.

Table 7.1 Pros and cons of digital 2D-3D visualization

Pros	Cons
• **Versatility** of use and implementation • **Static and dynamic visualizations** of the same model from multiple points of view are **fast** to produce and update • **Automatic check** of **interferences and inconsistencies** • Easy automatic **extraction of analytical data** (surface, volume, etc.) • **Immersive explorations** at different scales • Models can be **decontextualized** • **Photo-realistic** simulations of **nonexisting objects/environments** • **Virtual accessibility** to locations otherwise dangerous, impractical, or impossible to visit • Overlapped **models/variants on the same virtual location** • Models can be **infinitely duplicated**, decreasing the risk of short-term data loss • **Joint and remote work** on the same virtual model • **Appending and visualizing external data** to specific parts of the model • Visualization of the **final appearance before** the object is physically built • **Faster modifications** and iterations • **Faster and easier to share** and remote access	• 3D visualizations are **always approximations** of the real object • **Lacking the tactile feel** typical of physical maquettes • **Long-term preservation** is harder to guarantee than for their physical counterparts • **Adequate software and hardware are needed** to experience virtual content which makes it sometimes less **democratic** • **Data loss** can occur during file conversion or exporting • Digital **files can corrupt** because of software errors, hardware failing, and much rarer events such as bit flips • Digital 3D models are influenced by the software tolerance, which could produce numerical errors if not properly handled • Photorealistic renderings can be hardly distinguishable from reality; this can **cause misconceptions** • Digital models **can be unusable** because of geometrical errors

The creation of 3D **physical maquettes** (→ Basics and Definitions) was time-consuming work that usually required a precise and long phase of planning, and each minimal change to the design required non-trivial effort to update the model. The most popular way to study, analyze, and present any design was through 2D projections, usually made by and for specialists who knew the representation codes (format/type of lines, color, standard direction of view, etc.) and were able to mentally process that information, and mentally compose the 3D object. Digital 2D-3D visualization has overcome some of the limitations that have characterized analog physical representation. Nevertheless, there are positive and negative aspects of this new technology. In Table 7.1, we compare the pros and cons.

7.3 Aspects of Digital 3D Visualization

Four aspects contribute to the visualization of 3D models:

- Formal/geometrical aspects (e.g., digital 3D object, segmentation).
- Shading aspects (e.g., materials, light, rendering algorithms).
- Representation aspects and methods (e.g., point of view, camera, projection methods).
- Media and interfaces (e.g., display, monitor, image, 3D prototype).

Formal/geometrical aspects concern how the 3D model/scene is made (\rightarrow 3D modeling): the spatial relations between the parts; the level of detail; the mathematical description of surfaces; the scale; the segmentation.

Shading aspects include the surface appearance (textures, material properties, photorealistic vs. abstract shading); the use of light/shadows (position and intensity of lights); the rendering algorithm (biased or unbiased).

Representation aspects and methods concern the ways of projecting 3D objects into a 2D plane (e.g., perspective, axonometric, and double orthogonal projection, etc.), this includes camera settings, points of view, anamorphisms, and solid perspective.

Media and interfaces are the technological devices used to visualize 3D models: 2D displays (pixel monitors, projectors, etc.); 3D displays (holographic displays, holograms, 3D stereo displays, etc.); VR/AR headsets; physical 2D drawings, prints, 3D rapid prototyping (3D printing, laser cutting, CNC milling, etc.).

Further reading: Degrees of freedom in 3D visualization What are the visual properties of 3D/4D visualizations?

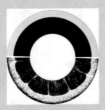

The level of detail (LoD) needs to be appropriate to the purpose [3]. While detailed visualizations of historical reconstructions are advantageous for imaginability [4], they may distract scholars from their research questions [5] or lead to cognitive overload [6].

Visual style is often discussed in terms of fit to scholarly recommendations and distraction of viewers [7]. Since early 3D/4D reconstructions strived for more immersive and realistic visualization [8], a current scope comprises a large variety of photorealistic and non-photorealistic styles [9–11].

Different degrees of certainty [12–14] have led to a multitude of visual strategies for heritage content [15]. Current approaches can be roughly categorized into enrichment of representations by explanatory elements [16] and adaptation of representation quality, e.g., LoD or visual styling [14, 3, 17–21].

Scaling has been frequently assessed as an important parameter for perceiving architecture [3, 22].

Visual acuity is the ability to distinguish details: in contrast to scale, the main influencing factor is the distance to a virtual or physical object [23–26].

Perspective depiction and perception of architecture include the viewer effect of different fields of view [27, 28, 26]; e.g., the top-down view is the predominant mode for investigating cityscapes [29].

Lighting is relevant to imagine historical architecture [30]. Specific workflows and approaches (based on visual comparisons) are proposed for virtual visualization [31–36].

Color is highly relevant for the perception of historical objects and ranges from realistic coloring to scales coding parameters or supporting visual distinction of model parts [37, 38]. Accurate reproduction of colors is challenging in both modeling [39, 40] and reproduction by digital devices [41].

In a **research context** visualization methods and technologies have a crucial role because they graphically synthesize aspects of the research, from critical reasoning via generating and sharing ideas to dissemination. Visualization choices might **enhance the**

communication of the study or strongly mislead or **distort** the interpretation of the results.

For example, it was long known that Greek temples were brightly colored, however, the **public misconception** is still that these temples were made with raw white marble. This misconception is mainly because the ruins that survived the centuries lost their colors and even when these structures were graphically reconstructed through operations of digital anastylosis, they were often represented with a white color in catalogs, magazines, pictures, and museum exhibitions.

The same risk looms over the visualization of any digital 3D reconstruction, thus those professionals aiming to produce scientifically accurate reconstructions have the responsibility not only to produce an accurate model, while documenting every step of the process, but also to communicate it clearly, limiting as much as possible any misconception. Shading and representation play the most important role in this regard.

7.4 Formal/Geometrical Aspects

Quite obviously, among all the elements necessary to produce any rendering of a 3D scene, the 3D geometrical model is the unavoidable starting point from which each other aspect derives. Without a 3D shape, there would be no medium to apply materials and textures into, target to point the camera toward, or obstacle with which the rendering algorithm could calculate the light bounces. All the aspects related to the generation of 3D geometry are extensively described in this chapter (\rightarrow 3D Modelling).

7.5 Shading Aspects

In painting and drawing, the word "shading" is usually used to define the process of darkening or coloring an illustration. It is fundamental to give an accurate perception of volume, sense of perspective, and material credibility to the objects. Painters who master the shading technique have deep knowledge of how our physical world works. For example, they know where a sphere is darker or lighter according to the direction of light, that the part of the sphere not exposed directly to the light source can be slightly lighted thanks to the light bouncing away from a near object, that the reflection of the light pointed on the sphere is sharp if the sphere is made with glossy material and smooth if the sphere has a rough material. **Shading depends on the shape, the light, and the materials**.

To be able to produce the same sphere properly shaded digitally, all this knowledge is not crucial anymore, because the proper calculation of the behavior of light bouncing on the surfaces is all delegated to the **render engine** through its sophisticated algorithm. A nonexpert, who does not know the laws of descriptive geometry well, may not notice errors in the model or in the automatic calculation of light. The two main types of render engines on the market nowadays are **biased** (approximated) and **unbiased**, (accurate). The most popular render engines in architecture and gaming have a certain level of bias

because they produce images faster than unbiased engines, as even with a small amount of approximation/bias, they can be still very close to producing physically plausible results. A good render artist can compensate for the biases by artistically manipulating the shading of the scene (adding hidden lights or manually changing the color channel of the surfaces of the objects to simulate penumbrae color bleeding, bouncing light, etc.), so it is still possible to get very close to physically plausible results even with biased engines.

Both biased and unbiased render engines support the applications of synthetically generated procedural textures and reality-based textures. Since synthetically generated procedural textures are computer-calculated images as e.g. fractal patterns; reality-based textures are based on images of material surfaces. This, paired with the ability of the render engines to produce images with a physically plausible light distribution are the ingredients of the recipe for **photorealistic rendering**. Render engines can also produce **non-photorealistic (NPR) images**, by applying rules which are not physically based on the distribution of light and the definition of the properties of the materials.

7.5.1 Photorealistic Shading

A completely textured scene with photorealistic textures (Figs. 7.1 and 7.2) and a physically plausible distribution of light is the aspiration of most reconstructions in entertainment and exhibition contexts [44, 45]. However, photorealism is sometimes mistrusted in the academic and scientific context of 3D historical reconstructions [11], not only because the radiosity of the scene can be approximated by itself due to biases of the render engines, but most importantly because it is very hard to retrieve enough information about materials for every object in the scene by direct inference from historical sources. When information is lacking, subjective interpretations has to compensate, which is one of the main causes of misinterpretations.

Fig. 7.1 Reconstruction of the water jets of Neptune fountain in Bologna. Photogrammetry + laser scanning + liquid simulations [42] (Image: Foschi)

Fig. 7.2 Reconstruction of the market in Piazza delle Erbe in Verona during the Middle Age. Project presented at Expo 2015 [43] (Image: Foschi)

Photorealism (physical plausibility) and theatricalization, are often priorities for entertainment applications (documentaries, games, movies, museums, etc.). To achieve that, it is necessary to precisely define the properties of every material applied to all the surfaces so the light can properly bounce on them. This requires a level of knowledge that is usually very hard (if not impossible) to retrieve by direct sources and thus it is usually heavily subject to personal interpretations, which is not desirable if the aim is to produce a scientific reconstruction with minimal subjective additions. Nevertheless, photorealistic visualizations can drive academic research forward as they can provide insights otherwise hardly deducible from an abstract visualization.

Thus, can photorealistic texturing ever be scientifically accurate in the context of digital 3D historical reconstruction? The reproduced result does not necessarily need to match the original artifact 100%, as despite the efforts and the abundance of sources, the reproduction will always be an approximation of the original. **Scientific reproducibility in this context means that the process is documented** so that any other researcher who follows the same process based on the same sources would end up with the same result. Given this definition, we can certainly assert that, yes, photorealistic texturing can be scientifically acceptable as far as uncertainties and subjective conjectures are clearly identified and documented.

Even if all the conjectures are perfectly documented, and the process complies with the requirements of the scientific method, **the risk of misinterpretation** by a casual viewer facing a photorealistic rendering, heavily based on conjectures, **is still high**. If there are no visual clues that some part of the scene or texture might have been completely conjectured, this might lead the viewer to think that the scene was exactly like it is pictured. To avoid ambiguities and misconceptions, in academic context photorealistic texturing

should be used with caution and only when there is a robust documental basis. The surface appearance uncertainties could be communicated visually, by pairing the photo-realistic view with another false color view indicating which areas have which level of uncertainty (\rightarrow Documentation).

Further reading: Scale of uncertainty The scale of uncertainty is a common tool often proposed in the context of 3D reconstruction of unbuilt or lost architecture (some authors use the terms reliability, plausibility, etc. [19]). These scales help to make each hypothetical reconstruction transparent and easier to understand and evaluate. A color is assigned to each level of the scale, and each level has a description usually related to the type and quality of the sources. The colors are then applied to each element of the 3D reconstructed model. This abstract shading gives information about the level of uncertainty of each element and the overall model at a single glance.

Several scales of uncertainties were developed over the years [19]. The scale presented in Tables 7.2 and 7.3 was developed to minimize ambiguities and overlapping between the different levels: it is based on the presence/absence of preserved/damaged sources and their authors [37].

Table 7.2 Level of uncertainty scale [37]

	Description
1	Reliable assumption derived from reality-based data (i.e., the full real object or parts of it, well-preserved archaeological founds, direct surveys, laser scans)
2	Reliable conjecture based on clear and accurate direct/primary sources* when the real object or parts of it are not available
3	Conjecture based on stylistic/structural references by the SAME AUTHORS when direct/primary sources are available, but unclear/damaged/inconsistent/inaccurate. Or logic deduction/selection of a variant derived from inconsistent direct sources
4	Conjecture based on stylistic/structural references by DIFFERENT AUTHORS when direct/primary sources are available, but unclear/damaged/inconsistent/inaccurate
5	Conjecture based on stylistic/structural references by the SAME AUTHORS when direct/primary sources are not available
6	Conjecture based on stylistic/structural references by DIFFERENT AUTHORS when direct/primary sources are not available
7	Conjecture based on personal knowledge due to missing or unreferenced sources
\	Not relevant/not considered/left unsolved/missing data and missing conjecture (it does not count for the calculation of the average uncertainty)

* Direct/primary sources: all the sources where the object is directly represented, reported, or recorded with any level of accuracy (e.g., drawings, sketches, surveys, pictures, paintings, texts, books, coins, medals, reliefs, physical models, sculptures)

Table 7.3 Level of uncertainty scale, reliability [37]

	Real object	Direct/primary sources		Other sources		Reliability
		Clear/ consistent	Damaged/ unclear	Same author/s	Other author/s	
1	✓	\	\	\	\	Reality
2	✗	✓	\	\	\	Reliable conjecture
3	✗	✗	✓	✓	\	Conjecture
4	✗	✗	✓	✗	✓	Conjecture
5	✗	✗	✗	✓	\	Conjecture
6	✗	✗	✗	✗	✓	Conjecture
7	✗	✗	✗	✗	✗	Conjecture
\	\	\	\	\	\	Abstention

Legend: ✓ = yes, \ = not relevant, ✗ = no

This particular scale not only gives clues about the type of sources and their author (primary sources by the same author, secondary sources by different authors, etc.), but also about their quality (damaged/undamaged, readable/unreadable, consistent/inconsistent, etc.), and about the level of reliability of the results of the reconstruction based on these sources (reliable/unreliable, conjecture/abstention). Each level of the scale was assigned to a recognizable/nominable color and number. These numbers are a possible alternative to colors in monochrome and visually accessible publications, and can be used to calculate the average global uncertainty of the reconstruction (Fig. 7.3). This specific scale was designed with 7 steps (+ one step for abstention) that can be reduced to 5 and 3 steps without losing comparability (Fig. 7.4).

Fig. 7.3 Left: false-color scale to show uncertainties; Right: calculation of the average uncertainty, Andrea Palladio, Villa Pisani, Bagnolo [37]

Fig. 7.4 Granularity of the scale of uncertainty [37] (Image: Foschi)

Can photorealistic texturing ever be free of subjective interpretations? Theoretically yes, if it is based on strong evidence. In modern render engines, diffuse color (albedo) of the surface is not the only property that is required to define a proper material; other properties are needed, such as roughness, glossiness, bump, IOR, and so on. Even if we find sources where the materials are precisely described textually and graphically with colored drawings, it is still formally impossible to retrieve only from textual and graphical sources all the properties that modern 3D render engines require. Not to mention that the color of the drawings is influenced by the intrinsic color of the paper and

they suffer discoloration or color shifting over time, so even colored documental sources are not 100% reliable.

The only plausible way to be able to identify with maximum objectivity the texture and material properties would be by having a physical sample of the original material. In architectural hypothetical reconstruction, it is very rare to have such a clear and complete source.

It is true that in photorealistic renderings the level of uncertainty is usually higher compared to abstract rendering, but it is also important to not demonize it. Sometimes, e.g. to enable visual assessment, definition of photorealistic surface appearance becomes a crucial aspect of the scope of the reconstruction. In these cases, it becomes even more important to document clearly the process of texturing as much as it is for the modeling.

7.6 Abstract Shading

When the sources about surface appearance are lacking, the most popular alternative to photorealistic shading is the application of a **neutral mono-material**, usually grey or white, because it is a fast solution and is considered more objective. However, this choice might cause **misconceptions** similar to those described above for Greek temples and does not add any useful information. The white mono-material is part of the more general method of **abstract shading**, also called non-photorealistic (NPR) shading, the counterpart of photorealistic (PR) shading. Abstract shading conveys **additional information through colors and textures**.

One of the most popular ways to convey additional information through abstract shading is to apply **false colors** to the elements of the model, organized in scales where each step is described through textual legends (Fig. 7.5). False colors can be used to express many different concepts: restorers use red and yellow to indicate which part of the building was reconstructed or demolished; archaeologists use colors to define the different palimpsests and ages; lighting designers use scales of color to identify which parts of the model receive more light radiation; fluid or gas speed in 3D simulations can be described with a false color scale. In digital reconstruction, one of the most popular uses of false color scales is to visually communicate eventual variants, the level of uncertainty or the type of sources used [37] (\rightarrow Documentation).

Another possible alternative abstract texturing technique is the projection of the graphical sources on the 3D model (Figs. 7.6, 7.7 and 7.8) [37]. This method is aimed to enrich the sources by adding the third dimension, or vice versa to enrich the model through the projection of its 2D graphical sources onto the 3D surfaces of the model, and it does not need any legend to be explicit. A similar shading technique which tries to mimic the graphic style of the sources, but without projecting the sources directly onto the model as

Fig. 7.5 Andrea Palladio, Villa Saraceno. False color scale to show uncertainties [46] (Image: Apollonio)

textures, is described by Daniela Sirbu [47]: the textures and lights are redesigned entirely by hand trying to reproduce the same lighting, surface appearance, and atmosphere of the reference source. This technique might be preferable to projection when the reference sources are particularly damaged or lacking, or low resolution.

Borderline techniques lie between photorealistic and abstract. For example, the **black and white view** can be close to the photorealistic rendition because it can use textures from photos and the distribution of light can still be physically plausible, but undeniably not realistic in a strict sense because the information about the colors was removed. This solution decreases the level of uncertainty when color information is lacking. Rather than converting the renderings from colored to black and white as the last step, it is also possible to convert each texture to black and white before rendering; with this solution, however, the surfaces would eventually inherit a bit of color from colored light sources.

Fig. 7.6 Projection of the original drawing on the 3D model by Mauro Guidi, Sepolcro antico di figura quadrata con portico di due gradini, Cesena Nuova, Atlante 41, Carta 48. Top: 3D CDM; Bottom: original drawing [37] (Image: Foschi)

Fig. 7.7 Projection of the original source on the 3D model. Claude Nicolas Ledoux, Atelier des gardes de la forêt, Cité idéale de Chaux, Tome 1, Pl. 102. Top: 3D CMD; Bottom: original drawing [37] (Image: Foschi)

Fig. 7.8 Projection of the original sources on the 3D model, Art gallery castle Schwerin (Image: Architectura Virtualis, Darmstadt 2018)

Other abstract shading techniques (Fig. 7.9) used for various scopes are listed below:

- Wireframe
- Ghosted
- X-ray
- Cartoon/Comix
- Silhouette
- Hand drawn
- Flat colors
- Technical drawing
- Ambient occlusion
- Water colored
- Inverted colors
- Black and white.

All these techniques, and many others not listed here, are very different from each other, but share the fact that they do not try to mimic reality. Some of them have only ornamental and aesthetic uses, while others can be useful for **enhancing the readability** of the images, bringing **attention to particular details**, or **showing hidden details**. For example, through wireframe/ghosted/X-ray shading it is possible to look inside the models without disassembling them, or through flat color shading, it is possible to see the albedo of the surfaces without the effect of lights and shadows.

Abstract shading is sometimes used only to characterize some elements in the scene, while others are photo-realistic textures. This solution can be useful to highlight explicit elements with known surface appearance (Figs. 7.10, 7.11 and 7.12). Sometimes abstract shading can also be used as an additional shading style, that accompanies photorealistic views, to highlight elements in the scene (Fig. 7.13).

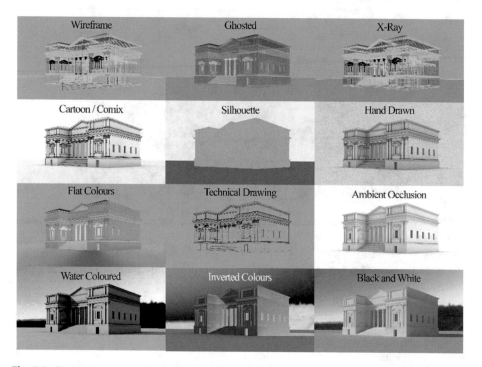

Fig. 7.9 Some abstract shading techniques (Image: Foschi)

Fig. 7.10 Cartoon style + photorealistic textures to indicate different surface appearance uncertainty, Carolingian Church Saint Gall (Image: Architectura Virtualis Darmstadt, 2019)

Fig. 7.11 Reconstruction in ghosted style to show the photo-realistically textured plan underneath, Plan of Saint Gall (Image: Architectura Virtualis Darmstadt 2019)

Fig. 7.12 Photorealistic texturing + gray monomaterials to indicate surface appearance uncertainty. Reconstruction of the exhibition organized by Antonio Canova around 1818, Church of Santo Spirito, Bologna [48]

Fig. 7.13 Left: bird's eye view of a cartoon-style shaded reconstruction; Right: the same reconstruction framed at human height with photorealistic shading, the medieval Jewish quarter in Cologne (Images: Stadt Köln, Dezernat Kunst und Kultur, VII/3—Archäologische Zone/Jüdisches Museum, MiQua. LVR-Jüdisches Museum im Archäologischen Quartier Köln and Technischen Universität Darmstadt, Fachgebiet Digitales Gestalten, 2019)

7.7 Representation Aspects and Methods

Nowadays the traditional methods of representation are used mostly to visualize 3D models. The visualization of 3D models uses various projections. Most relevant are:

- Double orthogonal projections (Fig. 7.14)
- Axonometric projection (Fig. 7.15)
- Perspective projection (Fig. 7.16)
- Topographic terrain projection (Fig. 7.17).

These methods start from the classical projection from a center and section (with the picture plane). We can identify two general cases: conical projection generating perspectives, and parallel projections (where the projection center is a direction) that generate axonometric projections and double projections. If the projection direction is perpendicular to the picture plane, we can obtain an orthogonal axonometric projection or a double orthogonal projection (plan and elevation, or section). If the projection direction is angled relative to the picture plane, we will obtain an oblique axonometric projection.

Double orthogonal projections are still used as a starting point to draw the 2D blueprints used as references for 3D models: plans, sections, and elevations. After building the 3D model, it is possible to extract an orthogonal view, an axonometry, or a perspective automatically. These methods of representation/visualization can be differentiated according to their use/scope. Double projections are used to geometrically and metrically describe the project; for example, the plan is used to control the positioning and size of spaces, walls, and furniture. Sections and elevations in general are used to design and communicate height. The axonometric view is used to study the relations between volumes and spaces. Lastly, the perspective view is used to formally control the perception of space: if used correctly it is the only method capable of representing the space viewed from the inside, from the point of view of an imaginary human visitor (placed in

Fig. 7.14 Double orthogonal projection: Villa Pisani Riba by Palladio (Image: Foschi and Fallavol-
lita 2024)

Fig. 7.15 Oblique axonometric projection: Villa Pisani Riba by Palladio (Image: Foschi 2024)

Fig. 7.16 Perspective projection: Villa Pisani Riba by Palladio (Image: Foschi 2024)

Fig. 7.17 Terrain topographic projection: Contour lines (Image: Foschi 2024)

a measurable point in the digital space). In contrast, double projections and axonometric projections always have a point of view outside the designed space (since their point of view is infinitely far).

There are three types of **orthogonal axonometry: trimetric, dimetric, and isometric**. This distinction addresses the three ways to view the three orthogonal Cartesian axes X, Y, and Z when viewed with a certain angle. The three orthogonal axes shrinking ratio and orientation are the main focuses of axonometric projection; even its etymology encapsulates these concepts. In digital representation, generating an orthogonal axonometric view is automated by the software, in fact, almost every **3D modeler or visualization software integrates the axonometric view** as one of the standard visualization modes. Traditionally, the distinction of these three main types of axonometric projections was important to differentiate which construction to use (usually performed with a ruler and compass), but in computer programs, it is not important anymore because the visualization is automatic from any angle and generally, we can choose the best axonometric view based on other criteria, such as the best angle of view.

In some rendering applications, axonometric views are created upon the activation of the specific viewport option or through virtual cameras placed inside the scene. However, some cameras, such as physical cameras, might not have any option to make orthogonal views, because to be able to generate parallel projections they should be placed infinitely far from the target, and this would not be acceptable for a simulation of a physical camera. A workaround that would return a good approximation of an axonometric projection would be adopting a very narrow field of view or long focal length (500/1000mm or more) and moving the camera very far away in the direction of the axis of view [49]. With this expedient, the final projected view would be very similar to an axonometric projection because the perspective foreshortening would be minimized. Even a professional with a keen eye would not be able to notice the difference without measuring some distances with highly accurate tools. This method is also useful to obtain approximations of obliquus axonometric projections (such as the military axonometry where the plan is in true form) which are much rarer than standard visualization modes in 3D computer applications.

For perspective views, it is important to know some principles of descriptive geometry that help to frame the scene. The first issue is the definition of the viewpoint. As mentioned, **perspective is the only method capable of framing the space from the inside**. This important quality can be exploited to see the space at human height. Even if the virtual cameras have many options that can be set, the perspective projection only depends on the viewpoint location. The focal length and the field of view of the virtual cameras depend on each other and only determine the amount of scene that is captured inside the frame. Shorter focal lengths and wider field of view capture more space (and vice versa) but changing these values will not change the perspective projection as far as the point of view is not moved. Given that, there are a few good practices that one can follow to capture good architectural views:

- **Place the viewpoint at realistic heights** (e.g., for views at a human height the average height would be 1.5/1.7 m).
- **Keep the projections of the vertical lines of the 3D object parallel to the sides of the frame** (to do so, it is sufficient to keep the camera projection plane perfectly vertical, or the camera and its target at the same height). This is not valid for bird's eye views or shots that try to emphasize the height of a building.
- **Choose the appropriate picture ratio and field of view** of the virtual camera according to what we want to include in the shot and according to the formal aspects of the content of the shot.

Virtual cameras are often similar to real cameras; thus, we refer to 35mm cameras. Focal lengths of 70/100mm are comparable to telephoto lenses, 35/50 mm are considered standard focal lengths, 18/28 mm are considered wide-angle lenses, and 18mm or less are considered fisheye lenses. There is no univocal rule to choose the best focal length in every situation because every architecture is different and can be appreciated with

different lenses. However, it is preferable to **avoid very short focal lengths for framing historical architecture** because apparent deformations (more visible along the perimeter of the picture) would not allow the viewers to appreciate the spaces properly and would distort the perception of proportions and shapes [27]. Contemporary architecture might benefit from the use of wide-angle lenses because the extreme and unconventional spaces and shapes would be emphasized by these apparent perspective deformations.

Apparent deformations in the field of visualization can be exploited to make **anamorphic illusions**. An iconic case in the field of architecture is the Church of Sant'Ignazio di Loyola in Campo Marzio, Rome. This church is well known for the paintings by Andrea Pozzo (1685) where, if standing from a specific point, the visitors can perceive the illusion of an additional architectural order that breaks through the vault. All the paintings performed with the technique known as trompe-l'œil are anamorphic illusions.

Other perspective illusions in the field of architecture can be obtained **through the theory of solid perspective**. In the solid perspective, the perspective space is not confined anymore in the picture plane, as in the previous examples, but it is expanded into another 3D space [49]. Some architects in the past used this technique to produce impressive perspective illusions, such as Andrea Palladio in the Teatro Olimpico, Vicenza (1580) or Francesco Borromini in the Galleria Spada, Rome (1652).

Another practical use of solid perspective in digital reconstruction can be seen in the study of the error committed by Leonardo da Vinci in his preparatory drawing of the Adoration of the Magi now housed at the Louvre, Paris [50]. Thanks to digital tools it is now possible to study the transformation of a shape from the real space to the perspective space, and vice versa, dynamically [51].

7.8 Media and Interfaces

The most popular media and interfaces **to view any digital content** comprise any type of **2D display** such as the ones mounted on smartphones, TVs, laptops, desktop PCs, and so on. Old technologies that are still available but have rapidly fallen into disuse, such as cathode-based displays, have given way to the newer **LCD and LED displays**. These are mostly 2D but can also be 3D, namely, they can reproduce two images at the same time that can be synchronized to give the illusion of depth through the **stereoscopic** view. 3D standard displays usually need secondary optical devices as e.g. polarizing filter glasses, Other techniques as **parallax displays** give the perception of depth without the need for secondary optical devices. Approaches like **head tracking** or **eye tracking** try to improve the visualization depending on the viewer's position of depth perception or the level of **interactivity** at the cost of limiting the number of viewers that can use the display at the same time. Beside those fixed screen devices there are several technologies using head mounted displays, which require user devices such as **headsets or holographic glasses**. Other recent strands using fixed screens are **holographic visualizations**, including

volumetric displays of heritage objects [52]. Deviceless approaches include **rapid prototyping** of manufactured models or printed images, which can be observed by viewers without specific devices.

7.8.1 Images and Films

Visual media and perception are the main sources of information, communication, and research on cultural heritage [53–55] and images are still the most frequent output of 3D modeling projects [56, 57]. Images are used in films and animations [58] or as still images. Formats and purposes differ greatly between the main target groups: the general public and domain experts [59]. Visualizations equally serve to represent relations, processes, and a constructive structure [60]. All these types of outputs are usually presented through 2D, or 3D displays shared digitally (online or offline) or printed on a physical support (e.g., paper, cardboard, wood).

7.8.2 Extended Reality

In contrast to asynchronous media like images and films, **extended realities (XR) provide a real-time, high level of engagement visualization**, which is not constrained to a single point of view and allows variable levels of interaction between the users and the virtual content [61]. A wide scope of interactive technologies [62] lies on the continuum between real and virtual [63] (Fig. 7.18). This ranges from real environments, **augmented realities (AR), and augmented virtuality (AV)**—together called **mixed reality (MR)**— to **virtual reality (VR)**, or fully computer-generated visual representations. According to Russo [64], MR can be additive by adding information that does not exist, or subtractive by hiding or deleting parts of the real world. Layouts for user interaction are highly dynamic, perspective-dependent, and require a high degree of temporal coherence [65, 66]. So far, the representation of time-independent data has been investigated most and developed into interaction patterns [67, 68]. Overviews about XR applications in cultural heritage have been presented in various publications with regard to museums [69, 70] and virtual tourism [71].

7.8.3 Rapid Prototyping

Rapid prototyping can be a useful visualization medium because it allows direct interaction with the model without needing prior knowledge of digital tools, so it is a more democratic way of presenting 3D objects. Furthermore, compared to a model visualized on a 3D screen, it helps to better understand the relation between 3D volumes and how light interacts with them. Lastly, it is less susceptible to digital deprecation, which might

Glass-based virtual reality Screencast of an augmented reality Glass less holographic projection

Fig. 7.18 Qualities of extended reality visualizations (Images: Left: Sauer 2019, Middle: Niebling 2019, Right: Münster 2019)

make older digital 3D models to not be accessible in future. However, 3D physical maquettes are susceptible to wearing and can break; are longer to produce, refine, and modify; and they are not suitable for joint remote working or inspection at different scales.

A wide range of rapid prototyping techniques is used to create physical representations of tangible heritage [72] (→ Fig. 7.19). This comprises **additive** manufacturing techniques that add layers of material to a 3D structure and **subtractive** techniques shaping a 3D structure by removing material [73–75, 76]. The used technology highly depends on the material—e.g., thermic processes such as FDM require materials with a low melting point, while sintering or milling approaches require specific physical properties of the material [77]. Another major influencing factor is the scale of reproduction, ranging from 1:1 reproduction at various scales to miniaturizations (e.g., city models) or maximizations of very small objects. There are three highly relevant technologies for additive manufacturing. (1) **stereolithography**, which builds objects in layers by tracing a laser beam on the surface of a vat of liquid photopolymer and hardening by UV or thermal processing. (2) **laser sintering** is based on powders (e.g., metals, polymers, composite materials) applied in layers and selectively fused or melted at the surface by laser bonding to the layer below; after removing unprocessed powder, a 3D structure remains. (3) **Fused filament fabrication** is application of thermoplastic material in layers, which are heated and deposited layer by layer [78]. Subtractive approaches comprise computer-controlled milling tools (**CNC machinery**), which mill 3D structures out of solid blocks of material [79] or **laser engraving**, which uses a cross laser beam to selectively overheat spots within solid glass and cause micro-cracks with differing refraction properties [80].

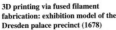

3D printing via fused filament fabrication: exhibition model of the Dresden palace precinct (1678)

3D printing via digital light processing: The Foundation of Medieval Cities exhibit

Manufacturing model of the Pirna steamship as diecast

Fig. 7.19 Rapid prototyping (Images: Left/Middle: Architectura Virtualis GmbH 2016, Right: Münster 2009)

7.8.4 Interaction and Motivational Design

The visual appearance, user presentation, and interaction with 3D content are marked by the level of interactivity and pose various design variables. Specifically for educational settings, motivational design is of relevance for engaging with users and enabling learning.

For **interaction design**, the interaction is classified by the engagement taxonomy developed by Grissom et al., which differentiates between six degrees of interactivity for visual output [80]. According to Tullis and Albert, user experience "refers to all aspects of someone's interaction with a product, application, or system" [81, p. 15].

For **digital interface design**, many interaction parameters are technically determined—e.g., by the capabilities of VR glasses. Especially, XR applications go well beyond passive information presentation and enable multiple freedom degrees for interaction design, as well as user requirements such as avoiding motion-sickness due to continuous movement [82, 83]. With regards to acceptance, the perceived usefulness of applications plays a major role, which in turn depends on optimal stimuli of representation and interaction [84]. Layouts for user interaction are highly dynamic and perspective-dependent and require a high degree of temporal coherence [65, 66]. Currently, mainly the representation of time-independent data has been investigated and developed into interaction patterns [67, 68], since validated strategies for time-dependent 4D data presentation are still missing.

Especially in cultural institutions and at sites, digital 3D applications are embedded in physical spaces. There are various recommendations for the design of **linked virtual and physical spaces**, e.g., in museums [85, 86] or at heritage sites via location-based 3D applications [87, 88]. Some recent evolvements comprised multi-user story-based virtual experiences in physical museums, enriching museum visits with augmented experiences [89].

Motivational design involves gamified and playful approaches. According to Deterding et al., gamification implicates the use of "elements of games that do not give rise to entire games" [90, p. 2]. Playful design—in contrast to gamification—contains

no rules or specific goals, and serious games are defined as full-fledged games for non-entertainment purposes [90]. All three types are intensively used with 3D contexts in heritage, particularly in educational settings. Examples are:

- **Playful design:** Examples are Minecraft-like creation games [91] or massive open online environments (MUVEs) as 3D social interaction spaces [92].
- **Gamification:** Applications using gamified elements and strategies to enhance interaction with heritage content [93].
- **Serious games:** Games either developed for didactic purposes or derived from entertainment games [94, 95].

Storytelling stands for the use of narratives and fictional or non-fictional stories to present a subject [96]. Psychological [97–99] and educational studies [100] have demonstrated that narratives can have both a positive motivational effect by making a subject more alive and engaging to the audience, and a positive learning effect by reducing cognitive load. Storytelling is widely used to digitally present heritage content [101], and particularly for digital 3D models in humanities in various educational settings [102–106]. Among the multitude of freedom degrees for design (e.g., by fictionality, media, storytelling modes, or poly-vocationality) [101], general types of scenarios from an educational perspective are:

- **Expositional:** Story elements are used in a pre-scripted way to explain specific 3D objects. Examples include the presentation of underwater archaeology through stories told by an avatar [102].
- **Explorative:** Open-world games or open-ended platforms encourage dialogic encounters where the user has various choices to interact with a dynamic supply of narrative contents. Examples include the discovery mode in the game Assassins Creed [107] or dynamically scripted heritage experiences [108].
- **Constructive or connective approaches:** Users can co-create stories and contribute story content and share with others. An example is the Jena4D project where users contribute location-based personal stories and photographs in a 4D environment [109].

Summary This chapter deals with the topic of visualizing architectures that have never been built or have been lost, including formal, geometrical, shading, and representation aspects, media and interfaces, interaction and motivational design. All the concepts are treated in terms of the digital reconstruction of cultural heritage.

Standards and guidelines

- Beacham, R.; Denard, H.; Niccolucci, F. An Introduction to the London Charter. In Papers from the Joint Event CIPA/VAST/EG/EuroMed Event, Ioannides, M., Arnold, D., Niccolucci, F., Mania, K., Eds.; 2006; pp. 263–269.
- Denard, H. (2009) The London Charter. For the Computer-Based Visualization of Cultural Heritage, Version 2.1. (https://www.londoncharter.org, accessed on 1.2.2023).
- Principles of Seville. International Principles of Virtual Archaeology. Ratified by the 19th ICOMOS General Assembly in New Delhi, December 2017 (http://sevill eprinciples.com, accessed on 1.2.2023).

Projects

- **The Computer-based Visualization of Architectural Cultural Heritage (CoV-Her) project** is a European project focused on fixing shared standards at the European level for the field of digital 3D reconstruction for heritage, and on the dissemination at the high education level for students and scholars.
- **Time Machine** is aiming to join Europe's rich past with up-to-date digital technologies and infrastructures, creating a collective digital information system mapping the European economic, social, cultural, and geographical evolution across times.
- **The Inception European project** realizes innovation in 3D modeling of cultural heritage through an inclusive approach for time-dynamic 3D reconstruction of artifacts, built and social environments. It enriches the European identity through an understanding of how European cultural heritage continuously evolves over long periods of time.

Key literature

- Migliari R, Fasolo, M. (2022) Prospettiva Teoria. Applicazioni Grafiche e Digitali. Hoepli Editore, ISBN 9788836008841 [49].
- Akenine-Moller, T., Haines, E., Hoffman, N., Pesce, A., Iwanicki, M. and Hillaire, S. (2018) Real-Time Rendering, 4th Edition. ISBN-13: 978–1138627000, ISBN-10: 1138627003 [110].
- Pharr, M., Jakob, W. and Humphreys, G. (2016) Physically Based Rendering: From Theory to Implementation, 3rd Edition. ISBN: 9780128006450 [111].

References

1. Ware C (2004) Information visualization: perception for design. The Morgan Kaufmann series in interactive technologies, vol 22
2. Frischer B et al (2008) Beyond illustration. 2D and 3D digital technologies as tools for discovery in archaeology. BAR international series 1805
3. Glaser M et al (2017) Designing computer-based learning contents: influence of digital zoom on attention. Etr&D-Educ Technol Res Dev 65(5):1135–1151
4. Tversky B (2005) Visuospatial reasoning. In: Holyoak K et al (eds) Handbook of reasoning. Cambridge University Press, Cambridge, pp 209–249
5. Strothotte T et al (1999) Visualizing knowledge about virtual reconstructions of ancient architecture
6. de Boer A et al (2009) Towards a 3D visualization interface for cultural landscapes and heritage information. In: Making history interactive, pp 1–10
7. Favro D (2006) In the eyes of the beholder. Virtual reality re-creations and academia. In: Haselberger L et al (eds) Imaging ancient Rome: documentation, visualization, imagination: proceedings of the 3rd Williams symposium on classical architecture, Rome, 20–23 May 2004. J Roman Archaeol Portsmouth 321–334
8. Grau O (1999) Die Sehnsucht, im Bild zu sein. Zur Kunstgeschichte der virtuellen Realität
9. Heeb N et al (2019) Strategien zur Vermittlung von Fakt, Hypothese und Fiktion in der digitalen Architektur-Rekonstruktion. In: Kuroczyński P et al (eds) Der Modelle Tugend 2.0: Digitale 3D-Rekonstruktion als virtueller Raum der architekturhistorischen Forschung, Heidelberg
10. Sayeed R et al (2006) State of the art non-photorealistic rendering (NPR) techniques. In: McDerby M et al (eds) EG UK theory and practice of computer graphics, pp 1–10
11. Roussou M et al (2003) Photorealism and non-photorealism in virtual heritage representation. In: Arnold D et al (eds) VAST2003 4th international symposium on virtual reality, archaeology, and intelligent cultural heritage. Eurographics Publications, Aire-La-Ville, pp 51–60
12. Spiegelhalter D et al (2011) Visualizing uncertainty about the future. Science 333(6048):1393–1400
13. Pang AT et al (1997) Approaches to uncertainty visualization. Vis Comput 13(8):370–390
14. Wood J et al (2012) Sketchy rendering for information visualization. IEEE Trans Vis Comput Graph 18(12):2749–2758
15. Mütterlein J et al (2017) Immersion, presence, interactivity: towards a joint understanding of factors influencing virtual reality acceptance and use
16. Dudek I et al (2015) How was this done? An attempt at formalising and memorising a digital asset's making-of. Digit Herit 2:343–346
17. Münster S (2018) Cultural heritage at a glance. Four case studies about the perception of digital architectural 3D models. In: Alonso F (ed) 2018 3rd digital heritage international congress (DigitalHERITAGE) held jointly with 2018 24th international conference on virtual systems & multimedia (VSMM 2018). IEEE, San Francisco
18. Apollonio FI et al (2013) 3D modeling and data enrichment in digital reconstruction of architectural heritage. Int Arch Photogram Remote Sens Spat Inf Sci XL-5/W2; XXIV international CIPA symposium, 2–6 September 2013, Strasbourg, pp 43–48
19. Apollonio FI (2016) Classification schemes for visualization of uncertainty in digital hypothetical reconstruction. In: Münster S et al (eds) 3D research challenges in cultural heritage II: how to manage data and knowledge related to interpretative digital 3D reconstructions of cultural heritage. Springer International Publishing, Cham, pp 173–197

20. Lengyel D et al (2011) Darstellung von unscharfem Wissen in der Rekonstruktion historischer Bauten. In: Heine K et al (eds) Von Handaufmaß bis High Tech III. 3D in der historischen Bauforschung. Verlag Philipp von Zabern, Darmstadt, pp 182–186

21. Fornaro P (2016) Farbmanagement im 3D Raum. In: Der Modelle Tugend 2.0

22. Yaneva A (2005) Scaling up and down: extraction trials in architectural design. Soc Stud Sci 35(6):867–894

23. Bernardini W et al (2013) Quantifying visual prominence in social landscapes. J Archaeol Sci 40(11):3946–3954

24. Polig M et al (2021) Assessing visual perception in heritage sites with visual acuity: case study of the Cathedral of St. John the Theologian in Nicosia, Cyprus. ACM J Comput Cult Herit 14(1)

25. Ogburn DE (2006) Assessing the level of visibility of cultural objects in past landscapes. J Archaeol Sci 33(3):405–413

26. Paliou E (2018) Visual perception in past built environments: theoretical and procedural issues in the archaeological application of three-dimensional visibility analysis. In: Siart C et al (eds) Digital geoarchaeology. Natural science in archaeology. Springer International Publishing, Cham, pp 65–80

27. Karelin D et al (2019) Methods of reconstructions' presentation and the peculiarities of human perception → 3D reconstruction, angle of view, architecture, methodology, perspective, plane of projection, presentation, Rauschenbach, viewpoint, visualisation. In: Kuroczyński P et al (eds) Der Modelle Tugend 2.0: Digitale 3D-Rekonstruktion als virtueller Raum der architekturhistorischen Forschung. Heidelberg, pp 186–201

28. Rauschenbach B (2002) Geometry of picture and visual perception

29. Johnson MH (2012) Phenomenological approaches in landscape archaeology. Annu Rev Anthropol 41(1):269–284

30. Mondini D et al (eds) (2014) Manipulating light in pre-modern times. Architectural, artistic and philosophical aspects. Mendrisio

31. Happa J et al (2012) Cultural heritage predictive rendering. Comput Graph Forum 31:1823–1836

32. Noback A (2019) Lichtsimulation in der digitalen Rekonstruktion historischer Architektur. Baugeschichte, Computervisualisierung, Lichtsimulation, Predictive Rendering. In: Kuroczyński P et al (eds) Der Modelle Tugend 2.0: Digitale 3D-Rekonstruktion als virtueller Raum der architekturhistorischen Forschung. Heidelberg, pp 162–185

33. Noback A et al (2014) Complex material models in radiance. In: Paper presented at the 13th radiance workshop, London

34. Papadopoulos C et al (2014) Formal three-dimensional computational analyses of archaeological spaces. In: Paliou E et al (eds) Spatial analysis and social spaces. De Gruyter, pp 135–166

35. Happa J et al (2010) Illuminating the past: state of the art. Virtual Real 14(3):155–182

36. Happa J et al (2020) Studying illumination and cultural heritage. In: Liarokapis F et al (eds) Visual computing for cultural heritage. Springer series on cultural computing. Springer International Publishing, Cham, pp 23–42

37. Apollonio FI et al (2021) the critical digital model for the study of unbuilt architecture. In: Niebling F et al (eds) Research and education in urban history in the age of digital libraries. Springer International Publishing, Cham, pp 3–24

38. Healey CG (1996) Choosing effective colours for data visualization. In: Proceedings of seventh annual IEEE visualization'96. IEEE, pp 263–270

39. Boochs F (2012) COSCH – colour and space in cultural heritage, A new COST action starts. In: Paper presented at the EuroMed, Lemesos, Cyprus

40. Martos A et al (2015) Acquisition and reproduction of surface appearance in architectural orthoimages. Int Arch Photogram Remote Sens Spat Inf Sci XL-5/W4:139–146
41. Dhanda A et al (2019) Recreating cultural heritage environments for VR using photogrammetry. Int Arch Photogram Remote Sens Spat Inf Sci XLII-2/W9:305–310
42. Apollonio FI, Foschi R, Gaiani M (2016) Una nuova acqua per la Fontana del Nettuno di Bologna: la simulazione di progetto del sistema degli zampilli/New water for the Neptune Fountain in Bologna: simulation of the design of the multi-jet system. In: Disegnare idee Immagini, Gangemi Editore, 53, pp 68–79. https://www.torrossa.com/en/resources/an/4570868
43. Apollonio FI et al (2017) A Journey in the Fourteenth Century. A Digital Reconstruction of Piazza delle Erbe in Verona. In: Disegno, 1, pp 35–44
44. Andrew Webster BABPIASCU (2019). https://www.theverge.com/2014/10/31/7132587/ass assins-creed-unity-paris
45. Bekerman R (2017) The TimeRide VR experience
46. Apollonio FI et al (2013) Characterization of Uncertainty and Approximation in Digital Reconstruction of CH Artifacts. In: Gambardella C (ed) Heritage Architecture Land design. Focus on Conservation Regeneration Innovation. Le vie dei Mercanti XI Forum Internazionale di Studi. Napoli. La scuola di Pitagora Editrice, pp 860–869. ISBN: 978886542290
47. Sîrbu D (2003) Digital exploration of unbuilt architecture: a non-photorealistic approach. In: Proceedings of the 23th Annual Conference of the Association for Computer-Aided Design in Architecture (ACADIA)
48. Apollonio FI et al (2021) La ricostruzione digitale della mostra allo Spirito Santo. In: Costarelli A (ed) Antonio Canova e Bologna. Alle origini della Pinacoteca. Milano, Electa, pp 104–113
49. Migliari R, Fasolo M (2022) Prospettiva. Teoria e applicazioni. Hoepli Milano
50. Apollonio FI et al (2021) Three points of view for the drawing adoration of the magi by Leonardo da Vinci. Heritage 4(3):2183–2204. https://doi.org/10.3390/heritage4030123
51. Baglioni L, Fallavollita F (2021) Generative models for relief perspective architectures. Nexus Netw J 23:879–898. https://doi.org/10.1007/s00004-021-00565-w
52. Pedersen I et al (2017) More than meets the eye: the benefits of augmented reality and holographic displays for digital cultural heritage. ACM J Comput Cult Herit 10(2):Article 11
53. Wheatley D (2014) Connecting landscapes with built environments: visibility analysis, scale and the senses. In: Paliou E et al (eds) Spatial analysis and social spaces. De Gruyter, pp 115–134
54. Llobera M (2007) Reconstructing visual landscapes. World Archaeol 39(1):51–69
55. Frieman C et al (2007) Seeing is perceiving? World Archaeol 39(1):4–16
56. Pfarr-Harfst M (2013) Virtual scientific models. In: Ng K et al (eds) Electronic visualisation and the arts. London, pp 157–163
57. Günther H (2001) Kritische Computer-Visualisierung in der kunsthistorischen Lehre. In: Frings M (ed) Der Modelle Tugend. CAD und die neuen Räume der Kunstgeschichte. Weimar, pp 111–122
58. Münster S (2011) Militärgeschichte aus der digitalen Retorte - Computergenerierte 3D-Visualisierung als Filmtechnik. In: Kästner A et al (eds) Mehr als Krieg und Leidenschaft. Die filmische Darstellung von Militär und Gesellschaft der Frühen Neuzeit (Militär und Gesellschaft in der frühen Neuzeit, 2011/2). Potsdam, pp 457–486
59. Berndt E et al (2000) Cultural heritage in the mature era of computer graphics. IEEE Comput Graph Appl 20(1):36–37
60. Glotzbach U (2010) Zur heuristischen Funktion der technischen Handzeichnung. acatech DISKUTIERT 0:105–119

61. Azuma R et al (2001) Recent advances in augmented reality. IEEE Comput Graph Appl 21(6):34–47
62. Wikimedia (2020) https://en.wikipedia.org/wiki/Extended_reality
63. Milgram P et al (1994) Augmented reality: a class of displays on the reality-virtuality continuum. SPIE 2351
64. Russo M (2021) AR in the architecture domain: state of the art. Appl Sci-Basel 11(15):6800
65. Tatzgern M et al (2013) Dynamic compact visualizations for augmented reality. In: 2013 IEEE virtual reality (VR). IEEE, pp 3–6
66. Tatzgern M et al (2016) Adaptive information density for augmented reality displays. In: IEEE Virtual reality (VR). IEEE, pp 83–92
67. Büschel W et al (2016) Improving 3D visualizations. In: Paper presented at the proceedings of the 2016 ACM companion on interactive surfaces and spaces, Niagara Falls, Ontario, Canada
68. Burmester M et al (2018) Lost in Space? 3D-Interaction-Patterns für einfache und positive Nutzung von 3D Interfaces. In: Hess S et al (eds) Mensch und computer 2018 – usability professionals (electronic book). Gesellschaft für Informatik e.V. und German UPA e.V., Bonn
69. ViMM WG 2.2 (2017) Meaningful content connected to the real world (report)
70. Bekele MK et al (2018) A survey of augmented, virtual, and mixed reality for cultural heritage. ACM J Comput Cult Herit 11(2):Article 7
71. Luna U et al (2019) Augmented reality in heritage apps: current trends in Europe. Appl Sci-Basel 9(13):2756
72. Balletti C et al (2017) 3D printing: state of the art and future perspectives. J Cult Herit 26:172–182
73. Grellert M (2016) Rapid prototyping in the context of cultural heritage and museum displays. buildings, cities, landscapes, illuminated models. In: Münster S et al (eds) 3D research challenges in cultural heritage II. Springer LNCS, Cham
74. Codarin S (2018) The conservation of cultural heritage in conditions of risk, with 3D printing on the architectural scale. In: Ioannides M (ed) Digital cultural heritage. Lecture notes in computer science. Springer International Publishing, Cham, pp 239–256
75. Scopigno R et al (2017) Digital fabrication techniques for cultural heritage: a survey. Comput Graph Forum 36(1):6–21
76. Neumüller M et al (2014) 3D printing for cultural heritage: preservation, accessibility, research and education. In: 3D research challenges in cultural heritage. Springer, pp 119–134
77. Bourell D et al (2017) Materials for additive manufacturing. CIRP Ann 66(2):659–681
78. Rase W-D (2007) Herstellung von 3D-Modellen mit Rapid-Prototyping-Verfahren
79. Scopigno R et al (2014) Digital fabrication technologies for cultural heritage (STAR). EUROGRAPHICS workshops on graphics and cultural heritage (Klein R, Santos P (eds))
80. Grissom S et al (2003) Algorithm visualization in CS education: Comparing levels of student engagement. In: Paper presented at the ACM symposium on software visualization, San Diego
81. Tullis T et al (2008) Measuring the user experience
82. Dörner R et al (2013) Wahrnehmungsaspekte von VR. In: Dörner R (ed) Virtual und augmented reality (VR/AR). Springer, Heidelberg, pp 33–63
83. Kim YM et al (2021) A comparative study of navigation interfaces in virtual reality environments: a mixed-method approach. Appl Ergon 96:103482
84. Sagnier C et al (2020) User acceptance of virtual reality: an extended technology acceptance model. Int J Hum-Comput Interact 36(11):993–1007
85. Ress S et al (2018) Mapping history: orienting museum visitors across time and space. ACM J Comput Cult Herit 11(3):Article 16
86. Hornecker E et al (2019) Human-computer interactions in museums. Synth Lect Hum-Center Inf 12(2):i–153

87. Panou C et al (2018) An architecture for mobile outdoors augmented reality for cultural heritage. ISPRS Int J Geo Inf 7(12):463
88. Haahr M (2017) Creating location-based augmented-reality games for cultural heritage. Joint international conference on serious games. Springer, pp 313–318
89. Maguid Y (2020) Ubisoft creates VR experience at Smithsonian's age-old cities exhibition
90. Deterding S et al (2011) From game design elements to gamefulness: defining" gamification". In: Proceedings of the 15th international academic MindTrek conference: envisioning future media environments, pp 9–15
91. Garcia-Fernandez J et al (2019) Cultural heritage and communication through simulation videogames-a validation of minecraft. Heritage 2(3):2262–2274
92. Urban RJ (2007) A second life for your museum: 3D multi-user virtual environments and museums
93. Kotsopoulos KI et al (2019) An authoring platform for developing smart apps which elevate cultural heritage experiences: a system dynamics approach in gamification. J Ambient Intell Hum Comput 1–17
94. Doukianou S et al (2020) Beyond virtual museums: adopting serious games and extended reality (XR) for user-centred cultural experiences. In: Liarokapis F et al (eds) Visual computing for cultural heritage. Springer series on cultural computing. Springer International Publishing, Cham, pp 283–299
95. Liarokapis F et al (2017) Multimodal serious games technologies for cultural heritage. In: Ioannides M et al (eds) Mixed reality and gamification for cultural heritage. Springer International Publishing, Cham, pp 371–392
96. Miller C (2014) Digital storytelling: a creator's guide to interactive entertainment, vol. 3
97. László J (2008) The science of stories: An introduction to narrative psychology
98. Kahneman D (2011) Thinking, fast and slow
99. Herman D (2007) Storytelling and the sciences of mind: cognitive narratology, discursive psychology, and narratives in face-to-face interaction. Narrative 15(3):306–334
100. Constantine LL et al (2002) Usage-centered engineering for Web applications. IEEE Softw 19(2):42
101. Sylaiou S et al (2020) Storytelling in virtual museums: engaging a multitude of voices. In: Liarokapis F et al (eds) Visual computing for cultural heritage. Springer series on cultural computing. Springer International Publishing, Cham, pp 369–388
102. Rizvic S et al (2020) Digital storytelling. In: Liarokapis F et al (eds) Visual computing for cultural heritage. Springer series on cultural computing. Springer International Publishing, Cham, pp 347–367
103. Katifori A et al (2020) Exploring the potential of visually-rich animated digital storytelling for cultural heritage. In: Liarokapis F et al (eds) Visual computing for cultural heritage. Springer series on cultural computing. Springer International Publishing, Cham, pp 325–345
104. Partarakis N et al (2020) Transforming heritage crafts to engaging digital experiences. In: Liarokapis F et al (eds) Visual computing for cultural heritage. Springer International Publishing, Cham, Springer Series on Cultural Computing, pp 245–262
105. Liuzzo P et al (2017) Storytelling and digital epigraphy-based narratives in linked open data. In: Ioannides M et al (eds) Mixed reality and gamification for cultural heritage. Springer International Publishing, Cham, pp 507–523
106. Storytelling in cultural heritage: tourism and community engagement (2022), pp 22–37
107. McMillan M et al (2019) Assassin's creed, an analysis. In: Lee N (ed) Encyclopedia of computer graphics and games. Springer International Publishing, Cham, pp 1–11

108. Casillo M et al (2016) An ontological approach to digital storytelling. In: Proceedings of the the 3rd multidisciplinary international social networks conference on social informatics 2016, data science, pp 1–8
109. Münster S, Maiwald F, Bruschke J, Kröber C, Sun Y, Dworak D, Komorowicz D, Munir I, Beck C, Münster DL (2024) A digital 4D information system on the world scale: research challenges, approaches, and preliminary results. Applied Sciences 14:1992
110. Akenine-Moller T, Haines E, Hoffman N, Pesce A, Iwanicki M, Hillaire S (2018) Real-time rendering, 4th edn. ISBN-13: 978–1138627000, ISBN-10: 1138627003
111. Pharr M, Jakob W, Humphreys G (2016) Physically based rendering: from theory to implementation, 3rd edn. ISBN: 9780128006450

Documentation

8

Abstract

The documentation of the working steps, the decisions made in a reconstruction, the applied method, and the results form one of the cornerstones of scientific practice. Over the centuries, scientific publication established itself with fixed basic principles, such as verifiability of methods, objectivity, disclosure of sources, comprehensibility of argumentation, accessibility of results, accuracy, reliability, and uniformity [1]. In computer-aided, hypothetical 3D reconstruction of destroyed architecture, the application of the above basic principles faces an as yet unsolved challenge. The model creation process is rarely documented, and when it is, the documentation is usually not publicly available. The knowledge embedded in reconstructions, scientific interpretation, argumentation, and hypothesis, is in danger of being lost. Due to the lack of resources, diverse and rapidly developing software applications, modelling methods and types, no application-based method for documenting and publishing 3D models has been established. Three decades into the spread of computer-assisted 3D visualization in the research and mediation of cultural heritage, discussion of the question of what and how to document has intensified. The Internet as a publication venue seems to make sense to most. Web-based documentation requires technical infrastructures and services as well as defined scientific methods for comprehensible modeling and sustainable provision. The following chapter is dedicated to describing and clarifying these developments.

© The Author(s) 2024
S. Münster et al., *Handbook of Digital 3D Reconstruction of Historical Architecture*,
Synthesis Lectures on Engineers, Technology, & Society 28,
https://doi.org/10.1007/978-3-031-43363-4_8

Guiding questions
- What guidelines and projects exist?
- Why is documentation important?
- What needs to be documented?
- How can one document and publish?

Basic terms
- Metadata and paradata
- Scientificity and traceability
- Findability and accessibility
- Interoperability and reusability

8.1 Introduction

The topic of documenting 3D reconstructions is examined below under four questions:

1. Why is documentation important?
2. What kind of research data are we dealing with at all?
3. What should be documented?
4. How should documentation be done?

The consideration of these aspects has two focal points: firstly, the documentation of information accompanying a 3D model and secondly, the documentation of the decision-making processes related to the reconstruction. Documentation should provide information about the circumstances surrounding the reconstruction and the digital model behind it as well as information about the actors, backgrounds, and technical conditions. Documentation ensures that the occasion, purpose, background, sources, and the decision-makers and others' creative considerations for and against creating a reconstruction in a certain way, are comprehensible. Documentation is part of good scientific practice [2]. In every scientific discipline, documentation of research results and the processes behind them is required in order to make findings and justifications comprehensible and available to future generations as a basis for further research.

Documentation of the decision-making processes and the sources behind them can be highly important for one's own reconstruction practice. Knowledge and effort have gone into reconstruction models. These models therefore have a certain value. If one wants to use and change these models again later, it is important to be able to reconstruct the

decision-making processes and the sources used in order to resume or repeat the work with as little effort of one's own as possible. Furthermore, such documentation can strengthen one's own reputation. If reconstructions are visible to the public and questions about their credibility arise, then documentation can help to communicate the earlier decisions and thus reject any doubts raised. If, on the other hand, objections are justified, then documentation helps one to make changes in a reconstruction model more quickly, more precisely, and thus more economically. Especially in the commercial sector, such as TV documentaries, entertainment, or reconstructions for museums, this can be advantageous.

8.2 Why Documentation is Important

8.2.1 Scientific Significance

Digital models have become widely established as tools of mediation and research in the context of architectural and urban studies [3]. Especially the increasing dissemination of digital architectural reconstructions in exhibitions and research projects and the public funding that often accompanies them raises questions about the sustainability of the reconstructions presented and the knowledge embedded in them. It is necessary to ask where and how reconstruction models and 3D datasets can be permanently presented, secured, and accompanying information documented. Yet it is challenge to document decision-making processes and the underlying thought processes and interpretations in digital reconstructions in a publicly accessible, transparent, and comprehensible way. If this does not succeed, the knowledge and thus the potential scientific value of a reconstruction risks being lost. Simply saving the results is not sufficient for valid documentation. The publication of research results from digital 3D reconstructions in print media, television, exhibitions and the Internet, including pure 3D repositories such as Sketchfab.com, usually only represent the result of research processes along with rudimentary accompanying information, but not their genesis and the discourse conducted in the process. Moreover, the lack of documentation of the reconstruction processes and the decisions and justifications they contain leads to the loss of knowledge about rejected solutions. However, these contain valuable information that was developed during the reconstruction process. In the event of a change in the source situation or a re-evaluation of the sources used, the documentation of sources that were rejected or not considered as plausible would make it possible to start the reconstruction process anew and ideally make use of the earlier findings.

Actors have been aware of the problem of lack of documentation for a long time: in theoretical policy papers such as the London Charter [4] and Principles of Seville [5] (→ Scholarly Method) are formulated in terms of sustainability, verifiability, and knowledge preservation: "The documentation of evaluative, analytical, deductive, interpretative and

creative decisions made in the course of computer-assisted visualization should be available in such a way that the relationship between research sources, tacit knowledge and explicit conclusions and visualization-based results can be understood" [6]. The working group on digital 3D construction for digital humanities in the German-speaking countries (DHd) sees the documentation as one of five core issues, as is reflected in their 2019 publication, *Der Modelle Tugend 2.0* [7]. Despite this awareness, scientific documentation of digital reconstruction is an absolute exception even in 2024. Several reasons seem to converge here. To date, documentation is generally neither explicitly demanded by funding agencies, nor are additional funds made available for it. This applies to funding lines of the federal and state governments, but also to museum commissions, in that digital reconstructions often trigger or are created based on the latest state of research and with scientific advice. Thus, it is usually left up to the persons and institutions that create a reconstruction to finance documentation with their own funds. Furthermore, there is no agreement on documentation standards, structure, or content.

8.2.2 Preliminary Work

At the latest since the EPOCH Research Agenda [8] in 2004–2008, the topic of documenting 3D reconstructions has come into focus. One result of this four-year research project is the London Charter, which remains decisive for theoretical considerations and practical implementations. For some years now, there have been initial attempts in the professional community to meet the challenge of a lack of documentation with concrete solutions. These include a good overview of the ideas that have emerged up to 2017 [9] and a first draft for a tool for systematic documentation [10] with a web-based tool based on wiki technology (i.e., interlinked pages). The aim of the tool was to systematically document sources, their interpretation, hypothesis formation, and the resulting visualizations. However, the development never went beyond a prototype.

To better ensure data sharing, projects have focused on data modeling and linked data technologies in the context of digital 3D modeling—most notably the CIDOC Conceptual Reference Model (CRM) [11, 12], an ontology for cultural heritage, originally designed for use in museums. Within the framework of the project Virtual Reconstructions in Transnational Research Environments—The Portal: Castles and Parks in Former East Prussia [13], the first CIDOC CRM-referenced application ontology was developed to document the creative decision-making processes and the results of a digital (hypothetical) 3D reconstruction, including versions and variants. In follow-up projects at the Hochschule Mainz, the OntSciDoc3D application ontology has been successfully used in the semantic enrichment and labeling of digital 3D models with information on the provenance of the digital 3D dataset and the historical context of the represented object [14].[1]

[1] Link to the. owl file: https://www.ontscidoc3d.hs-mainz.de/ontology, accessed on 1.2.2023.

At the Hochschule für Technik und Wirtschaft Dresden, the online tool DokuVis was developed, which enables exchange between modelers and scientific advisors directly on the 3D model. Further features are the display of variants and versions, integration of project management, measurement of distances and surfaces, and the ability to generate section views of and interactively compare sources with the model [15].

Extensive theoretical considerations on the topic of documentation were already developed in 2010 at the Department of Digital Design at the Technische Universität Darmstadt (TUD), first preliminary work 2010 Mieke Pfarr [16]. This department started from the assessment that simple, intuitive, and user-friendly approaches are needed to move toward a practice of scientific documentation. In 2016, the Reconstruction Argumentation Method (RAM) was developed, which was transferred into an online-based documentation tool, ScieDoc,[2] in 2017 [17, 18]. The core of the RAM approach in ScieDoc is the division of a reconstructed building into different spatial areas. Each of these areas is represented by 2D images of the reconstruction (renderings), by images of the sources used, and by a textual argumentation explaining how the reconstruction was inferred from the sources. For each area, it is possible to map several variants. ScieDoc was used in 86 projects by 2022.

Currently, Building Information Modeling (BIM), the 3D modeling standard in the construction industry, is being discussed in the field of digital (hypothetical) reconstructions [19–21]. BIM enables to store project information and to assign customized properties to building elements. BIM supporting software ensures interoperability and reusability of the project data through the common data exchange format Industry Foundation Classes.[3]

With an archaeological approach, Demetrescu [22] sees virtual reconstruction as an extension of the findings in excavations and links them with virtual elements and sources. Prototypically, an interactive tool was developed for the visualization and exploration of the data in conjunction with the 3D models [9].

Many actors also dealt with partial aspects of documentation. Above all, the degree of uncertainty associated with incomplete sources and the wide scope for interpretation plays a prominent role. Various metrics were developed, such as the level of hypothesis [23], or one based on fuzzy logic [24], or a classification depending on the information content and the need for interpretation of sources. [25] The question of visualizing the different levels of uncertainty directly on the model has been discussed several times [26] (\rightarrow Shading Aspects).

Thus, although several approaches to documentation of decision-making processes exist, the proposed solutions should rather be seen as prototypes that cannot be used ad hoc by a broad community. In 2022, the DFG project IDOVIR started, which combines the approaches of the abovementioned projects ScieDoc and DokuVis and uses the RAM method developed at the TUD. It is free to use and takes 15 min to learn. As it

[2] http://www.sciedoc.org, accessed on 1.2.2023.

[3] ISO 16739-1:2018, see https://www.iso.org/standard/70303.html.

is embedded in the system landscape of the University and State Library Darmstadt, the professional provision and continuation of the project results is guaranteed.

Beyond documentation of the decision-making processes, it is desirable to be able to permanently refer to a reconstruction and to cite it well in a scientific sense. For many reconstructions that are created for exhibitions or documentaries, permanent access to the results achieved is often not guaranteed. For this purpose, it would be useful to have freely accessible 3D repositories, which visualize 3D models and make 3D datasets available, document the corresponding metadata, and provide information on the often unclear legal situation regarding the (re-)use of results or models of a reconstruction. Complementary to the IDOVIR project in this context is the DFG-funded project DFG 3D-Viewer, which provides an infrastructure for publishing, locating, and displaying 3D models and records information on the circumstances surrounding both the digital reconstruction and the digital 3D model behind it.

Both DFG projects have agreed on common data structures and terms and are also seeking this understanding with other initiatives in the field of digital infrastructures. Both are briefly explained and recommended in the section on key projects at the end of this chapter.

One general challenge is that no new tool, method, or standard can solve the restrictions concerning the publication of the (historical) sources on which a reconstruction is based [27]. This would be necessary for scientific discourse, but the rights holders do not always allow this or demand fees, a circumstance that results in major restrictions and hurdles. General agreements would have to be reached here.

8.2.3 Current Developments

Documentation that enables computer-assisted work with the digitally available research data requires formalization of the knowledge in a human- and machine-readable form. This is primarily a matter of setting up rules for all data that clearly communicate the logic and meaning of that data to the computer, so that instead of data ruins, a homogeneous and consistent database is created.

As early as the 1980s, fundamental ideas and concepts for the description and documentation of art and architecture were developed. Foto Marburg provided an important basis for this with far-reaching considerations on the cataloging of cultural heritage [28], which led to their documentation and administration system MIDAS in 1989 [29].

Standards enable subject-specific classification of subject matter and make an essential contribution to the unambiguous indexing of cultural heritage. First and foremost, these are the controlled Getty Vocabularies, such as Art & Architecture Thesaurus (AAT), Getty Thesaurus of Geographic Names (TGN), Cultural Objects Name Authority (CONA), and Union List of Artist Names (ULAN), as well as ICONCLASS for iconographic indexing.

Further Reading: Classification Standards for Knowledge Modeling

Controlled Vocabularies: A controlled vocabulary is an organized arrangement of words and phrases used to index content and/or to retrieve content through browsing or searching. It typically includes preferred and variant terms and has a defined scope or describes a specific domain [52, p. 12].

Thesaurus: A thesaurus combines the characteristics of synonym ring lists and taxonomies, together with additional features. A thesaurus is a semantic network of unique concepts, including relationships between synonyms, broader and narrower (parent/child) contexts, and other related concepts. Thesauri may be monolingual or multilingual [52, p. 24].

Taxonomies: A taxonomy is an orderly classification for a defined domain. It may also be known as a faceted vocabulary. It comprises controlled vocabulary terms (generally only preferred terms) organized into a hierarchical structure. Each term in a taxonomy is in one or more parent/child (broader/ narrower) relationships to other terms in the taxonomy. There can be different types of parent/child relationships, such as whole/part, genus/species, or instance relationships. However, in good practice, all children of a given parent share the same type of relationship. A taxonomy may differ from a thesaurus in that it generally has shallower hierarchies and a less complicated structure. For example, it often has no equivalent (synonyms or variant terms) or related terms (associative relationships) [52, p. 22].

Ontologies: These are less commonly used than the above three standards for art information. In common usage in computer science, an ontology is a formal, machine-readable specification of a conceptual model in which concepts, properties, relationships, functions, constraints, and axioms are all explicitly defined [52, p. 24]. A main distinction is between application-overarching reference ontologies and the deriving application ontologies, which are purpose-specific applications of reference ontologies [13].

In cultural heritage, CIDOC CRM has prevailed as a reference ontology since the mid-1990s. This human- and machine-readable formalization of knowledge is based on around 100 classes (entities) and 150 relations (properties) that describe the essential facts and the context of an object, starting from an activity, e.g., the creation of a work of art (Fig. 8.1).

The demand for the worldwide networking of knowledge is being addressed by the development of the Internet into Web 3.0. The idea of a Web 3.0 network of knowledge was first presented in 2001 under the term Semantic Web by Tim Berners-Lee, the inventor of the World Wide Web [30]. It is based on a **Resource Description Framework** (RDF), a graph-based data format. The basic units of RDF are the triples consisting of subject, predicate and object. Data models such as CIDOC CRM [31] are used to describe

MAPPING THE ACTIVITY

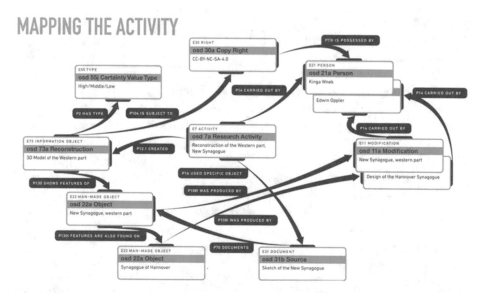

Fig. 8.1 Graphical representation of the CIDOC CRM referenced application ontology OntSci-Doc3D for mapping the knowledge of the 3D reconstruction process, https://www.ontscidoc3d.hs-mainz.de/ontology/, accessed on 1.2.2023 (Image: AI MAINZ, 2019)

individual basic units, which in turn enable the machines to read out the meaning of the digitally available data (semantics = meaning). If the RDF datasets (graph databases) are linked with other external, similarly structured online resources, a network of information is created that extends beyond the datasets themselves and is known as **Linked (Open) Data**.

The formalized and structured documentation of knowledge is the basic prerequisite for the processing information or making it available digitally. The proper handling of digital research data became an important concern of national education and research initiatives in the 2010s, which found expression in the endeavor to establish National Research Data Infrastructures (→Further reading: Infrastructure programs for 3D data). The **new data culture** formulated here [32] follows the general desire of academic circles for digital research data to be findable, accessible, interoperable, and reusable (FAIR) (→Legislation) [33].

Parallel to these developments in digital humanities, digital 3D modeling was examined in the engineering sciences. With the development of computer graphics since the 1960s and the arrival of powerful PCs in planning offices since the 1990s, efficiency increased because of improved interoperability and sustainability of digital 3D datasets. Regarding digital source-based 3D reconstruction, the approaches from architecture and spatial and urban planning represent interesting points of reference.

Since the mid-1990s, representatives from the construction industry, with software companies, have been developing a data exchange format that can store not only the

geometry but also the object-based properties (property sets) and exchange them between different disciplines involved in construction. The resulting data exchange format, Industry Foundation Classes (IFC), form the common language of those involved in construction and introduce a new planning methodology that began in the 1970s and became known as Building Information Modeling (BIM) in the early 2000s [34]. The methodology is based on the communication of the parties involved by means of discipline-related 3D models (architectural design, construction engineering, MEP engineering, etc.), which are federated in a coordination model, as the **Single Source of Truth**. The IFC ensures a low-loss flow of information in the process and the information is mapped in the object-oriented 3D model, which has a different Level of Geometry, and Level of Information as well as accompanying documents (2D plans, photos, drawings, audio-/video-files, etc.) linked to it, depending on the required Level of Information Need. The increase in efficiency is thus based on an internationally recognized standard according to which projects are structured and BIM Execution Plans designed in response to Exchange Information Requirements [35].

In the early 2000s, a similar effort began in spatial and urban planning. As a result, an xml-based application schema for storing and exchanging digital 3D city models was introduced. City Geography Markup Language [36] enables digital 3D city models to be enriched with additional information that is of crucial importance for sustainable urban planning and administration of large scale build environment.

8.3 What Are We Dealing With

8.3.1 Model Types, Methods, and Data Formats

Digital 3D reconstruction deals with a wide variety of data that pose a particular challenge in terms of documentation. If we start from the 3D models, different types of models and modelling methods entail different properties [37]. The common subdivision introduces three types of models: **wireframe, surface, and solid**. The wireframe model is mainly used today for visualization purposes. Thus, the surface and solid models are the actual model types, which are essentially based on two different modeling methods. While the surface model consists of several independent surfaces that are not assigned to a concrete object, the solid model is a closed body that represents an object.

In terms of methods, object-based 3D modeling software solutions use **Constructive Solid Geometry** (CSG), which depicts completed solid models of the objects. This modeling methodology is preferred in industrial design, machinery, and construction (architecture and civil engineering, especially in BIM-supporting applications). The surface models that favor free-form modeling are used in animated films, product and architectural visualization, and urban planning. The associated modeling methodology is called **Boundary Representation** (B-Rep).

The manifold **data formats** for 3D datasets pose a further challenge. With regard to documentation, especially interoperability and thus the sustainability of data formats, a distinction is made between **proprietary** 3D model formats (e.g. C4D for Maxon Cinema 4D or 3DS for Autodesk 3D Studio Max) which are specific to software in which they were created, and **data exchange** formats (e.g., OBJ, DAE, STL, FBX, IFC, CityGML, X3D, and gITF), which are widely used and supported by many software applications [38]. The construction industry and urban planning use specific standards that integrate both the geometric information and the meaning of the objects or the surfaces that define them, such as IFC for BIM (ISO 16739–1:2018) or CityGML [39]. For web-based visualization of the 3D models, formats such as X3D and gITF were designed, which enable high-performance interactive display [40], but present challenges when converting the digital models from proprietary formats.

Finally, two trends should be briefly mentioned. First, **standardization** of methods and types of models, such as CSG/BIM and B-Rep/CityGML, can technically guarantee a documentation link and interoperability, are developing further and further, also regarding the graphic appearance. Second, increasing **differentiation** of the creation process for quasi-photorealistic reconstructions, e.g., immersive virtual reality simulations. A wide variety of software types are used, each of which fulfills specific functions to create geometries and represent textures, vegetation, or lighting conditions in generative models. However, the generative approach is not based on storing the resulting 3D geometries but on parameters and generates a 3D object in real time [41, 42]. In result storing 3D information in a state is not possible. With such modeling methods and creation processes, annotation of documentation directly on the 3D model is rather more difficult and storage in non-proprietary file formats may be impossible [43].

The question of a common language, the lowest common denominator of digital 3D models, may arise here. Agreement on a modeling, documentation, and publication method could guarantee the FAIR use of 3D models as serious 3D in archaeology, art and architectural history. Further considerations in this regard can be based on the concept of the **Digital Critical Model** [44], and the **Scientific Reference Model** [45, 51] (\rightarrow Scholarly Method).

8.3.2 Intellectual Argumentation

The documentation of decision-making processes is about recording trains of thought, interpretations of sources, and the considerations derived from them. Intellectual argumentation is supposed to explain—based on selected sources and analogies—why the reconstruction turned out the way it did, and which other possibilities were considered or discarded. If documentation exists at all, it is usually not in interoperable form. The situation is very inconsistent: apart from a few project descriptions online or in printed publications, documentation tends to exist internally, if at all. The spectrum ranges from

handwritten records and/or the collection of sources used in file folders to embedding in complex internal communication tools that are based on commercial software and then developed by the users. Publishing/networking the data in this internal form is rather undesirable and seems technically difficult.[4]

In addition, some projects map decision-making processes with online databases and may link sources and considerations to 2D images of the reconstructions, or annotate them on the 3D models, and try to establish further references using Linked (Open) Data technologies. In almost all cases these are pilot projects that take up larger resources and have not yet been put to widespread use.

8.4 What Needs to be Documented

Documentation concerns the information about the created dataset and the decision-making processes involved in the reconstruction accompanied by object (physical and digital) related data. The information about a dataset is called **metadata** (data about data). From the long experience of recording objects, e.g., in a museum context, two main types exist: descriptive and administrative metadata. The essential data that is collected during documentation is known as the core dataset. Since 2006, the digital visualization of cultural heritage has included **paradata** [4]. By paradata, we mean the collection of information describing the process of creating the 3D model and the associated 3D visualization. First and foremost, it is the recording and documentation of the creative interpretation process that distinguishes the source-based 3D reconstructions from a retro-digitization of existing objects by terrestrial laser scanning or photogrammetry [46]. Here, the sources used, the gaps in knowledge uncovered, and the interpretation of the result are to be documented.

8.4.1 Documentation of the 3D Models: Metadata

The **descriptive** metadata describes the digital 3D model and the represented physical object. Usually, the name of the object, its function or type, its origin, its classification in an architectural epoch, the persons and events associated with it, etc. are mentioned.

The **technical** metadata related to the digital 3D model can include information on file size, file format, number of faces, edges, and nodes, model type, modeling methodology, software used, etc. This type of data can be partly mapped automatically during web-based 3D visualization.

[4] The assessment is based on unpublished qualitative interviews conducted in the DFG project IDOVIR with people who create digital reconstructions, from larger production companies to self-employed individuals.

The **administrative** metadata regulates the legal aspects of the object, in this case the digital 3D model. They name the author (creator) and possibly the persons involved, the persons and/or institutions as rights holders, and the license under which the 3D model can be used. They are the basic prerequisite for legally secure access to the 3D model and its future use.

As part of the development of infrastructure projects, core datasets for the documentation of 3D models, including digital-source-based 3D reconstruction, are currently being discussed and developed.[5] The documentation schema presented here represents the comparison between IDOVIR and DFG 3D-Viewer and represents the status of the discussion from June 2022 (Fig. 8.2).

When capturing the digital 3D model, the data types can be classified according to the following pattern. The description of the dataset should contain the basic, mostly field-based information about the digital 3D model. Usually, this is the model's name, the time period the model represents, and a free-text description of the model.

A central part of the documentation is the rights declaration, which clarifies the use of the model and should ideally be available under Creative Commons licenses. It contains field-based entries on the license, the author (creator), and other rights holders (e.g. legal bodies). It is important to refer to common international standards and norms regarding licenses (\rightarrow Legislation), persons, and entities (ORCID,[6] GND,[7] VIAF,[8] etc.). In this way, ambiguities regarding machine information processing can be avoided and the datasets can be linked. To document the history of the model more comprehensively, the software used, the modeling method, other people involved, and time span of the 3D modeling can be recorded. Information on the physical (no longer existing) object is documented, which further contextualizes the model. Here, in addition to listing alternative names for the object, the object type can be defined following controlled vocabularies, and a link given to the Wikipedia and Wikidata datasets. Historical relationships to persons with a role and to historical events can ensure further contextualization of the object. The location of the object in relation to norm data, such as Geonames, should enable clear georeferencing of the object in question.

Finally, the project under which the 3D model was created can be documented within a project description. Here, it is useful to include the project title, possibly its acronyms, the website, the purpose, and the result as well as a free-text description of the project and

[5] The mapping of metadata started in 2022 as a workshop series and included the DFG projects DFG 3D-Viewer (https://dfg-viewer.de, accessed on 1.2.2023.) and IDOVIR (https://idovir.com/, accessed on 1.2.2023), the specialist information serviceBAUdigital (https://fid-bau.de, accessed on 1.2.2023), Baureka (https://baureka.de, accessed on 1.2.2023) and national and European efforts such as the German Research Data Infrastructure, particularlyNFDI4Culture and the Europeana (https://europeana.eu, accessed on 1.2.2023). It has been extended to further international infrastructures since then.

[6] https://orcid.org/, accessed on 1.2.2023.

[7] https://www.dnb.de/, accessed on 1.2.2023.

[8] https://viaf.org/, accessed on 1.2.2023.

Fig. 8.2 Miro board documentation scheme for alignment of core datasets between IDOVIR and DFG 3D Viewer (Image: AI MAINZ, 2022)

the project duration including the institutions involved in the project and their respective roles (Fig. 8.3).

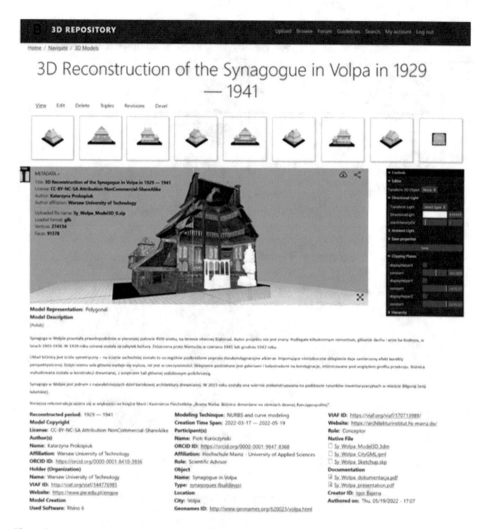

Fig. 8.3 Documentation of the 3D reconstruction of the wooden synagogue in Volpa in the 3D repository developed in the DFG 3D-Viewer project. (Image: AI MAINZ, 2022)

8.4.2 Documentation of the Decision-Making Processes: Paradata

When documenting the decision-making processes, the **intellectual argumentation** behind them is central. It must be explained which sources, analogies, and considerations led to the reconstruction (Fig. 8.4). These explanations should be visually juxtaposed with the presented sub-area of a reconstruction in manageable spatial divisions (e.g., north façade, east façade, etc.) to enable immediate reference and comparison. The reconstruction can be visualized in a 2D image of the reconstruction model or by means of an

Fig. 8.4 IDOVIR: documentation of the reconstruction of Altenberg Monastery (Image: IDOVIR, 2022)

annotation and a pre-set perspective on the 3D model. Both have different constraints and advantages. The 2D image does not require much effort to create. The representation of the 3D model may mean saving in a format suitable for the web, which may lead to a loss of representation or high effort but allows a good spatial clarification of the situation.

Furthermore, it makes sense to describe the **variants** considered and excluded in order to secure the knowledge stored in them and make it visible and, as described in the previous section, to include the metadata.

It could also be helpful to show the degree of **uncertainty**. Interesting work at the University of Bologna (\rightarrow Visualization) should be mentioned here [44], which is developing proposals on how the degree of uncertainty and sources used could be visualized on the 3D model or its representation.

8.5 How to Document

Once it has been decided what is to be documented, there is the legitimate question of how to do so. This technical methodological aspect has so far been disregarded in the relevant guidelines and directives, not least due to the lack of research data infrastructures. As a result, 3D datasets could not be documented on a significant scale. New technological solutions were presented in the above section on preliminary work.

With funding from the German Research Foundation (DFG) and efforts from the German Research Data Infrastructures (NFDI), technological services are currently being developed and made available in the short term to enable the documentation and publication of research data, including 3D models, while adhering to the FAIR Principles and applying Linked Data technologies.

In analogy to Tim Berners Lee's 5 Star Model for Open Data, the technical solutions for documenting 3D models within the 3D repositories are also described here in stages (Fig. 8.5).

★ Provide your 3D model and the associated metadata on the web under an Open License (OL). The format does not matter (scanned sheet, PDF, etc.)

★★ Provide your 3D model in a format supporting Model Structure (MS) and the associated metadata on the web in a structured format (e.g. Excel instead of a scanned sheet, image or PDF)

★★★ Provide your 3D model in Neutral Format (NF) and use open, non-proprietary formats (e.g. CSV instead of Excel) for the associated metadata on the web

★★★★ Provide your 3D model with Structural Elements Properties (SEP) and use URIs to label things so that your data can be linked to

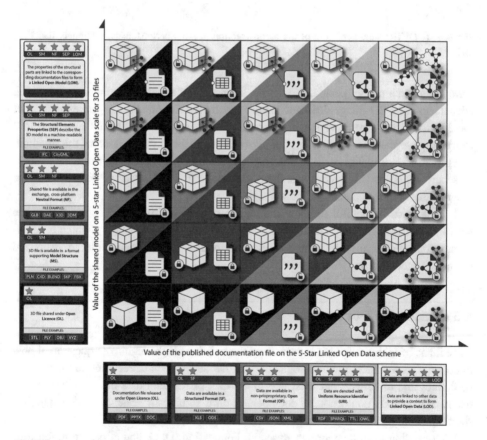

Fig. 8.5 Assessment schema for 3D formats in terms of their interoperability, based on the criteria of the 5-star deployment schema presented by Tim Berners-Lee in 2012 (Image: AI MAINZ/Igor Bajena, 2023)

★★★★★ Provide your 3D model as Linked Open Model (LOM) and link your data with other data to create contexts (Linked Open Data).

This technical networked semantic documentation of 3D models (**metadata**) in 3D repositories is followed by documentation of the creative processes behind the visual representation (**paradata**). The striking feature of this context is the focus on recording the individual decision in a source-based reconstruction of art and architectural objects that no longer exist. Depending on the scientific questions of the research projects, what is to be documented may vary. Regarding standardization, jointly developed **core datasets** are of fundamental importance. The comprehensive documentation of decisions in a reconstruction process can also make use of the stage-like representation described above. The main difference here is that the 3D model does not necessarily have to be provided, as in the case of 3D repositories on the web.

Finally, it is important in the "how to document" that the hurdles are kept as low as possible e.g.: A cost-free infrastructure that can perhaps already be used as a communication platform during reconstruction. A minimal training time and as little additional effort as possible. Securing the data through renowned, experienced institutions such as libraries, can build trust. The core task remains to reveal the knowledge behind the reconstruction, whether in 2D or 3D. Ultimately, any form of documentation—publicly accessible or not—is better than no documentation at all.

Summary
After reading this chapter you should understand why it is important to document meta- and paradata of digital 3D reconstructions, what and how to document, and how to document projects with existing online tools.

Standards and guidelines

- UNESCO Charter (2003) Charter on the preservation of the digital heritage, published 2009 (https://unesdoc.unesco.org/ark:/48223/pf0000179529, accessed on 1.2.2023).
- DFG Guidelines for Safeguarding Good Scientific Practice (2019), https://www.dfg.de/download/pdf/foerderung/rechtliche_rahmenbedingungen/gute_wissenschaftliche_praxis/kodex_gwp.pdf, accessed on 1.2.2023; https://www.dfg.de/download/pdf/foerderung/rechtliche_rahmenbedingungen/gute_wissenschaftliche_praxis/kodex_gwp_en.pdf, accessed on 1.2.2023.
- DFG Code of Practice "Digitization" (2016) https://www.dfg.de/formulare/12_151/, accessed on 1.2.2023.
- London Charter, Denard H (2012) A new introduction to the London charter. In: Bentkowska-Kafel A et al (eds) Paradata and transparency in virtual heritage.

Ashgate, Burlington, pp 57–72. https://www.londoncharter.org/fileadmin/templa tes/main/docs/london_charter_2_1_de.pdf, accessed on 1.2.2023.

- Principles of Seville. International Principles of Virtual Archaeology. Ratified by the 19th ICOMOS General Assembly in New Delhi, December 2017 (http://sev illeprinciples.com, accessed on 1.2.2023).
- FAIR Principles, Wilkinson et al (2016) The FAIR guiding principles for scientific data management and stewardship. Scientific Data 3(1):160,018. https://doi. org/10.1038/SDATA.2016.18.

Projects

- **DFG 3D-Viewer** (2021–2023). The development of a 3D viewer infrastructure for historical 3D reconstructions is intended to provide permanent publishing and archiving of 3D datasets and the associated metadata, and to enable collaboration and expert discourse on digital 3D models. The overall goal of the project is to develop a web-based 3D viewer and exchange format for distributed 3D repositories that ensure findable, accessible, interoperable and reusable 3D models as research data. Subgoals include creating an interdisciplinary application profile, including the assignment of rights (licensing of models) and developing a prototype 3D repository and workflow for delivering a 3D model into 3D repositories. https://dfg-viewer.de/en/dfg-3d-viewer, accessed on 1.2.2023.
- **DFG Project IDOVIR**: Infrastructure for the documentation of virtual reconstructions (2022–2024). The aim of IDOVIR is to make decision-making processes in architectural reconstruction permanently traceable and openly accessible online with embedding at the University and State Library Darmstadt. The core is the presentation of the intellectual argumentation behind a reconstruction. Special attention is paid to the ability to present any number of variants or working states. Other features of the research infrastructure, which can be used free of charge, include low-threshold use (familiarization time 15 min), guided data entry, automatic PDF generation of the documentation, visualization via 2D renderings and an interactive 3D model, and various tools for evaluation, measurement, and communication. Depending on the available resources, it allows minimal or extensive documentation. IDOVIR also developed a proposal on how to depict the degree of uncertainty (plausibility) of the reconstruction and the sources used. https://idovir.com/, accessed on 1.2.2023.
- **Semantic Kompakkt**: A tool for the semantic annotation of 3D models, developed within NFDI4Culture (2020–2025). The open-source components Wikibase (indexing, knowledge graph), Open Refine (data transformation and import) and Kompakkt (storage, visualization, interaction) will be integrated. Initially, for the

use case of cultural heritage and its specific vocabularies and ontologies such as CIDOC CRM, this enables the annotation of 3D data within an open and flexible knowledge graph environment. This facilitates the linking of 3D models, annotations, and their cultural context with the semantic web and with national and international standards data. Semantic Kompakkt is designed as a collaborative environment with different levels of read/write access, where research groups can use graphical user interfaces to upload and annotate data with a clear provenance and metadata.

https://gitlab.com/nfdi4culture/ta1-data-enrichment/kompakkt-docker, accessed on 1.2.2023.

Key literature

- Grellert, M., Pfarr-Harfst, M., 2019. The Reconstruction Argument Method—Minimum Documentation Standard in the Context of Digital Reconstruction. In: Kuroczyński, P., Pfarr-Harfst, M., Münster, S. (eds.), Der Modelle Tugend 2.0: Digitale 3D-Rekonstruktion als virtueller Raum der architekturhistorischen Forschung, arthistoricum.net, Heidelberg, pp. 264–280 [47].
- Wacker, M., Bruschke, J., 2019. Documentation of digital reconstruction projects. In: Kuroczyński, P., Pfarr-Harfst, M., Münster, S. (eds.), Der Modelle Tugend 2.0: Digitale 3D-Rekonstruktion als virtueller Raum der architekturhistorischen Forschung, arthistoricum.net, Heidelberg, pp. 282–294 [48].
- Apollonio, F.I., 2016. Classification Schemes for Visualization of Uncertainty in Digital Hypothetical Reconstruction. In: Münster, S., Pfarr-Harfst, M., Kuroczyński, P., Ioannides, M. (eds.), 3D Research Challenges in Cultural Heritage II: How to Manage Data and Knowledge Related to Interpretative Digital 3D Reconstructions of Cultural Heritage, Springer International Publishing, Cham, pp. 173–197 [25].
- Kuroczyński P., Bajena I.P., Große P., Jara K., Wnęk K., 2021. Digital Reconstruction of the New Synagogue in Breslau: New Approaches to Object-Oriented Research. In: Niebling F., Münster S., Messemer H. (eds.): Research and Education in Urban History in the Age of Digital Libraries. UHDL 2019. Communications in Computer and Information Science, vol 1501. Springer, Cham, pp. 25–45 [49].
- Apollonio F.I., Fallavollita F., Foschi R., 2021. The Critical Digital Model for the Study of Unbuilt Architecture, in: F. Niebling et al. (Eds.): UHDL 2019, CCIS 1501, pp. 3–24 [50].
- Kuroczyński P., Apollonio F.I., Bajena I., Cazzaro I., 2023. Scientific Reference Model – Defining standards, methodology and implementation of serious 3D models in archaeology, art and architecture history, in: The International

Archives of the Photogrammetry, Remote Sensing and Spatial Information Sciences, Volume XLVIII-M-2 – 2023, pp. 895–902 [51].

- Bajena I.P., Kuroczyński P., 2023. Development of the Methodology and Infrastructure for digital 3D Reconstructions, in: Proceedings of (IN)TANGIBLE HERITAGE(S) A conference on technology, culture and design, Canterbury 2022, AMPS conference proceedings series, ISSN 2398–9467, pp. 72–83 [45].

References

1. Brink A (2013) Anfertigung wissenschaftlicher Arbeiten S, S. 3–4. https://doi.org/10.1007/978-3-658-02511-3
2. German Research Foundation (2023) „Guidelines for Safeguarding Good Research Practice. Code of Conduct", https://doi.org/10.5281/zenodo.3923601.
3. Münster S (2011) Entstehungs- und Verwendungskontexte von 3D-CAD-Modellen in den Geschichtswissenschaften. In: Meissner K et al (eds) Virtual enterprises, communities & social networks. TUDpress, Dresden, pp 99–108
4. Denard H (2012) A new introduction to the London charter. In: Bentkowska-Kafel A et al (eds) Paradata and transparency in virtual heritage. Ashgate, Burlington, pp 57–72
5. Principles of Seville. International principles of virtual archaeology. Ratified by the 19th ICOMOS general assempbly in New Delhi DHSC
6. London Charter, Denard H (2012) A new introduction to the London charter. In: Bentkowska-Kafel A et al (eds) Paradata and transparency in virtual heritage. Ashgate, Burlington, pp 57–72. https://www.londoncharter.org/fileadmin/templates/main/docs/london_charter_2_1_de.pdf, accessed on 1.2.2023.
7. Kuroczyński P et al (eds) (2019) Der Modelle Tugend 2.0: Digitale 3D-Rekonstruktion als virtueller Raum der architekturhistorischen Forschung. arthistoricum.net, Heidelberg
8. Arnold D et al (2008) EPOCH research agenda – final report
9. Demetrescu E et al (2017) A white-box framework to oversee archaeological virtual reconstructions in space and time: Methods and tools. J Archaeol Sci: Rep 14:500–514
10. Pletinckx D (2012) In: (2012) How to make sustainable visualizations of the past: an EPOCH common infrastructure tool for interpretation management. In: Bentkowska-Kafel A et al (eds) Paradata and transparency in virtual heritage. Ashgate Publishing, Farnham, pp 203–244
11. Doerr M (2003) The CIDOC CRM – an ontological approach to semantic interoperability of metadata. AI Mag 24(3)
12. Doerr M et al (2011) CRMdig: a generic digital provenance model for scientific observation. In: Proceedings of TaPP'11: 3rd USENIX workshop on the theory and practice of provenance, Heraklion
13. Kuroczyński P et al (2016) 3D models on triple paths – new pathways for documenting and visualising virtual reconstructions. In: Münster S et al (eds) 3D research challenges in cultural heritage II. Springer LNCS, Cham, pp 149–172
14. Kuroczyński P, Große P (2020) OntSciDoc3D—Ontology for Scientific Documentation of source-based 3D reconstruction of architecture. In: Long Abstracts of the International Conference on Cultural Heritage and New Technologies, Vienna, (https://chnt.at/wp-content/uploads/OntSciDoc3D--Ontology-for-Scientific-Documentation-of-source-based-3D-reconstruction-of-architecture.pdf)

15. Bruschke J, Wacker M (2018) DokuVis – ein Dokumentationssystem für digitale Rekonstruktionen. In: Breitling S, Giese J (eds) Bauforschung in der Denkmalpflege – Qualitätsstandards und Wissensdistribution. University of Bamberg Press, Bamberg, pp 213–218

16. Pfarr-Harfst M (2010) Dokumentations system für Digitale Rekonstruktionen am Beispiel der Grabanlage Zhaoling, Provinz Saanxi, China. Dissertation

17. Pfarr-Harfst M et al (2016) The reconstruction – argumentation method. In: Digital heritage. Progress in cultural heritage: documentation, preservation, and protection. Lecture notes in computer science, pp 39–49

18. Grellert M, Pfarr-Harfst M, Schmid J (2019) Documentation for virtual reconstructions. One year R-A-M – reconstruction-argumentation-method – a report of first experiences. In: Proceedings of the 22nd international conference on cultural heritage and new technologies. CHNT 22, 2017, Wien

19. Kuroczyński P et al (2021) Digital reconstruction of the new Synagogue in Breslau: New approaches to object-oriented research. In: Research and education in urban history in the age of digital libraries. Springer International Publishing, Cham, pp 25–45

20. Kuroczyński P et al (2019) Historic Building Information Modeling (hBIM) und Linked Data – Neue Zugänge zum Forschungsgegenstand objektorientierter Fächer. In: Sahle P (ed) DHd 2019. Digital humanities: multimedial & multimodal. Konferenzabstracts. Universitäten zu Mainz und Frankfurt, Mainz, pp 138–141

21. Martens B (2019) Virtuelle Rekonstruktion: Building Information Modelling (BIM) als Rahmenbedingung für eine langfristige Nutzung von digitalen 3D-Gebäudemodellen. In: Kuroczyński P et al (eds) Der Modelle Tugend 2.0: Digitale 3D-Rekonstruktion als virtueller Raum der architekturhistorischen Forschung. Heidelberg University Press, Heidelberg

22. Demetrescu E (2015) Archaeological stratigraphy as a formal language for virtual reconstruction. Theory and practice. J Archaeol Sci 57:42–55

23. Hauck O et al (2014) Cultural heritage markup language – how to record and preserve 3D assets of digital reconstruction. In: CHNT 19, Vienna. http://chml.foundation/wp-content/uploads/2015/06/CHNT19_Hauck_Kuroczynski.pdf. 09 July 2015

24. Niccolucci F et al (2006) A fuzzy logic approach to reliability in archaeological virtual reconstruction. In: Niccolucci F et al (eds) Beyond the artifact. Digital interpretation of the past. Budapest

25. Apollonio FI (2016) Classification schemes for visualization of uncertainty in digital hypothetical reconstruction. In: Münster S et al (eds) 3D Research challenges in cultural heritage II: how to manage data and knowledge related to interpretative digital 3D reconstructions of cultural heritage. Springer International Publishing, Cham, pp 173–197

26. Kensek KM et al (2004) Fantastic reconstructions or reconstructions of the fantastic? Tracking and presenting ambiguity, alternatives, and documentation in virtual worlds. Autom Constr 13(2):175–186. https://doi.org/10.1016/j.autcon.2003.09.010

27. Michl F (2018) Digitale Bilder—analoges Recht: Von den Untiefen des Bildrechts. In: Kuroczyński P, Bell P, Dieckmann L (eds) Computing Art Reader: Einführung in die digitale Kunstgeschichte. arthistoricum.net (Computing in Art and Architecture, Band 1), Heidelberg, pp 254–264

28. Lutz Heusinger (1983) Kunstgeschichte und EDV: 8 Thesen: In: Bd. 11 Nr. 4, Kritische Berichte. https://doi.org/10.11588/kb.1983.4.9808. https://journals.ub.uni-heidelberg.de/index.php/kb/article/view/9808/3674)

29. Laupichler F (1998) MIDAS, HIDA, DISKUS - was ist das? AKMB news 4

30. Berners-Lee T et al (2001) The semantic web. J Sci Am 284(5):34–43

31. Doerr M, Bruseker G, Bekiari C, Ore CE, Belios T, Stead S (2020) Volume A: definition of the CIDOC conceptual reference model. Version 6.2.9. ICOM/CIDOC documentation standards group, continued by the CRM special interest group. http://www.cidoc-crm.org/Version/version-6.2.9

32. RfII Recommendations "Performance through Diversity"—May 2016, pp 46. https://d-nb.info/1121685978/34

33. Wilkinson et al (2016) The FAIR guiding principles for scientific data management and stewardship. Scientific Data 3

34. Eastman CM (1975) The use of computers instead of drawings in building design. In: AIA Journal 63:46–50

35. See UK BIM Framework setting out the approach for implementing BIM in the UK using the framework for managing information provided by the ISO 19650 series. https://www.ukbimframework.org/standards/

36. Ohori KA et al (2018): Modeling cities and landscapes in 3D with CityGML. In: Building information modeling. Springer, pp 199–215. https://doi.org/10.1007/978-3-319-92862-3_1

37. Roubanov D (2014) Mechanikkonstruktion (M-CAD),. In: Eigner M et al (eds) Modellbasierte virtuelle Produktentwicklung. Springer Vieweg, pp 115–136

38. Fernie K et al (2020) 3D content in Europeana task force. https://pro.europeana.eu/post/3d-content-in-europeana-task-force-review

39. OGC (2012) OGC City Geography Markup Language (CityGML) Encoding Standard, Version 2.0.0

40. Cieslik E (2020) 3D digitization in cultural heritage institutions guidebook

41. Havemann S et al (2004) Generative parametric design of gothic window tracery. VAST 2004: the 5th international symposium on virtual reality, archaeology and cultural heritage

42. S. Garagnani et al (2013) parametric accuracy: building information modeling process applied to the cultural heritage preservation. In: 3DARCH 2013

43. Rossenova L, Schubert Z, Vock R, Sohmen L, Günther L, Duchesne P, Blümel I (2022) Collaborative annotation and semantic enrichment of 3D media: a FOSS toolchain. In: Proceedings of the 22nd ACM/IEEE joint conference on digital libraries (JCDL '22). Association for Computing Machinery, New York, NY, USA, Article 40, pp 1–5. https://doi.org/10.1145/3529372.3533289

44. Apollonio FI et al (2021) The critical digital model for the study of unbuilt architecture. In: Research and education in urban history in the age of digital libraries. Springer International Publishing, Cham, pp 3–24

45. Bajena IP, Kuroczyński P (2023) Development of the Methodology and Infrastructure for digital 3D Reconstructions. In: Proceedings of (IN)TANGIBLE HERITAGE(S) A conference on technology, culture and design, Canterbury 2022, AMPS conference proceedings series, ISSN 2398–9467, pp 72–83

46. DFG (2016) DFG-Praxisregeln "Digitalisierung"

47. Grellert M et al (2019) Die Rekonstruktion – Argument – Methode: Vorschlag für einen minimalen Dokumentationsstandard im Kontext digitaler Rekonstruktionen. In: Kuroczyński P et al (eds) Der Modelle Tugend 2.0: Digitale 3D-Rekonstruktion als virtueller Raum der architekturhistorischen Forschung. Heidelberg

48. Wacker M et al (2019) Documentation of digital reconstruction projects. In: Kuroczyński P et al (eds) Der Modelle Tugend 2.0: Digitale 3D-Rekonstruktion als virtueller Raum der architekturhistorischen Forschung. Heidelberg, pp 282–294

49. Kuroczyński P et al (2021) Digital reconstruction of the new Synagogue in Breslau: new approaches to object-oriented research. In: Niebling F et al (eds) Research and education in urban history in the age of digital libraries. Springer International Publishing, Cham, pp 25–45

50. Apollonio FI et al (2021) The critical digital model for the study of unbuilt architecture. In: Niebling F et al (eds) Research and education in urban history in the age of digital libraries. Springer International Publishing, Cham, pp 3–24
51. Kuroczyński P, Apollonio FI, Bajena I, Cazzaro I (2023) Scientific Reference Model – Defining standards, methodology and implementation of serious 3D models in archaeology, art and architecture history, in: The International Archives of the Photogrammetry, Remote Sensing and Spatial Information Sciences, Volume XLVIII-M-2 – 2023, pp 895–902
52. Getty (2022) What are controlled vocabularies?

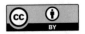

Infrastructure

9

Abstract

Currently, a large variety of infrastructures are targeting 3D models. Recently, several overview reports on extant platforms and repositories [1–5] and 3D visualization frameworks and formats [6] were compiled. Infrastructures differ from services by including tools or services and facilities for operation. Particularly for 3D models, there is a main difference between such as repositories and aggregators for storing, collecting, and preserving 3D data as well as 3D viewers or virtual research environments that allow access to 3D models and research activities with them.

Guiding questions

- What are the types of infrastructures?
- What are current challenges and developments?

Basic terms

- Linked open data
- Virtual research environments
- 3D information systems

© The Author(s) 2024
S. Münster et al., *Handbook of Digital 3D Reconstruction of Historical Architecture*,
Synthesis Lectures on Engineers, Technology, & Society 28,
https://doi.org/10.1007/978-3-031-43363-4_9

9.1 Digital Research Tools and Services

Infrastructures differ from services and tools.

- Digital **tools** are specialized software programs to treat a specific problem [7], e.g., the creation of a 3D model or conversion of metadata.
- A digital **service** is a managed tool operated and offered to others.
- A **digital infrastructure** comprises one or several services and/or facilities necessary for operation.

Concerning tools, basically not several research **tools** exist yet in the context of 3D reconstruction of historical architecture. Only examples can be mentioned here, as a possible list of desirable tools could be extended almost indefinitely. An overview of generic types of infrastructures is in Fig. 7.5. Examples of tool types are:

- **Plan analysis** merges the partial 2D designs of a building (plan sets) in a 3D model to uncover correlations, congruencies, and divergences.
- **3D verification** of 2D building designs with regard to construction and planning logics, impact intentions, constructability, functionality; ultimately consistent thinking and analysis in 3D.
- **Data validation** software checks the consistency of 3D datasets e.g., in the context of (H)BIM or polygonal models.
- Analysis/spatialization of **3D generated images**.

Access to 3D models is needed to evaluate and assess the quality of 3D data. In 3D reconstructions, this includes highlighting the knowledge and sources on which the modeling process is based. In addition to a number of technical requirements described in the following section, this implies a need to document processes and their results and to increase the capacity for making a model logic transparent [8, 9] (\rightarrow Documentation). A recent overview of 3D information systems and user demands revealed an especially high demand for open and accessible 3D content [5, 10].

> **Types of Infrastructures for 3D Models**
> **Data repositories** are collections of 3D models, which are stored and provided for secondary use. Sketchfab is the most widely used 3D repository worldwide; its heritage and history section contained around 74,000 3D models as of early 2019 [11].[1]

[1] https://sketchfab.com, accessed on 1.2.2023.

Data aggregators do not store 3D models but compile databases with the intent to prepare combined datasets for data processing. As an example, Europeana is a data aggregator compiling its collection from data in national and regional libraries.[2]

3D data viewers use computer graphics to visualize and view 3D models dynamically and enable user interactions, e.g., rotation or zooming. Current viewers, e.g., Kompakkt, are browser based [12].[3]

Virtual research environments (VREs) are web-based information systems that provide a working environment for researchers, by including various tools for analysis, comparison etc. [13]. An example is Patrimonium VRE to analyze buildings arrangements of Prussian manor houses (Fig. 9.1).[4]

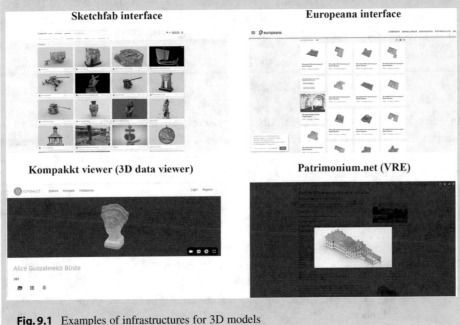

Fig. 9.1 Examples of infrastructures for 3D models

[2] https://www.europeana.eu, accessed on 1.2.2023.

[3] https://kompakkt.de/, accessed on 1.2.2023.

[4] https://www.herder-institut.de/projekte/digitale-3d-rekonstruktionen/, accessed on 1.2.2023.

9.2 Virtual Research Environments

Specifically for cultural heritage research, a large number of VREs are available—often
for specific communities like archeology [14] or architectural history [15]. Depending
on the group of users, there are several partially contradictory requirements: e.g., his-
tory research requires the comparability and contextualization of sources [16–19]. For
architectural studies, the transparent relationship between source and representation is
essential [20, 21]. For style analysis, visualization should ideally allow the identifica-
tion of abstract characteristics such as ideas and systems, breaks, or deviations [22, 23].
Concerning the use and development of information, two essential modes are discernible:
browsing as a self-directed search of historical sources and information [24], and location-
or context-related information shared in the course of heritage presentation [25]. Finally,
both research and communication approaches are usually individually adapted to a spe-
cific context. Digital tools are either tailored to individual scholarly communities or focus
on laypersons and do not meet the requirements of researchers [26].

9.3 3D Information Systems

In extension to classically 2D information systems, 3D user interfaces allow users to
interact with computer-generated 3D environments [27]. Especially in German-speaking
countries, such systems usually focus on 2D spatial and time mapping of historical
artefacts with related relation and aggregation information.

> **Further reading: Infrastructure Programs for 3D data**
> - **The European digital library Europeana** is a meta-data aggregator and a col-
> laboration of thousands of European archives, libraries, and museums, Europeana
> Collections provides access to more than 50 million objects in digitized form. As
> part of the EU Digital Europe Program, Europeana will be empowered to contain
> a large number of 3D assets.
> - The **German Research Data Infrastructure NFDI** is a national framework of
> consortia to provide domain-specific research infrastructures. Currently, three
> NFDI consortia provide infrastructures related to 3D data for humanities:
> NFDI4Culture serves the communities in art and architectural history and
> musicology; NFDI4Objects, archaeology; and NFDI4Memory, history.[5]

This is reflected not only in a large number of projects [28]. Perspective representations of
3D data open up a number of possibilities, especially for linking and illustrating complex

[5] https://www.nfdi.de, accessed on 1.2.2023.

historical information; virtual city and landscape models can be enriched with a variety of other site-related information [29, 30]. The linking of historical sources of different genres, their digitized data, digital research artifacts, research results, and associated meta-, para-, and context data has long been the focus of a large number of projects [31]. Specifically for history content, purposes range from humanities research and information issues to education and tourist applications [32].

9.4 Design Challenges in 3D Information Systems

The mainly technology-driven interaction forms and industry standards that have become established for 2D user interfaces [33–35] are not yet available for 3D. Research results on interaction solutions have so far gained little acceptance in the design practice of 3D applications for cultural heritage [27]. Various projects focus on gaining grounded implications for the design of 3D interfaces [36]; these design principles need to be adapted specifically for researchers in architectural history. Simple approaches based on 2D maps (e.g., Google Maps [37] or OpenStreetMap [38]) are available, also for historical images (e.g., Historypin [39]). In this spatial context, information like the distribution of images becomes visible. Deeper information becomes available in a 3D perspective: the orientation of the image and the situation of the photographer within the context of the surrounding buildings becomes clearer [40]. The user can take up the position and orientation of the camera and blend between the image and the 3D model. Combined with various historic states of a 3D model into a 4D city model, this allows comparisons between buildings.

9.5 Linked and Authority Data

Since metadata for digital objects is well established, 3D content segmentation and indexing are still unsolved these days, although this is the biggest community demand for standardization [41]. As mentioned in the previous chapter (→ Documentation), metadata provides a widely established concept for documenting processes and their results and has the capacity of making a model logic transparent [9, 42]. An important prerequisite in this respect is to identify and link elements across media [43]. Against this background, authority data is important to avoid data silos and to link enclosed projects across different media [44]. An overarching challenge is to classify 3D content information. Simple structures [45], but also complex objects such as buildings [46, 47], can be automatically segmented and assigned from datasets created by imaging processes [48, 49]. Inferences can also be made as to which parts of the image reference which parts of the 3D object geometries [50, 51]. Machine learning is playing an increasingly important

role in image segmentation, object recognition [52, 53], and classification of unstructured 3D data [54–58]. A current extension is to investigate multimodal 3D retrieval and cross-validation comprising 3D data, images, and texts [59].

Summary

Infrastructures fulfill an important function in storing, sharing, and providing access to 3D models, which enables users to research and contextualize 3D data. Repositories and aggregators store data and build collections of models, while 3D viewers and VREs enable user interaction with 3D models and support specific search tasks.

Projects

- **Baureka online**: Until now, a subject-specific research data infrastructure for historical building research has been lacking. Baureka will close this gap. It is conceived as a central online research data platform for thematically international historical building research in the German-speaking area. The expert community includes architects, architectural and art historians, and monument conservators from public authorities, research institutes, foundations for building culture, and architectural and engineering offices. This heterogeneity makes internal communication and exchange across the boundaries of science and practice difficult. Baureka will promote this exchange of research data and information and significantly facilitate networked work. In the future, the platform will publish research results in an open-access format. For historical building research, this is an important step into the digital age. https://baureka.de/, accessed on 1.2.2023.
- **Monarch**: This information system specializes in the spatial digital documentation of buildings and geographical areas. It also enables the assignment of semantic information to the building structures. Thus, all information belonging to a structural object can be represented in a model-like way [60].

Key literature

- Champion, E., and H. Rahaman, Survey of 3D Digital Heritage Repositories and Platforms. Virtual Archaeology Review, 2020, 11(23):1–15 [61].
- Münster, S. Advancements in 3D Heritage Data Aggregation and Enrichment in Europe: Implications for Designing the Jena Experimental Repository for the DFG 3D Viewer. Applied Sciences, 2023, 13:9781 [62].
- Storeide, M., George, S., Sole, A., Hardeberg, J.Y. Standardization of digitized heritage: a review of implementations of 3D in cultural heritage. Heritage Science, 2023, p. 11. https://doi.org/10.1186/s40494-023-01079-z [63].

References

1. Cieslik E (2020) 3D digitization in cultural heritage institutions guidebook
2. Champion E et al (2020) Survey of 3d digital heritage repositories and platforms. Virtual Archaeol Rev 11(23):1–15
3. Benardou A et al (2018) Cultural heritage infrastructures in digital humanities
4. Nishanbaev I (2020) A web repository for geo-located 3D digital cultural heritage models. Digit Appl Archaeol Cult Herit 16:e00139
5. Münster S (2023) Advancements in 3D heritage data aggregation and enrichment in Europe: implications for designing the Jena Experimental Repository for the DFG 3D viewer. Applied Sciences 13, 9781. https://doi.org/10.3390/app13179781
6. Fernie K et al (2020) 3D content in Europeana task force
7. Hildebrand K (1990) Was sind software tools? In: Hildebrand K (ed) Software tools: Automatisierung im software engineering: Eine umfassende Darstellung der Einsatzmöglichkeiten von Software-Entwicklungswerkzeugen. Springer, Berlin, pp 11–38
8. Keul H-K (1999) Der Wert der Wertfreiheit. Zu M. Webers theoretischem Postulat und seiner universal-pragmatischen Transformation. In: Znepolski I (ed) Max Weber - Relectures 1 Ouest, relectures 1 st. Actes du colloque de Sofia
9. Günther H (2001) Kritische Computer-Visualisierung in der kunsthistorischen Lehre. In: Frings M (ed) Der Modelle Tugend. CAD und die neuen Räume der Kunstgeschichte. Weimar, pp 111–122
10. Derudas P (2021) Archaeological publication systems: Which route to take? A compass for addressing future development
11. Flynn T (2019) What happens when you share 3D models online (In 3D)? In: Grayburn J et al (eds) 3D/VR in the academic library: emerging practices and trends
12. 'Comparison of Features Available on Aton SV, 3DHOP, Kompakkt and Virtual Interiors'. In Fung N, Schoueri K, Scheibler C (2021) Pure 3D: technical report, Maastricht University et al.
13. Candela L et al (2013) Virtual research environments: an overview and a research agenda. Data Sci J:GRDI-013
14. Meyer E et al (2007) A web information system for the management and the dissemination of cultural heritage data. J Cult Herit 8(4):396–411

15. Kuroczynski P (2017) Virtual research environment for digital 3D reconstructions – standards, thresholds and prospects. Stud Digit Herit 1(2):456–476
16. Friedrichs K et al (2018) Creating suitable tools for art and architectural research with digital libraries. In: Münster S et al (eds) Digital research and education in architectural heritage. 5th conference, DECH 2017, and first workshop, UHDL 2017, Dresden, Germany, 30–31 March 2017, Revised Selected Papers. Springer, pp 117–138
17. Münster S et al (2017) Von Plan- und Bildquellen zum virtuellen Gebäudemodell. Zur Bedeutung der Bildlichkeit für die digitale 3D-Rekonstruktion historischer Architektur. In: Ammon S et al (eds) Bildlichkeit im Zeitalter der Modellierung. Operative Artefakte in Entwurfsprozessen der Architektur und des Ingenieurwesens. eikones. Wilhelm Fink Verlag, München, pp 255–286
18. Brandt Av (2012) Werkzeug des Historikers. Urban-Taschenbücher, Bd. 33, 18. Auflage [1958] edn
19. Wohlfeil R (1986) Das Bild als Geschichtsquelle. Hist Z 243:91–100
20. Favro D (2006) In the eyes of the beholder. Virtual reality re-creations and academia. In: Haselberger L et al (eds) Imaging ancient Rome: documentation, visualization, imagination: proceedings of the 3rd Williams symposium on classical architecture, Rome, 20–23 May 2004. J Roman Archaeol Portsmouth 321–334
21. Niccolucci F et al (2006) A fuzzy logic approach to reliability in archaeological virtual reconstruction. In: Niccolucci F et al (eds) Beyond the artifact. Digital interpretation of the past. Budapest
22. Bürger S (2011) Unregelmässigkeit als Anreiz zur Ordnung oder Impuls zum Chaos. Die virtuose Steinmetzkunst der Pirnaer Marienkirche. Z Kunstgeschichte 74(1):123–132
23. Andersen K (2007) The geometry of an art. The history of the mathematical theory of perspective from Alberti to Monge. Sources and studies in the history of mathematics and physical sciences
24. Münster S et al (2018) Image libraries and their scholarly use in the field of art and architectural history. Int J Digit Libr 19(4):367–383
25. Münster S (2018) The big data time machine. In: CEBIT, Hannover
26. Fokus GmbH metigo MAP. http://www.fokus-gmbh-leipzig.de/metigo_map-Kartierung.php. Accessed 9 May 2014
27. LaViola JJ et al (2017) 3D user interfaces: theory and practice
28. Münster S et al (2018) Digital 3D reconstruction projects and activities in the German-speaking countries. In: Digital heritage. Progress in cultural heritage: documentation, preservation, and protection. Springer International Publishing, Cham, pp 599–606
29. Prechtel N et al (2013) Presenting cultural heritage landscapes - from GIS via 3D models to interactive presentation frameworks. ISPRS Ann Photogram Remote Sens Spat Inf Sci XL-5/W2 (XXIV International CIPA Symposium):253–258
30. 231. Dell'Unto N et al (2022) Archaeological 3D GIS.
31. Bentkowska-Kafel A et al (2012) Paradata and transparency in virtual heritage
32. Münster S (2011) Entstehungs- und Verwendungskontexte von 3D-CAD-Modellen in den Geschichtswissenschaften. In: Meissner K et al (eds) Virtual enterprises, communities & social networks. TUDpress, Dresden, pp 99–108
33. Tidwell J (2010) Designing interfaces: patterns for effective interaction design
34. Welie M et al (2003) Pattern languages in interaction design: structure and organization
35. Duyne DKV et al (2007) The design of sites - patterns for creating winning web sites
36. Burmester M et al (2018) Lost in space? 3D-interaction-patterns für einfache und positive Nutzung von 3D interfaces. In: Hess S et al (eds) Mensch und Computer 2018 – usability professionals (electronic book). Gesellschaft für Informatik e.V. und German UPA e.V., Bonn
37. Google Google Maps. https://www.google.com/maps. Accessed 9 Feb 2022

38. Open Street Map Open Street Map https://www.openstreetmap.de/. Accessed 9 Feb 2022
39. Historypin (2022) Historypin. www.historypin.org. Accessed 2 Feb 202
40. Schindler G et al (2012) 4D cities: analyzing, visualizing, and interacting with historical urban photo collections. J Multimed 7(2):124–131
41. Ulutas Aydogan S et al (2021) A framework to support digital humanities and cultural heritage studies research. In: Research and education in urban history in the age of digital libraries. Springer International Publishing, Cham, pp 237–267
42. Hoppe S (2001) Die Fußnoten des Modells. In: Frings M (ed) Der Modelle Tugend. CAD und die neuen Räume der Kunstgeschichte. Weimar, pp 87–102
43. Davis E et al (2021) Linked data and cultural heritage: a systematic review of participation, collaboration, and motivation. J Comput Cult Herit 14(2):Article 21
44. Auer S et al (2014) Linked Open data - creating knowledge out of the interlinked data
45. Vosselman G et al (2004) Recognising structure in laser scanner point clouds. ISPRS Arch 46(8):33–38
46. Agarwal S et al (2011) Building Rome in a day. Commun ACM 54(10):105–112
47. Li ML et al (2016) Reconstructing building mass models from UAV images. Comput & Graph-UK 54:84–93
48. Martinovic A et al (2015) 3d all the way: semantic segmentation of urban scenes from start to end in 3d. IEEE Comput Vis & Pattern Recognit 4456–4465
49. Hackel T et al (2016) Fast semantic segmentation of 3D point clouds with strongly varying density. ISPRS Ann 3(3):177–184
50. Vosselman G (2009) Advanced point cloud processing. In: Photogrammetric week'09, pp 137–146
51. Xie J et al (2016) Semantic instance annotation of street scenes by 3d to 2d label transfer. IEEE Comput Vis & Pattern Recognit 3688–3697
52. Minaee S et al (2021) Image segmentation using deep learning: a survey. IEEE Trans Pattern Anal Mach Intell PP:1–1
53. Jiao LC et al (2019) A survey of deep learning-based object detection. IEEE Access 7:128837–128868
54. Guo Y et al (2021) Deep learning for 3D point clouds: a survey. IEEE Trans Pattern Anal Mach Intell 43(12):4338–4364
55. Grilli E et al. (2017) A Review of Point clouds segmentation and classification algorithms. Int Arch Photogram Remote Sens Spat Inf Sci XLII-2/W3:339–344
56. Matrone F et al (2020) Comparing machine and deep learning methods for large 3D heritage semantic segmentation. ISPRS Int J Geo Inf 9(9):535
57. Ponciano JJ et al. (2021) From Acquisition to Presentation-The Potential of Semantics to Support the Safeguard of Cultural Heritage. Remote Sensing 13 (11).
58. Morbidoni C et al (2020) Learning from synthetic point cloud data for historical buildings semantic segmentation. J Comput Cult Herit 13(4):Article 34
59. Münster S et al (2022) Multimodale KI zur Unterstützung geschichtswissenschaftlicher Quellenkritik – ein Forschungsaufriss. In: Geierhos M et al (eds) Kulturen des digitalen Gedächtnisses. Konferenzabstracts (First Edition) [Computer software]. Kulturen des digitalen Gedächtnisses (DHd2022). Zenodo, Potsdam, Germany
60. Freitag B et al (2017) MonArch – a digital archive for cultural heritage. In: Vinken G et al (eds) Das Digitale und die Denkmalpflege: Bestandserfassung - Denkmalvermittlung - Datenarchivierung - Rekonstruktion verlorener Objekte
61. Champion E, Rahaman H (2020) Survey of 3D digital heritage repositories and platforms. Virtual Archaeol Rev 11:1–15. https://doi.org/10.4995/var.2020.13226

62. Münster S (2023) Advancements in 3D heritage data aggregation and enrichment in Europe: implications for designing the jena experimental repository for the DFG 3D viewer. Applied Sciences 13:9781
63. Storeide M, George S, Sole A, Hardeberg JY (2023) Standardization of digitized heritage: a review of implementations of 3D in cultural heritage. Herit Sci 11. https://doi.org/10.1186/s40494-023-01079-z

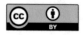

Legislation

10

Abstract

This chapter is proposed to provide an overview of the different types of legal rights and legislation relating to 3D reconstruction. Since reconstructions originate from various sources and comprise intellectual work by multiple persons, they affect different levels of legal and property rights, although the specific legal situation greatly depends on national laws.

Guiding questions
- What generic legal frameworks are there for 3D reconstruction?
- What types of licenses are there?

Basic terms
- Copyright
- Open licenses
- Closed licenses
- Public domain

© The Author(s) 2024
S. Münster et al., *Handbook of Digital 3D Reconstruction of Historical Architecture*,
Synthesis Lectures on Engineers, Technology, & Society 28,
https://doi.org/10.1007/978-3-031-43363-4_10

10.1 Intellectual Property

Intellectual Property rights (IP) comprise a wide range of legal rights related to intellectual works. The most relevant concepts are:

- **Copyright** is the "exclusive right to produce copies and to control an original literary, musical, or artistic work, granted by law for a specified number of years" (Collins Dictionary 2022). Some other types of intellectual output such as computer code are borderline cases and protected in some nations. When an individual creates and intellectual work, that author is granted a copyright. A main distinction is whether copyright is transferable (as in the US) or is not transferable and belongs to the author (as in most European states).
- **Usage rights** can be granted by copyright holders to users of a specific work and define types and modalities of this usage. These rights can be granted on an individual basis or via standard licenses, offering predefined conditions to users. Licenses may be closed, or open to allow unpaid use under certain conditions, e.g., naming the author.
- Potentially, 3D modeling can affect rights, e.g., **personality rights** (in cases of digitizing or modeling humans) or **security** (in cases of military objects or 3D printable weapons).

10.2 Legal Aspects

With regard to media, there are several legal aspects to 3D modeling. The most relevant are copyright and design laws [1, 2]:

- While older **cultural heritage objects** are now in the public domain [3], younger objects may be subject to copyright. Especially for museum objects, other legislation on property rights may effectively prevent 3D digitization without an exhibitor's permission [4].
- **Reproduction media** such as photographs potentially become an original object and add intellectual property for both copyright and design laws. The legal situation is uneven, not least with regard to the level of originality necessary (especially in the digitization of analog heritage objects, e.g., plans) to gain intellectual property rights for media depicting or digitizing a cultural heritage object [5, 6].
- A **3D model** may be subject to copyright [7]. It is currently being debated whether 3D digitization fulfills the requirements for being original or is simply copying and therefore creates nonoriginal works [8]. Although the situation for 3D reconstructions seems more clear, as substantial originality is inherent, not all national legislation sees reconstructions as original work [9].

- **3D printing** is subject to specific legislation. Specific overviews about copyright in the EU for 3D printing date from 2010 [10], 2014 [11], and 2019 [12].

Since legislation is implemented very much depending on the national situation, there are various national laws, e.g., for Germany maintained by NFDI4Culture for imagery [13] or web usage [14]. Another main distinction concerns the use of restricted media for commercial purposes or in research and education. In most national legislation there are exceptions for the latter cases and less restricted legislation applies.

10.3 Licenses: Open, Closed, or Public?

Recent developments at the EU level [15]—the Open Data Directive [16] and the Digital Single Market Directive [17]—provide political and legal framework conditions for digital humanities and digital heritage research. Despite this EU-wide attempt, the current situation on a member state level is very uneven [15].

> **Further reading: The FAIR Principles and open science**
> Co-production and user-generated content enable cultural innovation. Many institutions and members of scientific communities therefore do not limit themselves to the digital and open provision of cultural objects and data. Fundamental principles for this are that the data are **findable, accessible, interoperable, and reusable (FAIR)**. These require rich and interoperable metadata, high quality and resolution, open interfaces and open (data exchange) formats. 3D objects and data should be made available following the FAIR principles, both technically and legally [18]. The aim of this paradigm is to support the use of research data or works by others without restriction: specific guidelines to ensure FAIR research [19].

Another main distinction is between open and closed licenses. Creative content under **closed licenses** cannot be used without a specifically granted permission and in most cases payment to the license holder. **Open licenses** refer to creative content (media, software etc.) which the general public can access and use under certain conditions without having to explicitly ask for permission. Various open-source licensing models predefine conditions under which creative content can be used. Creative Commons (CC), a major open license, predefines modalities which enable everyone to use content under the same conditions and free of charge (Fig. 10.1). In contrast to closed and open source, **public domain** means creative works to which no intellectual property rights or copyright exist. Usually, public domain is coupled to periods—in most cases works enter the public domain 70 years after the death of the author. Public domain goods can be used by anyone for any purpose without a license or obligation to pay.

Abbrev.	Symbol	Sharing, remix, amending allowed	Naming of author	Commercial use allowed	Editing	Sharing only under same license
CC0/ Public Domain		✓	✗	✓	✓	✗
BY		✓	✓	✓	✓	✗
BY-SA		✓	✓	✓	✓	✓
BY-ND		✓	✓	✓	✗	✗
BY-NC		✓	✓	✗	✓	✗
BY-NC-SA		✓	✓	✗	✓	✓
BY-NC-ND		✓	✓	✗	✗	✗

Fig. 10.1 Types of creative commons licenses [20]

A specific facet of open versus closed content is **open versus closed source**—the legal and technical availability and reusability of software code or files. Closed source code (e.g., programs or 3D model files) is not publicly available or readable (e.g., proprietary software). In contrast, open-source files are publicly available and can be used under an open license.

Summary

3D reconstructions are linked to different legal rights, mostly concerning intellectual property. Creative works by other authors use as sources are subject to copyright, which can also be potentially obtained by the author(s) of a 3D reconstruction. Licenses can be closed or open—the first are paid, the second can be used for free. Open licensing modes—esp. Creative Commons—are well established now.

Concepts

- **Copyright** is the "exclusive right to produce copies and to control an original literary, musical, or artistic work, granted by law for a specified number of years" [21].
- **Creative Commons (CC)** are different mixable standard license agreements, through which license holders can define the legal conditions for distributing and sharing their creative content free of charge.

- **3D printing** is subject to specific legislation. Specific overviews about copyright in the EU for 3D printing date from 2010 [10], 2014 [11], and 2019 [12].

Since legislation is implemented very much depending on the national situation, there are various national laws, e.g., for Germany maintained by NFDI4Culture for imagery [13] or web usage [14]. Another main distinction concerns the use of restricted media for commercial purposes or in research and education. In most national legislation there are exceptions for the latter cases and less restricted legislation applies.

10.3 Licenses: Open, Closed, or Public?

Recent developments at the EU level [15]—the Open Data Directive [16] and the Digital Single Market Directive [17]—provide political and legal framework conditions for digital humanities and digital heritage research. Despite this EU-wide attempt, the current situation on a member state level is very uneven [15].

> **Further reading: The FAIR Principles and open science**
> Co-production and user-generated content enable cultural innovation. Many institutions and members of scientific communities therefore do not limit themselves to the digital and open provision of cultural objects and data. Fundamental principles for this are that the data are **findable, accessible, interoperable, and reusable (FAIR)**. These require rich and interoperable metadata, high quality and resolution, open interfaces and open (data exchange) formats. 3D objects and data should be made available following the FAIR principles, both technically and legally [18]. The aim of this paradigm is to support the use of research data or works by others without restriction: specific guidelines to ensure FAIR research [19].

Another main distinction is between open and closed licenses. Creative content under **closed licenses** cannot be used without a specifically granted permission and in most cases payment to the license holder. **Open licenses** refer to creative content (media, software etc.) which the general public can access and use under certain conditions without having to explicitly ask for permission. Various open-source licensing models predefine conditions under which creative content can be used. Creative Commons (CC), a major open license, predefines modalities which enable everyone to use content under the same conditions and free of charge (Fig. 10.1). In contrast to closed and open source, **public domain** means creative works to which no intellectual property rights or copyright exist. Usually, public domain is coupled to periods—in most cases works enter the public domain 70 years after the death of the author. Public domain goods can be used by anyone for any purpose without a license or obligation to pay.

Abbrev.	Symbol	Sharing, remix, amending allowed	Naming of author	Commercial use allowed	Editing	Sharing only under same license
CC0/ Public Domain		✓	✗	✓	✓	✗
BY		✓	✓	✓	✓	✗
BY-SA		✓	✓	✓	✓	✓
BY-ND		✓	✓	✓	✗	✗
BY-NC		✓	✓	✗	✓	✗
BY-NC-SA		✓	✓	✗	✓	✓
BY-NC-ND		✓	✓	✗	✗	✗

Fig. 10.1 Types of creative commons licenses [20]

A specific facet of open versus closed content is **open versus closed source**—the legal and technical availability and reusability of software code or files. Closed source code (e.g., programs or 3D model files) is not publicly available or readable (e.g., proprietary software). In contrast, open-source files are publicly available and can be used under an open license.

Summary

3D reconstructions are linked to different legal rights, mostly concerning intellectual property. Creative works by other authors use as sources are subject to copyright, which can also be potentially obtained by the author(s) of a 3D reconstruction. Licenses can be closed or open—the first are paid, the second can be used for free. Open licensing modes—esp. Creative Commons—are well established now.

Concepts

- **Copyright** is the "exclusive right to produce copies and to control an original literary, musical, or artistic work, granted by law for a specified number of years" [21].
- **Creative Commons (CC)** are different mixable standard license agreements, through which license holders can define the legal conditions for distributing and sharing their creative content free of charge.

Key literature

- Hoeren, T. (2021). Internetrecht: De Gruyter [14].
- Fischer, V. and G. Petri, Bildrechte in der kunsthistorischen Praxis—ein Leitfaden.—Zweite, überarbeitete und erweiterte Auflage. 2022, Heidelberg: arthistoricum [13].
- Ulutas Aydogan, S., Münster, S., Girardi, D., Palmirani, M., & Vitali, F. (2021). A Framework to Support Digital Humanities and Cultural Heritage Studies Research, Cham [15].

References

1. Borissova V (2018) Cultural heritage digitization and related intellectual property issues. J Cult Herit 34:145–150
2. Cieslik E (2020) 3D Digitization in cultural heritage institutions guidebook
3. Wallace A et al (2020) Revisiting access to cultural heritage in the public domain: EU and international developments. IIC-Int Rev Intellect Prop Compet Law 51(7):823–855
4. Euler E et al (2017) Bereit zu teilen?
5. Truyen F et al (2016) Copyright, cultural heritage and photography: a gordian knot? Cultural heritage in a changing world. Springer, Cham, pp 77–96
6. Margoni T (2014) The digitisation of cultural heritage: originality, derivative works and (non) original photographs. Derivative Works and (Non) Original Photographs, 3 December 2014
7. Elias C (2019) Whose digital heritage? Contemporary art, 3D printing and the limits of cultural property. Third Text 33(6):687–707
8. Oruc P (2020) 3D Digitisation of cultural heritage copyright implications of the methods, purposes and collaboration. 11 J INTELL PROP INFO TECH & ELEC COM L (149)
9. Probst S (2019) 3D-Druck trifft auf Urheber-und Patentrecht
10. Bradshaw S et al (2010) The intellectual property implications of low-cost 3D printing. ScriptEd 7:5
11. European Commission (2014) Overview of 3D printing & intellectual property law. Under the contract with the Directorate General Internal Market, Industry, Entrepreneurship and SMEs (MARKT2014/083/D)
12. Osborn LS (2019) 3D printing and intellectual property
13. Fischer V et al (2022) Bildrechte in der kunsthistorischen Praxis – ein Leitfaden. - Zweite, überarbeitete und erweiterte Auflage
14. Hoeren T (2021) Internetrecht
15. Ulutas Aydogan S et al (2021) A framework to support digital humanities and cultural heritage studies research. In: Cham, 2021. Research and education in urban history in the age of digital libraries. Springer International Publishing, pp 237–267
16. The European Parliament and The Council of the European Union (2019) DIRECTIVE (EU) 2019/1024 OF THE EUROPEAN PARLIAMENT AND OF THE COUNCIL of 20 June 2019 on open data and the re-use of public sector information (recast)

17. The European Parliament and The Council of the European Union (2019) DIRECTIVE (EU) 2019/790 OF THE EUROPEAN PARLIAMENT AND OF THE COUNCIL of 17 April 2019 on copyright and related rights in the Digital Single Market and amending Directives 96/9/EC and 2001/29/EC (Text with EEA relevance)
18. Forschungsdaten.org (2022) FAIR data principles. https://www.forschungsdaten.org/index.php/FAIR_data_principles
19. Wilkinson MD et al (2016) The FAIR guiding principles for scientific data management and stewardship. Sci Data 3:160018
20. Burgert (2022) Symbole von Creative Commons Schweiz CC BY 4.0
21. Collins Dictionary (2022). https://www.collinsdictionarycom/de/worterbuch/englisch/copyright

Printed in the United States
by Baker & Taylor Publisher Services